8/03

THE GENTLE ART

OF

MAKING ENEMIES

by

James Abbott McNeill Whistler

WITH AN INTRODUCTION BY
ALFRED WERNER

Dover Publications, Inc., New York

This Dover edition, first published in 1967, is an unabridged and unaltered republication of the second, enlarged edition published by William Heinemann, London, in 1892. An Introduction has been written especially for the Dover edition by Alfred Werner.

International Standard Book Number: 0-486-21875-9
Library of Congress Catalog Card Number: 67-24225

Manufactured in the United States of America

Dover Publications, Inc.
180 Varick Street
New York, N.Y. 10014

Introduction to the Dover Edition

"ARTISTS say the silliest things," an American painter once, self-mockingly, titled his autobiography. Indeed, many people still cherish the quaint notion that artists, however skillful, have no brains. But this malicious and false concept arose only in the last century. During the Renaissance the artist was respected as a man who often wrote poetry, treatises on aesthetic problems or manuals on technique, and could hold his own in conversations with sophisticated scholars. A painter of the Baroque Age, Rubens, spoke several languages and was assigned delicate diplomatic missions. Cambridge University conferred upon him the honorary degree of Master of Arts.

Up to the French Revolution artists were frequently lions of salon society and indistinguishable in appearance from the aristocracy. Only in the nineteenth century, with the advent of the age of technology, did the artist become an outsider, a "Bohemian," relegated to the poorer sections of the cities and barred by his straitened circumstances

from mingling with bourgeois society. Exceptions to the rule were the few who began with substantial financial resources. An artist could also climb to the top of the fashionable world if he could cater to the limited tastes of the *nouveaux riches*—something Whistler, among others of distinction, refused to do. The conservative practitioner of art, if skillful, could hope to become a professor at an École des Beaux-Arts, to receive medals, to obtain remunerative commissions. By contrast, the truly good artist—a man like Whistler—was hard up.

As for the image of the artist as an impulsive dolt who commits the most egregious blunders whenever he dares step out of his narrow domain, it arose even before Whistler was born. " *Bilde, Künstler, rede nicht!* " Goethe advised the artist, who was to make pictures but keep silent. Among the first modern artists who did not keep thus silent, who did talk back to critics, officials, and the so-called art-loving public, was Whistler. The code of silence was punctured, once and for all, by the witty, proud and pugnacious author of *The Gentle Art of Making Enemies.* In his century, the nineteenth, there was of course no dearth of artists who could think well and write well. But Delacroix and Van Gogh, to cite two examples, did not use their sharp pens for counterattack, as Whistler did. Delacroix may have hoped that after his death his journals would be published, but there is no shred of evidence that the

humble Van Gogh ever thought that his numerous and often long letters to his brother and to friends might ever be collected and appear in print.

Whistler was among the first modern artists to refuse to tolerate misunderstanding by critics and art lovers. His weapon was that of letters to the press, the first of which appeared in the *Athenaeum*, London, in 1862, to repudiate a statement made concerning one of his pictures (*Symphony in White No. 1: The White Girl*, now in the National Gallery of Art, Washington, D.C.). He wrote these letters in order to explain his aesthetic goals, but equally to rebuke those who did not agree with him on various aspects of art. When he reached his mid-fifties, he felt that unless he collected the letters, they would be buried forever in the dusty files of newspapers. With the help of an American critic and poet, Sheridan Ford, an expatriate like himself, he dug them up and added other material, his own writings along with those of "enemies." The compilation appeared in 1890 under a title that is now often quoted, while the book itself, long out of print, has been read only infrequently in recent years, mostly by students poring over it in libraries.

The present republication of the complete text of the enlarged edition of 1892, in a photographic reprint that retains all the flavor of the best of Victorian book-making, will be welcomed by many. But to appreciate this book

fully, one needs an acquaintance with the author's intriguing personality, and its specific milieu. Inevitably, some of the malicious innuendoes which made Londoners chuckle seventy-odd years ago are bound to be lost on all of us who cannot recognize the minor characters and local scandals alluded to. Still, enough is left to entertain and enlighten us, for the inherent theme, that of the Artist versus Society, is universal and eternal; and the philosophical, moral, aesthetic and sociological problems treated in the text earnestly, despite an amusing light manner, are still with us in the nineteen-sixties.

Who was James Abbott McNeill Whistler the man? Those who recall only the amusing anecdotes circulated about him, or the triumphantly witty things he said, or is supposed to have said, will be surprised to learn that he was really a frustrated, unhappy man. Had he met with more understanding during his years of struggle, he might have been less aggressive. His behavior was that of an individual who had been hurt deeply and frequently. When greeted in London by a fellow American who informed him that he too had been born in Lowell, Massachusetts, the artist superciliously adjusted his monocle and remarked in a penetrating voice, "I do not choose to be born at Lowell."

He would not have said that, nor would he have designated St. Petersburg, Russia, where he lived as a child, as

his place of birth, had not his ego been often and severely lacerated during his youth in America. He became a querulous person who found it difficult to make friends, and even more difficult to keep them. Asked why he was so unpleasant to so many people, he gave the characteristic reply, "Early in life I made the discovery that I was charming, and if one is delightful, one has to thrust the world away to keep from being bored to death." Characteristic, too, is the dedication of the present volume, indicating his voluntary alienation from men, "To The rare Few, who, early in Life, have rid Themselves of the Friendship of the Many, these pathetic Papers are inscribed."

Whistler was neither charming nor delightful to his teachers at West Point. Once, when he could not give the date of the battle of Buena Vista, an event of the Mexican War, the professor asked him good-naturedly what he would do at a dinner table were he asked the same question. He retorted, indignantly, "Do? Why, I should refuse to associate with people who could talk of such things at dinner."

Pyrrhic victories like this caused him, who had flunked out of West Point, subsequently to lose his job as a draftsman in the United States Coast Guard. Following his natural bent by concentrating on art, he led the kind of dissolute life in London and Paris for which he would have

been ostracized in his native country. He had servants and drank costly champagne even when he owned nothing but debts. To attract attention, he dressed like a music-hall artist, and from the more conservative Degas he elicited this remark: "If you were not a genius, you would be the most ridiculous man in Paris."

His sharp intelligence triumphed over his slow-witted patrons, but he frightened away potential buyers. His arrogant manner cloaked a deep insecurity: "Why drag in Velásquez?" was his rejoinder to an admirer who had compared him to the Spanish master. He needed love, but for a long time he had only fleeting relationships with women who served him as models, mistresses, housekeepers, business managers, and the mothers of his children. At fifty-four he finally married (his wife soon after died of cancer).

Only the most discerning among his contemporaries, such as his colleagues Degas and Pissarro, knew that, apart from being a brilliant conversationalist, controversialist and showman, Whistler was also an important master whose oils, watercolors and etchings were of far greater significance than all his wit. His was the not unusual dilemma of the imaginative artist filled with creative energy and plagued by an insatiable perfectionism, in a milieu largely hostile to non-conformist spirits. He was a contemporary and associate of many of the Impressionists but he walked alone: he neither adopted

their special technique nor wanted to limit himself, as they did, to recording the ephemeral "impression" of a scene.

He was a great innovator who, though remaining within the realm of representation, anticipated aspects of abstract art by fifty or sixty years. He spoke and wrote daringly and lucidly about the aims of art. Art should "stand alone, and appeal to the artistic sense of eye or ear, without confounding this with emotions entirely foreign to it, as devotion, pity, love, patriotism, and the like" (*The Gentle Art*, pp. 127 and 128). He differed from most of his contemporaries by insisting that the artist must do more than just imitate the visual world: "If the man who paints only the tree, or flower, or other surface he sees before him were an artist, the king of artists would be the photographer" (p. 128).

As a young man in Paris, he was under the spell of Courbet, champion of *réalisme*, whom he emulated to the point of making the same frequent use of palette knife and thick impasto. But he did not remain a Realist for a long time, for he became infected by *Japonisme*, that excitement for everything imported from Japan that intoxicated the French capital. More than any other painter, Whistler learned from the Japanese to be rigorously selective, to eliminate unnecessary details, and to arrange nature freely for the sake of a firm, rhythmically balanced design. Through his work, so utterly different from the anecdotal

pictures favored by Victorian England, he slowly suc-
ceeded in educating the more sensitive that art should be
an evocation rather than a statement; that a picture was
not nature but an artifact, and must not compete with, or
try to be mistaken for, reality; and that a person looking
at a picture should be moved to exclaim, "How beauti-
ful!" rather than "How true!"

Whistler's most celebrated and most widely known
picture is, of course, the portrait of his mother, Anna
Mathilde Whistler, née McNeill. Purposely, he titled it
Arrangement in Grey and Black. He explained: "To me it
is interesting as a picture of my mother; but what can or
ought the public to care about the identity of the por-
trait?" (p. 128). He meant to say: The subject matter is
immaterial, and exact representation of actuality has
nothing to do with painting. We must look for the intrinsic
aesthetic qualities of a work! Those who love the picture
(now in the Louvre) because it appeals to their sentimental
concept of motherhood, and for no other reasons, have
failed to grasp the artist's intentions. For Whistler's
important achievement is the evocation of an enigma in
the effect created by the juxtaposition of the black (the
subject's dress) and the gray of the wall. Beyond this effect,
of course, Whistler captured superbly the dreamy quality
of old people, interrupted by neither gesture nor loud word.

It is a delicate work, and indeed his creations in all

media are characterized by delicacy, even reticence, as one would expect from the hypersensitive individual that he was beneath his brash pose. In his Thames river scenes particularly, Whistler accomplished what Verlaine does in poetry—giving, in faint color (or in his etchings, in subtle outlines) the dim twilight aspects of things. From his windows in Chelsea, or on long walks he took along the Thames, he loved to watch the luminosity of the fleeting river, the mysterious movements of heavily laden barges guided by the silhouetted figures of pilots. Unlike the Impressionists, he did not start sketching on the spot, but would let the impression be filtered through the fine screen of his retentive memory so that, in most cases, there was a long interval between observation and execution.

It is easy for us, as it was not for nineteenth-century art lovers, to appreciate, in particular, those remarkable river scenes which he called Nocturnes. For we no longer expect from a draftsman or painter more than hints and suggestions on which to construct a vision. But in the 1870's, when these pictures were painted, most people resented them as too sketchy, as unfinished. Indeed, there is little to "see" in the oil (now in the Detroit Institute of Art) that roused the anger of art critic and historian John Ruskin: a curve of yellow and reddish dots (indicative of the fireworks) pierces subtle variations of black, dark green and dark blue. Yet the mystery of the scene—its poetry or,

to use the term Whistler would have preferred, its music—
is superbly presented.

This *Nocturne in Black and Gold: The Falling Rocket* led
to the celebrated lawsuit between Ruskin and Whistler.
Ruskin, on July 2, 1877, furiously wrote in his own
monthly publication, *Fors Clavigera: Letters to the Work-
men and Laborers of Great Britain*, concerning this picture,
exhibited at London's Grosvenor Gallery:

"I have seen, and heard, much of cockney impudence
before now; but never expected to hear a coxcomb ask two
hundred guineas for flinging a pot of paint in the public's
face."

Whistler sued Ruskin for libel. The jury brought in a
verdict for the plaintiff, and awarded him damages of one
farthing—a drawing of this coin embellishes page 19—but
the artist had to pay the court costs and thus was brought
to the brink of bankruptcy. His was a moral victory, but
another Pyrrhic one.

The first eighteen pages of *The Gentle Art* (after a few
angry notes referring to a pirated edition of the book, about
which more below) deal with the trial. The artist gives a
summing up—not, however, without willfully altering
entire passages to make himself appear more heroic and
his enemies more ridiculous. (Whistler's biographers have
pointed out the differences between the accounts in several
newspapers and the artist's version.)

In his youth, Ruskin was an astute critic who took up the cudgels for Turner and subsequently for the Pre-Raphaelites. Later, however, he lost contact with contemporary art, and even thought that concerning oneself with it was a waste of time. As a middle-aged man, he had his blind spots and was, in particular, incapable of appreciating what we might call the abstract, purely aesthetic merits of pictures such as those of Whistler. It is an ironic fact that his "libelous" charge against Whistler was very similar to that which, thirty-five years earlier, had been employed by a critic who had written in the *Literary Gazette* that Turner's pictures were produced "as if by throwing handfuls of white, blue, and red at the canvas, and letting what would stick, stick." Ruskin, then young and still open-minded, rallied to Turner's support by writing *Modern Painters.*

Whether or not Whistler's own account is entirely accurate, it still makes fascinating reading, so many decades after the trial. Fortunately for the artist, his adversaries in court were not brilliant men like himself, but only competent jurists with little wit and less understanding of art (Ruskin was not allowed by his doctors to appear in court). When the Attorney General, cross-examining Whistler, gave vent to his surprise that the artist had dared demand two hundred guineas (a considerable sum of money in 1877) for a picture he admitted had taken only

two days' work, the painter corrected him, "No;—I ask it for the knowledge of a lifetime," and, according to his account, was greeted with applause (*The Gentle Art*, p. 5). When the jurist asked whether Whistler could make him see the beauty of the picture, the defendant replied, to the laughter of the public, "No! Do you know I fear it would be as hopeless as for the musician to pour his notes into the ear of a deaf man" (*The Gentle Art*, p. 10).

England, which lacked artists of any significance after the demise of Turner in 1851, had no progressive critics in the decades Whistler lived there, certainly no one of the stature of Baudelaire, and not even the equivalents of the sensitive and courageous men who supported Manet, the Impressionists, Cézanne, Gauguin and Van Gogh. Whistler therefore came to conclude, rather arbitrarily, that literary men (like Ruskin) were incapable of judging the merits of pictures, and that the painter ought to be considered the only authority on that subject. "In the length of time," he declared in his pamphlet *Whistler v. Ruskin: Art and Art Critics*, "[the painter's] assertion alone has established what even the gentlemen of the quill accept as the canons of art" (*The Gentle Art*, p. 30). These men, of course, held an entirely opposite view: "God help the artists," wrote the critic Tom Taylor, "if ever the criticism of pictures falls into the hands of painters! It would be a case of vivisection all round" (*The Gentle Art*, p. 35).

Six years after the trial, Whistler decided that he had not done enough to educate the Tom Taylors, and to lay down the aesthetic law, he gave a public lecture (on February 20, 1885, at Prince's Hall, at the unusual hour of 10 P.M.). This lecture had a *succès de scandale*, and Whistler repeated it at Oxford and Cambridge. "Ten O'Clock," reprinted in *The Gentle Art*, contains several pivotal statements heralding a break with the Renaissance tradition that it was the artist's duty to imitate Nature as faithfully as possible. The most celebrated of these dicta:

"Nature contains the elements, in colour and form, of all pictures, as the keyboard contains the notes of all music.

"But the artist is born to pick, and choose, and group with science, these elements, that the result may be beautiful—as the musician gathers his notes, and forms his chords, until he brings forth from chaos glorious harmony" (*The Gentle Art*, pp. 142 and 143).

Art, never static, has of course developed far beyond Whistler's tenets. But at one time his work was considered so revolutionary that nobody cared, or dared, to buy his pictures. During his lifetime, there was little tolerance among the majority for what seemed to be a combination of snobbery and frivolity. It was only after Whistler's death in 1903 that critics, dealers and collectors became fully aware that they had been unjust to one of the most remarkable talents of the nineteenth century. *The Gentle*

Art certainly helped change their attitude towards modern painting, and, considering the book's importance, a note on its genesis might be added here.

It was to the above-mentioned Sheridan Ford that Whistler had assigned the chore of digging up all the necessary material from the newspaper files in the British Museum. Whistler and his wife also made their own researches at home, plowing through boxes filled with old newspapers and clippings. The artist repolished his texts, even though he had rewritten every sentence a dozen times before he had first submitted it for publication, so that every bit would be terse and penetrating rather than long-winded and turgid.

Credit for the compilation was to be given to Ford, but Whistler (perhaps on prompting by Mrs. Whistler) changed his mind, paid off Ford, and proceeded to do his own editing and publishing. Ford departed with his copy, determined to publish the book under his own responsibility. Knowing that what he was about to do was illegal, he gave the manuscript to a printer in Antwerp, Belgium, hoping to sell unauthorized copies in England. This printer objected to the dull title, *The Correspondence of James McNeill Whistler*, and picked six words from Ford's introduction to the text: "This collection . . . illustrates the gentle art of making enemies. . . ." Ford's compilation, incidentally, is not identical with Whistler's version, for it contains, among

other things, writings by Ford about the artist, plus many
Whistler anecdotes.

Ford's selection was printed, but Whistler sued his
compatriot. There was a trial in Antwerp, at the Palais de
Justice, with Whistler in the witness box, conversing in
fluent French, and an attorney named Maeterlinck, a
cousin of the poet, appearing for Whistler. Ford was con-
victed and heavily fined, and the entire edition, minus a
few copies already smuggled into England, was confiscated.
The undaunted Ford found a printer in Paris, but he was
again stopped by the painter. This unauthorized version
was also printed in New York, and published by Frederick
Stokes and Brother. But all save a few copies perished in a
fire that ravaged the premises of the firm. Only a few
volumes of this version have survived to this day. It is a
small duodecimo volume of 256 pages, bound in gray-green
paper, with type-set titles printed in red. Butterflies in
silhouettes mark Whistler's texts.

The victor in this struggle helped himself to the excellent
title provided by Ford and his Antwerp printer, but made
numerous changes in the text of the book. He proceeded
with great punctiliousness. Coaxing the publisher, William
Heinemann, to the Savoy Hotel, Whistler made him discuss
every detail, for hours on end. At the Ballantyne Press in
London, where the authorized version was printed, the
artist chose the type and spaced the text (he insisted on

very wide margins). He designed the title page, selected the brown cover and the yellow back. Having adopted a butterfly as his signature, he signed this book with one: the author's name is omitted from cover, spine, and title page. Moreover, the text is interspersed with numerous butterflies; each is individually drawn to underscore the mood of the text.

Heinemann published the book in 1890, a few months after the pirated edition. Two years later, a second edition was printed, enlarged by the section called "Auto-Biographical." It is this latter edition which is reproduced in the Dover reprint. In the United States, *The Gentle Art* was first published by John Lovell Co., and in 1904 taken over by the well-known firm of G. P. Putnam's Sons, New York. The book was repeatedly reprinted, even though it was not received with all the seriousness and respect it deserved. This was partly the author's fault. In the first place, by his eccentric behavior, Whistler had created a public image as a sensation seeker, as a frivolous jester, though he was anything but that. Secondly, *The Gentle Art* has something of a vendetta, of a personal act of revenge, about it. But it is more than merely a record of the artist's quarrels; it is the passionate reaction of a dedicated man to injustice and stupidity. It is an iconoclast's plea for a new, better attitude towards art. It is, in the last analysis, the outcry of one who wants mankind to recognize art as a necessity

rather than a plaything; it is a credo, echoing Baudelaire who, in a short phrase, told the bourgeoisie: "You need art."

The book should be required reading for every student of art and art history. Whistler helped liberate English art not only from the literary predilections and sham medievalism of the Pre-Raphaelites but also from the equally loathsome prosaic realism of the anecdotal pictures. The book is also significant for the student of English literature. For Whistler wrote simply, directly, tersely, forever seeking the right word, the exact phrase. He was finicky even about the division of paragraphs and the punctuation. As a matter of fact, one is surprised that one with such command of precise, rhythmical English did not write more than he actually did.

Whistler regarded, partly in jest, partly in earnest, *The Gentle Art* as his Bible. He hoped that it would have its place and live with the writings of Benvenuto Cellini, Leonardo da Vinci, and Albrecht Dürer. Though the book itself has been out of print for a number of years, excerpts have kept appearing in numerous anthologies. Dover Publications is pleased to make it available again to the English-speaking world. Among those who would have approved the step would have been, among others, Max Beerbohm, who once wrote that certain books ought to be treated tenderly as one would treat a flower, and then continued:

"Such a book is, in its own brown-papered boards, whereon gleam little gilt italics and a little gilt butterfly, Whistler's *The Gentle Art of Making Enemies.* It happens to be also a book which I have read and read again. . . . Yet it comes as fresh as when first . . . it came into my possession. A flower freshly plucked, one would say—a brown and yellow flower, with a little gilt butterfly fluttering over it. And its inner petals, its delicately proportioned pages, are as white and undishevelled as though they had never been opened."

ALFRED WERNER

New York, New York
March, 1967

THE GENTLE ART

OF

MAKING ENEMIES

Chelsea

PUBLISHER'S NOTE

IN the presence of a continued attempt to issue a spurious and garbled version of Mr. Whistler's writings, the Publisher has obtained his permission to bring out the present volume, printed under his own immediate care and supervision.

AN EXTRAORDINARY PIRATICAL
PLOT

A most curiously well-concocted piratical scheme to publish, without his knowledge or consent, a complete collection of Mr. Whistler's writings, letters, pamphlets, lectures, &c., has been nipped in the bud on the very eve of its accomplishment. It appears that the book was actually in type and ready for issue, but the plan was to bring out the work simultaneously in England and America. This caused delay, the plates having to be shipped to New York, and the strain of secrecy upon the conspirators during the interval would seem to have been too great. In any case indications of surrounding mystery, quite sufficient to arouse Mr. Whistler's attention, brought about his rapid action. Messrs. Lewis and Lewis were instructed to take out immediate injunction against the publication in both England and America, and this information, at once cabled across, warning all publishers in the United States, exploded the plot, effectually frustrating the elaborate machinations of those engaged in it.

" American Register," Paris, March 8, 1890.

SEIZURE OF MR WHISTLER'S PIRATED WRITINGS

"*New York Herald,*" *London Edition, March* 23, 1890.

This pirated collection of letters, writings, &c., to whose frustrated publication in this country and America we have already alluded, was seized in Antwerp, at the printers', on Friday last—the very day of its contracted delivery. The persistent and really desperate speculator in this volume of difficult birth, baffled in his attempt to produce it in London and New York, had been tracked to Antwerp by Messrs. Lewis and Lewis ; and he was finally brought down by Maître Maeterlinck, the distinguished lawyer of that city.

THE EXPLODED PLOT

With regard to this matter, to which we have already alluded on a previous occasion, Messrs. Lewis and Lewis have received the following letter from Messrs. Field and Tuer, of the Leadenhall Press, dated March 25, 1890:—

"*Pall Mall Gazette*," March 27, 1890.

"*We have seen the paragraph in yesterday's ' Pall Mall Gazette' relating to the publication of Mr. Whistler's letters. You may like to know that we recently put into type for a certain person a series of Mr. Whistler's letters and other matter, taking it for granted that Mr. Whistler had given permission. Quite recently, however, and fortunately in time to stop the work being printed, we were told that Mr. Whistler objected to his letters being published. We then sent for the person in question, and told him that until he obtained Mr. Whistler's sanction we declined to proceed further with the work, which, we may tell you, is finished and cast ready for printing, and the type distributed. From the time of this interview we have not seen or heard from the person in question, and there the matter rests.*"

MR. WHISTLER'S PAPER HUNT

"Sunday Times,"
March 30, 1890.

The fruitless attempt to publish without his consent, or rather in spite of his opposition, the collected writings of Mr. Whistler has developed into a species of chase from press to press, and from country to country. With an extraordinary fatality, the unfortunate fugitive has been invariably allowed to reach the very verge of achievement before he was surprised by the long arm of Messrs. Lewis and Lewis. Each defeat has been consequently attended with infinite loss of labour, material and money. Our readers have been told how the London venture came to nought, and how it was frustrated in America. The venue was then changed, and Belgium, as a neutral ground, was supposed possible ; but here again, on the very day of its delivery, the edition of 2000 vols. was seized by M. le Procureur du Roi, and under the nose of the astounded and discomfited speculator, the packed and corded bales, of which he was about to take possession, were carried off in the Government van ! The upshot of the untiring efforts of this persistent adventurer at length results in furnishing Mr. Whistler with the first and only copy of this curious work, which was certainly anything but the intention of its compiler, who clearly, judging from its contents, had reserved for him an unpleasing if not crushing surprise !

A GREAT LITERARY CURIOSITY

I have to-day seen the printed book itself of the Collected Writings of Mr. Whistler, whose publication has proved so comically impossible. The style of the preface and accessory comments is in the worst style of Western editorship ; while the disastrous effect of Mr. Whistler's literature upon the one who has burned his fingers with it, is amusingly shown.

" Pall Mall Gazette." March 1890.

In the index occur such well-known names as Mr. J. C. Horsley, R.A., Mr. Labouchere, Mr. Ruskin, Mr. Linley Sambourne, Mr. Swinburne, Tom Taylor, Mr. Frith, and Rossetti. The famous catalogue of the " Second Exhibition of Venice Etchings, February 19, 1883," in which Mr. Whistler quotes the critics, is also given.

A LAST EFFORT

"Pall Mall
Gazette," April 9,
1890.

We hear that a third attempt has been made to produce the pirated copy of Mr. Whistler's collected writings. Messrs. Lewis and Lewis have at once taken legal steps to stop the edition (printed in Paris) at the Customs. A cablegram has been received by Mr. Whistler's solicitors stating that Messrs. Stokes's name has been affixed to the title-page of the pirated book without the sanction of those publishers.

THE GENTLE ART

OF

MAKING ENEMIES

*AS PLEASINGLY EXEMPLIFIED
IN MANY INSTANCES, WHEREIN THE SERIOUS ONES
OF THIS EARTH, CAREFULLY EXASPERATED, HAVE
BEEN PRETTILY SPURRED ON TO UNSEEMLINESS
AND INDISCRETION, WHILE OVERCOME BY AN*

UNDUE SENSE OF RIGHT

A NEW EDITION

LONDON MDCCCXCII
WILLIAM HEINEMANN

To

*The rare Few, who, early in Life,
have rid Themselves of the Friendship
of the Many, these pathetic Papers
are inscribed*

"MESSIEURS LES ENNEMIS!"

Prologue

Professor John
Ruskin in *Fors
Clavigera*, July 2,
1877.
" FOR Mr. Whistler's own sake, no less than for the
protection of the purchaser, Sir Coutts Lindsay ought
not to have admitted works into the gallery in which
the ill-educated conceit of the artist so nearly ap-
proached the aspect of wilful imposture. I have seen,
and heard, much of cockney impudence before now ;
but never expected to hear a coxcomb ask two hundred
guineas for flinging a pot of paint in the public's
face."

JOHN RUSKIN.

The Action

IN the Court of Exchequer Division on Monday, before Baron Huddleston and a special jury, the case of Whistler *v.* Ruskin came on for hearing. In this action the plaintiff claimed £1000 damages.

Lawsuit for Libel against Mr. Ruskin Nov. 15, 1878.

Mr. Serjeant Parry and Mr. Petheram appeared for the plaintiff; and the Attorney-General and Mr. Bowen represented the defendant.

Mr. SERJEANT PARRY, in opening the case on behalf of the plaintiff, said that Mr. Whistler had followed the profession of an artist for many years, both in this and other countries. Mr. Ruskin, as would be probably known to the gentlemen of the jury, held perhaps the highest position in Europe and America as an art critic, and some of his works were, he might say, destined to immortality. He was, in fact, a gentleman of the highest reputation. In the July number of *Fors Clavigera* there appeared passages in which Mr. Ruskin criticised what he called " the

modern school," and then followed the paragraph of which Mr. Whistler now complained, and which was .
" For Mr. Whistler's own sake, no less than for the protection of the purchaser, Sir Coutts Lindsay ought not to have admitted works into the gallery in which the ill-educated conceit of the artist so nearly approached the aspect of wilful imposture. I have seen, and heard, much of cockney impudence before now ; but never expected to hear a coxcomb ask two hundred guineas for flinging a pot of paint in the public's face." That passage, no doubt, had been read by thousands, and so it had gone forth to the world that Mr. Whistler was an ill-educated man, an impostor, a cockney pretender, and an impudent coxcomb.

Mr. WHISTLER, cross-examined by the ATTORNEY-GENERAL, said : " I have sent pictures to the Academy which have not been received. I believe that is the experience of all artists. The nocturne in black and gold is a night piece, and represents the fireworks at Cremorne."

" Not a view of Cremorne ? "

" If it were called a view of Cremorne, it would certainly bring about nothing but disappointment on the part of the beholders. (*Laughter.*) It is an artistic arrangement. It was marked two hundred guineas."

"Is not that what we, who are not artists, would call a stiffish price?"

"I think it very likely that that may be so."

"But artists always give good value for their money, don't they?"

"I am glad to hear that so well established. (*A laugh.*) I do not know Mr. Ruskin, or that he holds the view that a picture should only be exhibited when it is finished, when nothing can be done to improve it, but that is a correct view; the arrangement in black and gold was a finished picture, I did not intend to do anything more to it."

"Now, Mr. Whistler. Can you tell me how long it took you to knock off that nocturne?"

. . . . "I beg your pardon?" (*Laughter.*)

"Oh! I am afraid that I am using a term that applies rather perhaps to my own work. I should have said, How long did you take to paint that picture?"

"Oh, no! permit me, I am too greatly flattered to think that you apply, to work of mine, any term that you are in the habit of using with reference to your own. Let us say then how long did I take to—'knock off,' I think that is it—to knock off that nocturne; well, as well as I remember, about a day."

"Only a day?"

"Well, I won't be quite positive; I may have still put a few more touches to it the next day if the painting were not dry. I had better say then, that I was two days at work on it."

"Oh, two days! The labour of two days, then, is that for which you ask two hundred guineas!"

"No;—I ask it for the knowledge of a lifetime." (*Applause.*)

"You have been told that your pictures exhibit some eccentricities?"

"Yes; often." (*Laughter.*)

"You send them to the galleries to incite the admiration of the public?"

"That would be such vast absurdity on my part, that I don't think I could." (*Laughter.*)

"You know that many critics entirely disagree with your views as to these pictures?"

"It would be beyond me to agree with the critics."

"You don't approve of criticism then?"

"I should not disapprove in any way of technical criticism by a man whose whole life is passed in the practice of the science which he criticises; but for the opinion of a man whose life is not so passed I would have as little regard as you would, if he expressed an opinion on law."

"You expect to be criticised?"

" Yes; certainly. And I do not expect to be affected
by it, until it becomes a case of this kind. It is
not only when criticism is inimical that I object to it,
but also when it is incompetent. I hold that none
but an artist can be a competent critic."

" You put your pictures upon the garden wall, Mr.
Whistler, or hang them on the clothes line, don't you
—to mellow ? "

" I do not understand."

" Do you not put your paintings out into the
garden ? "

" Oh ! I understand now. I thought, at first, that
you were perhaps again using a term that you are
accustomed to yourself. Yes ; I certainly do put the
canvases into the garden that they may dry in the
open air while I am painting, but I should be sorry to
see them ' mellowed.' "

" Why do you call Mr. Irving ' an arrangement in
black ' ? " (*Laughter.*)

Mr. BARON HUDDLESTON : " It is the picture and
not Mr. Irving that is the arrangement."

A discussion ensued as to the inspection of the
pictures, and incidentally Baron Huddleston remarked
that a critic must be competent to form an opinion,
and bold enough to express that opinion in strong
terms if necessary.

The ATTORNEY-GENERAL complained that no answer was given to a written application by the defendant's solicitors for leave to inspect the pictures which the plaintiff had been called upon to produce at the trial. The WITNESS replied that Mr. Arthur Severn had been to his studio to inspect the paintings, on behalf of the defendant, for the purpose of passing his final judgment upon them and settling that question for ever.

Cross-examination continued : " What was the subject of the nocturne in blue and silver belonging to Mr. Grahame ? "

" A moonlight effect on the river near old Battersea Bridge."

" What has become of the nocturne in black and gold ? "

" I believe it is before you." (*Laughter.*)

The picture called the nocturne in blue and silver, was now produced in Court.

" That is Mr. Grahame's picture. It represents Battersea Bridge by moonlight."

BARON HUDDLESTON : " Which part of the picture is the bridge ? " (*Laughter.*)

His Lordship earnestly rebuked those who laughed. And witness explained to his Lordship the composition of the picture.

" Do you say that this is a correct representation of Battersea Bridge ? "

" I did not intend it to be a ' correct ' portrait of the bridge. It is only a moonlight scene and the pier in the centre of the picture may not be like the piers at Battersea Bridge as you know them in broad daylight. As to what the picture represents that depends upon who looks at it. To some persons it may represent all that is intended ; to others it may represent nothing."

" The prevailing colour is blue ? "

" Perhaps."

" Are those figures on the top of the bridge intended for people ? "

" They are just what you like."

" Is that a barge beneath ? "

" Yes. I am very much encouraged at your perceiving that. My whole scheme was only to bring about a certain harmony of colour."

" What is that gold-coloured mark on the right of the picture like a cascade ? "

" The ' cascade of gold ' is a firework."

A second nocturne in blue and silver was then produced.

Witness : " That represents another moonlight scene on the Thames looking up Battersea Reach. I completed the mass of the picture in one day."

The Court then adjourned. During the interval the jury visited the Probate Court to view the pictures which had been collected in the Westminster Palace Hotel.

After the Court had re-assembled the "Nocturne in Black and Gold" was again produced, and Mr. WHIS-TLER was further cross-examined by the ATTORNEY-GENERAL : " The picture represents a distant view of Cremorne with a falling rocket and other fireworks. It occupied two days, and is a finished picture. The black monogram on the frame was placed in its position with reference to the proper decorative balance of the whole."

" You have made the study of Art your study of a lifetime. Now, do you think that anybody looking at that picture might fairly come to the conclusion that it had no peculiar beauty ? "

" I have strong evidence that Mr. Ruskin did come to that conclusion."

" Do you think it fair that Mr. Ruskin should come to that conclusion ? "

" What might be fair to Mr. Ruskin I cannot answer."

" Then you mean, Mr. Whistler, that the initiated in technical matters might have no difficulty in understanding your work. But do you think now that you could make *me* see the beauty of that picture ?"

The witness then paused, and examining attentively the Attorney-General's face and looking at the picture alternately, said, after apparently giving the subject much thought, while the Court waited in silence for his answer :

" No ! Do you know I fear it would be as hopeless as for the musician to pour his notes into the ear of a deaf man. (*Laughter.*)

" I offer the picture, which I have conscientiously painted, as being worth two hundred guineas. I have known unbiassed people express the opinion that it represents fireworks in a night-scene. I would not complain of any person who might simply take a different view."

The Court then adjourned.

The ATTORNEY-GENERAL, in resuming his address on behalf of the defendant on Tuesday, said he hoped to convince the jury, before his case closed, that Mr. Ruskin's criticism upon the plaintiff's pictures was perfectly fair and *bonâ fide ;* * and that, however severe it might be, there was nothing that could reasonably be complained of. Let them examine the nocturne in blue and silver, said to represent Battersea Bridge. What was that structure in the middle? Was it a telescope or a fire-escape? Was it like Battersea Bridge? What were the figures

* " Enter now the great room with the Veronese at the end of it, for which the painter (*quite rightly*) was summoned before the Inquisition of State."—Prof. JOHN RUSKIN : *Guide to Principal Pictures, Academy of Fine Arts, Venice.*

at the top of the bridge? And if they were horses and carts, how in the name of fortune were they to get off? Now, about these pictures, if the plaintiff's argument was to avail, they must not venture publicly to express an opinion, or they would have brought against them an action for damages.

After all, Critics had their uses.* He should like to know what would become of Poetry, of Politics, of Painting, if Critics were to be extinguished? Every Painter struggled to obtain fame.

No Artist could obtain fame, except through criticism.†

. . . . As to these pictures, they could only come to the conclusion that they were strange fantastical conceits, not worthy to be called works of Art.

. . . . Coming to the libel, the Attorney-General said it had been contended that Mr. Ruskin was not justified in interfering with a man's livelihood. But why not? Then it was said, "Oh! you have ridiculed Mr. Whistler's pictures." If Mr. Whistler disliked ridicule, he should not have subjected himself to it by exhibiting publicly such productions. If a man thought a picture was a daub‡ he had a right to say so, without subjecting himself to a risk of an action.

He would not be able to call Mr. Ruskin, as he was far too ill to attend; but, if he had been able to appear,

* " I have now given up ten years of my life to the single purpose of enabling myself to judge rightly of art earnestly desiring to ascertain, and *to be able to teach*, the truth respecting art ; also knowing that this truth was *by time and labour* definitely ascertainable."—Prof. RUSKIN: *Modern Painters*, Vol. III.

" Thirdly, that TRUTHS OF COLOUR ARE THE LEAST IMPORTANT OF ALL TRUTHS."—Mr. RUSKIN, Prof. of Art: *Modern Painters*, Vol. I. Chap. V.

" And that colour is indeed a most unimportant characteristic of objects, would be further evident on the slightest consideration. The colour of plants is constantly changing with the season . . . but the nature and essence of the thing are independent of these changes. An oak is an oak, whether green with spring, or red with winter ; a dahlia is a dahlia, whether it be yellow or crimson ; and if some monster hunting florist should ever frighten the flower blue, still it will be a dahlia ; but not so if the same arbitrary changes could be effected in its form. Let the roughness of the bark and the angles of the boughs be smoothed or diminished, and the oak ceases to be an oak ; but let it retain its universal structure and outward form, and though its leaves grow white, or pink, or blue, or tri-colour, it would be a white oak, or a pink oak, or a republican oak, but an oak still."—JOHN RUSKIN, Esq., M.A., Teacher and Slade Prof. of Fine Arts: *Modern Painters*.

† " Canaletto, had he been a great painter, might have cast his reflections wherever he chose but he is a little and a bad painter."—Mr. RUSKIN, Art Critic.

" I repeat there is nothing but the work of Prout which is true, living, or right in its general impression, and nothing, therefore, so inexhaustively *agreeable* " (sic).—J. RUSKIN, Art Professor : *Modern Painters*.

‡ " Now it is evident that in Rembrandt's system, while the contrasts are not more right than with Veronese, the colours are all wrong from beginning to end."—JOHN RUSKIN, Art Authority.

REFLECTION :
" In conduct and in conversation,
It did a sinner good to hear
Him deal in ratiocination ! "

he would have given his opinion of Mr. Whistler's work in the witness-box.

He had the highest appreciation for *completed pictures ;* † and he required from an Artist that he should possess something more than a few flashes of genius ! *

Mr. Ruskin entertaining those views, it was not wonderful that his attention should be attracted to Mr. Whistler's pictures. He subjected the pictures, if they chose, ‡ to ridicule and contempt. Then Mr. Ruskin spoke of "the ill-educated § conceit of the artist, so nearly approaching the action of imposture." If his pictures were mere extravagances, how could it redound to the credit of Mr. Whistler to send them to the Grosvenor Gallery to be exhibited ? Some artistic gentleman from Manchester, Leeds, or Sheffield might perhaps be induced to buy one of the pictures because it was a Whistler, and what Mr. Ruskin meant was that he might better have remained in Manchester, Sheffield, or Leeds, with his money in his pocket. It was said that the term " ill-educated conceit " ought never to have been applied to Mr. Whistler, who had devoted the whole of his life to educating himself in Art ; || but Mr. Ruskin's views ¶ as to his success did not accord with those of Mr. Whistler. The libel complained of said also, " I never expected to hear a coxcomb ask two hundred guineas for fling-

† "I was pleased by a little unpretending modern German picture at Dusseldorf, by Bosch, representing a boy carving a model of his sheep dog in wood."—J. RUSKIN : *Modern Painters.*

‡ "Vulgarity, dulness, or impiety will indeed always express themselves through art, in brown and gray, as in Rembrandt."— Prof. JOHN RUSKIN : *Modern Painters.*

¶ "And thus we are guided, almost forced, by the laws of nature, to do right in art. Had granite been white and marble speckled (and why should this not have been, but by the definite Divine appointment for the good of man?), the huge figures of the Egyptian would have been as oppressive to the sight as cliffs of snow, and the Venus de Medicis would have looked like some exquisitely graceful species of frog."— Slade Professor JOHN RUSKIN.

* "I have just said that every class of rock, earth and cloud must be known by the painter with geologic and meteorologic accuracy. — Slade Prof. RUSKIN : *Modern Painters.*

§ "It is physically impossible, for instance, rightly to draw certain forms of the upper clouds with a brush; nothing will do it but the palette knife with loaded white after the blue ground is prepared."—JOHN RUSKIN, Prof. of Painting.

¶ "The principal object in the foreground of Turner's 'Building of Carthage ' is a group of children sailing toy boats. The exquisite choice of this incident is quite as appreciable when it is seen, as when it is seen— it has nothing to do with the technicalities of painting ; such a thought as this is something far above all art." —JOHN RUSKIN, Art Professor : *Modern Painters.*

REFLECTION:

" Be not righteous overmuch, neither make thyself overwise ; why shouldest thou destroy thyself ? "

ing a pot of paint in the public's face." What was a coxcomb? He had looked the word up, and found that it came from the old idea of the licensed jester who wore a cap and bells with a cock's comb in it, who went about making jests for the amusement of his master and family. If that were the true definition, then Mr. Whistler should not complain, because his pictures had afforded a most amusing jest! *He did not know when so much amusement had been afforded to the* * *British Public as by Mr. Whistler's pictures.* He had now finished. Mr. Ruskin had lived a long life without being attacked, and no one had attempted to control his pen through the medium of a jury. Mr. Ruskin said, through him, as his counsel, that he did not retract one syllable of his criticism, believing it was right. Of course, if they found a verdict against Mr. Ruskin, he would have to cease writing,† but it would be an evil day for Art, in this country, when Mr. Ruskin would be prevented from indulging in legitimate and proper criticism, by pointing out what was beautiful and what was not.‡

Evidence was then called on behalf of the defendant. Witnesses for the defendant, Messrs. Edward Burne-Jones, Frith, and Tom Taylor.

Mr. EDWARD BURNE-JONES called.

Mr. BOWEN, by way of presenting him properly to

* " It is especially to be remembered that drawings of this simple character [Prout's and W. Hunt's] were made for these same middle classes, exclusively ; and even for the second order of middle classes, more accurately expressed by the term 'bourgeoisie.' They gave an unquestionable tone of liberal-mindedness to a suburban villa, and were the cheerfullest possible decorations for a moderate sized breakfast parlour, opening on a nicely mown lawn." —JOHN RUSKIN, Art Professor: *Notes on S. Prout and W. Hunt.*

† " It seems to me, and seemed always probable, that I might have done much more good in some other way."—Prof. JOHN RUSKIN, Art Teacher : *Modern Painters*, Vol. V.

‡ " Give thorough examination to the wonderful painting, *as such,* in the great Veronese and then, for contrast with its reckless power, and for final image to be remembered of sweet Italian art in its earnestness the Beata Catherine Vigri's St. Ursula, I will only say in closing, as I said of the Vicar's picture in beginning, that it would be well if any of us could do such things nowadays — and more especially if our vicars and young ladies could."—JOHN RUSKIN, Prof. of Fine Art : *Guide to Principal Pictures, Academy of Fine Arts, Venice.*

the consideration of the Court, proceeded to read extracts of eulogistic appreciation of this artist from the defendant's own writings.

The examination of witness then commenced; and in answer to Mr. BOWEN, Mr. JONES said: "I am a painter, and have devoted about twenty years to the study. I have painted various works, including the 'Days of Creation' and 'Venus's Mirror,' both of which were exhibited at the Grosvenor Gallery in 1877. I have also exhibited 'Deferentia,' 'Fides,' 'St. George,' and 'Sybil.' I have one work, 'Merlin and Vivian,' now being exhibited in Paris. In my opinion complete finish ought to be the object of all artists. A picture ought not to fall short of what has been for ages considered complete finish.

Mr. BOWEN: "Do you see any art quality in that nocturne, Mr. Jones?"

Mr. JONES: "Yes I must speak the truth, you know" (*Emotion.*)

Mr. BOWEN: ! . . "Yes. Well, Mr. Jones, what quality do you see in it?"

Mr. JONES: "Colour. It has fine colour, and atmosphere."

Mr. BOWEN: "Ah. Well, do you consider detail and composition essential to a work of Art?"

Mr. JONES: "Most certainly I do."

Mr. Bowen: "Then what detail and composition do you find in this nocturne?"

Mr. Jones: "Absolutely none."*

Mr. Bowen: "Do you think two hundred guineas a large price for that picture?"

Mr. Jones: "Yes. When you think of the amount of earnest work done for a smaller sum."

Examination continued: "Does it show the finish of a complete work of art?"

"Not in any sense whatever. The picture representing a night scene on Battersea Bridge, is good in colour, but bewildering in form; and it has no composition and detail. A day or a day and a half seems a reasonable time within which to paint it. It shows no finish—it is simply a sketch. The nocturne in black and gold has not the merit of the other two pictures, and it would be impossible to call it a serious work of art. Mr. Whistler's picture is only one of the thousand failures to paint night. The picture is not worth two hundred guineas."

Mr. Bowen here proposed to ask the witness to look at a picture of Titian,† in order to show what finish was.‡

Mr. Serjeant Parry objected.

Mr. Baron Huddleston: "You will have to prove that it is a Titian."

Mr. Bowen: "I shall be able to do that."

Side notes:

" The action of imagination of the highest power in Burne Jones, under the conditions of scholarship, of social beauty, and of social distress, which necessarily aid, thwart, and colour t in the nineteenth century, are alone in art,—unrivalled in their kind; and I *know* that these will be immortal, as the best things the mid-nineteenth century in England could do, in such true relations as it had, through all confusion, retained with the paternal and everlasting Art of the world."— JOHN RUSKIN, LL.D.: *Fors Clavigera*, July 2, 1877.

REFLECTION

* There is a cunning condition of mind that *requires to know*. On the Stock Exchange this insures safe investment. In the painting trade this would induce certain picture-makers to cross the river at noon, in a boat, before negotiating a Nocturne, in order to make sure of detail on the bank, that honestly the purchaser might exact, and out of which he might have been tricked by the Night!

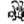

† "I believe the world may see another Titian, and another Raffaelle, before it sees another Rubens."— r. RUSKIN.

‡ "The Butcher's Dog, in the corner of Mr. Mulready's ' Butt,' displays, perhaps, the most wonderful, because the most dignified, finish and assuredly the most perfect unity of drawing and colour which the entire range of ancient and modern art can exhibit. Albert Durer is, indeed, the only rival who might be suggested."—JOHN RUSKIN Slade Professor of Art: *Modern Painters*.

Mr. Baron Huddleston : " That can only be by re-
pute. I do not want to raise a laugh, but there is a
well-known case of ' an undoubted ' Titian being
purchased with a view to enabling students and others
to find out how to produce his wonderful colours.
With that object the picture was rubbed down, and
they found a red surface, beneath which they thought
was the secret, but on continuing the rubbing they
discovered a full length portrait of George III. in
uniform ! "

The witness was then asked to look at the picture,
and he said : " It is a portrait of Doge Andrea Gritti,
and I believe it is a real Titian. It shows finish. It
is a very perfect sample of the highest finish of
ancient art.* The flesh is perfect, the modelling of
the face is round and good. That is an ' arrange-
ment in flesh and blood ! ' "

The witness having pointed out the excellences of
that portrait, said : " I think Mr. Whistler had great
powers at first, which he has not since justified. He
has evaded the difficulties of his art, because the
difficulty of an artist increases every day of his pro-
fessional life."

Cross-examined : " What is the value of this picture
of Titian ?"—" That is a mere accident of the sale-
room."

*. . . "I feel en-
titled to point out
that the picture by
Titian, produced in
the case of Whistler
v. Ruskin, is an
early specimen of
that master, and
does not represent
adequately the
style and qualities
which have obtained
for him his great re-
putation—one ob-
vious point of differ-
ence between this
and his more ma-
ture work being the
far greater amount
of finish—I do not
say completeness—
exhibited in it . . and
as the picture was
brought forward
with a view to in-
form the jury as to
the nature of the
work of the greatest
painter, and more
especially as to the

"Is it worth one thousand guineas ? "—" It would be worth many thousands to me."

high finish introduced in it, it is evident that it was calculated to produce an erroneous impression on their minds, if indeed any one present at the inquiry can hold that those gentlemen were in any way fitted to understand the issues raised therein.—I am, Sir, your obedient servant,

 · A. MOORE.

" Nov. 28."

Extract of a letter to the Editor of the *Echo.*

Mr. FRITH was then examined : " I am an R.A. ; and have devoted my life to painting. I am a member of the Academies of various countries. I am the author of the ' Railway Station,' ' Derby Day,' and ' Rake's Progress.' I have seen Mr. Whistler's pictures, and in my opinion they are not serious works of art. The nocturne in black and gold is not a serious work to me. I cannot see anything of the true representation of water and atmosphere in the painting of ' Battersea Bridge.' There is a pretty colour which pleases the eye, but there is nothing more. To my thinking, the description of moonlight is not true. The picture is not worth two hundred guineas. Composition and detail are most important matters in a picture. In our profession men of equal merit differ as to the character of a picture. One may blame, while another praises, a work. I have not exhibited at the Grosvenor Gallery. I have read Mr. Ruskin's works."

Mr. Frith here got down.

"I was just a toss up whether I became an Artist or an Auctioneer."— W. P. FRITH, R.A.

REFLECTION :

He must have tossed up.

REFLECTION :

A decidedly honest man—I have not heard of him since.

Mr. Tom Taylor—Poor Law Commissioner, Editor of *Punch*, and so forth—and so forth :—" I am an art critic of long standing. I have been engaged in this capacity by the *Times*, and other journals, for the last twenty years. I edited the ' Life of Reynolds,' and ' Haydon.' I have *always* studied art. I have seen these pictures of Mr. Whistler's when they were exhibited at the Dudley and the Grosvenor Galleries. The ' Nocturne' in black and gold I do not think a serious work of art." The witness here took from the pockets of his overcoat copies of the *Times*, and with the permission of the Court, read again with unction his own criticism, to every word of which he said he still adhered. " All Mr. Whistler's work is unfinished. It is sketchy. He, no doubt, possesses artistic qualities, and he has got appreciation of qualities of tone, but he is not complete, and all his works are in the nature of sketching. I have expressed, and still adhere to the opinion, that these pictures only come ' one step nearer pictures than a delicately tinted wall-paper.' "

REFLECTION: To perceive in Ruskin's army Tom Taylor, his champion—whose opinion he prizes— Mr. Frith, his ideal —was gratifying. But to sit and look at Mr. Burne Jones, in common cause with Tom Taylor—whom he esteems, and Mr. Frith—whom he respects —conscientiously appraising the work of a *confrère*—was a privilege ! !

This ended the case for the defendant.

Verdict for plaintiff. Damages one farthing.

Professor Ruskin's Group

M Y dear Sambourne—I know I shall be only charmed, as I always am, by your work, and if I am myself its subject, I shall only be flattered in addition.

The World,
Dec. 11, 1878.

Punch in person sat upon me in the box; why should not the most subtle of his staff have a shot? Moreover, whatever delicacy and refinement Tom Taylor may still have left in his pocket (from which, in Court, he drew his ammunition) I doubt not he will urge you to use, that it may not be wasted. Meanwhile you must not throw away sentiment upon what you call "this trying time."

A pleasant *résumé* of the situation—in reply to Mr. Sambourne's expressed hope that his historical cartoon in *Punch* might not offend

To have brought about an "Arrangement in Frith, Jones, *Punch* and Ruskin, with a touch of Titian," is a joy! and in itself sufficient to satisfy even my craving for curious "combinations."—Ever yours,

Whistler v. Ruskin

ART & ART CRITICS

Chelsea, Dec. 1878.

Dedicated to

ALBERT MOORE

Whistler v. Ruskin : Art and Art Critics

THE *fin mot* and spirit of this matter seems to have been utterly missed, or perhaps willingly winked at, by the journals in their comments. Their correspondents have persistently, and not unnaturally as writers, seen nothing beyond the immediate case in law—viz., the difference between Mr. Ruskin and myself, culminating in the libel with a verdict for the plaintiff.

Now the war, of which the opening skirmish was fought the other day in Westminster, is really one between the brush and the pen ; and involves literally, as the Attorney-General himself hinted, the absolute " raison d'être " of the critic. The cry, on their part, of " Il faut vivre," I most certainly meet, in this case, with the appropriate answer, " Je n'en vois pas la nécessité."

Far from me, at that stage of things, to go further into this discussion than I did, when, cross-examined

by Sir John Holker, I contented myself with the
general answer, " that one might admit criticism when
emanating from a man who had passed his whole life
in the science which he attacks." The position of
Mr. Ruskin as an art authority we left quite un-
assailed during the trial. To have said that Mr.
Ruskin's pose among intelligent men, as other than a
littérateur is false and ridiculous, would have been
an invitation to the stake ; and to be burnt alive, or
stoned before the verdict, was not what I came into
court for.

Over and over again did the Attorney-General cry
out aloud, in the agony of his cause, " What is to
become of painting if the critics withhold their lash ? "

As well might he ask what is to become of mathe-
matics under similar circumstances, were they possible.
I maintain that two and two the mathematician
would continue to make four, in spite of the whine of
the amateur for three, or the cry of the critic for
five. We are told that Mr. Ruskin has devoted his
long life to art, and as a result—is " Slade Professor "
at Oxford. In the same sentence, we have thus his
position and its worth. It suffices not, Messieurs ! a
life passed among pictures makes not a painter—
else the policeman in the National Gallery might
assert himself. As well allege that he who lives in a

library must needs die a poet. Let not Mr. Ruskin flatter himself that more education makes the differ- ence between himself and the policeman when both stand gazing in the Gallery.

There they might remain till the end of time; the one decently silent, the other saying, in good English, many high-sounding empty things, like the cracking of thorns under a pot—undismayed by the presence of the Masters with whose names he is sacrilegiously familiar; whose intentions he interprets, whose vices he discovers with the facility of the incapable, and whose virtues he descants upon with a verbosity and flow of language that would, could he hear it, give Titian the same shock of surprise that was Balaam's, when the first great critic proffered his opinion.

This one instance apart, where collapse was im- mediate, the creature Critic is of comparatively modern growth—and certainly, in perfect condition, of recent date. To his completeness go qualities evolved from the latest lightnesses of to-day—indeed, the *fine fleur* of his type is brought forth in Paris, and beside him the Englishman is but rough-hewn and blundering after all; though not unkindly should one say it, as reproaching him with inferiority resulting from chances neglected.

The truth is, as compared with his brother of

the Boulevards, the Briton was badly begun by
nature.

To take himself seriously is the fate of the humbug
at home, and destruction to the jaunty career of the
art critic, whose essence of success lies in his strong
sense of his ephemeral existence, and his consequent
horror of *ennuyer*ing his world—in short, to per-
ceive the joke of life is rarely given to our people,
whilst it forms the mainspring of the Parisian's
savoir plaire. The finesse of the Frenchman, ac-
quired in long loafing and clever *café* cackle—the glib
go and easy assurance of the *petit crevé*, combined
with the *chic* of great habit—the brilliant *blague*
of the ateliers—the aptitude of their *argot* — the
fling of the *Figaro*, and the knack of short para-
graphs, which allows him to print of a picture " C'est
bien écrit ! " and of a subject, " C'est bien dit ! "—these
are elements of an *ensemble* impossible in this island.

Still, we are " various " in our specimens, and a
sense of progress is noticeable when we look about
among them.

Indications of their period are perceptible, and
curiously enough a similarity is suggested, by their
work, between themselves and the vehicles we might
fancy carrying them about to their livelihood.

Tough old Tom, the busy City 'Bus, with its heavy

jolting and many halts; its steady, sturdy, stodgy
continuance on the same old much worn way, every
turning known, and freshness unhoped for; its
patient dreary dulness of daily duty to its cheap
company—struggling on to its end, nevertheless, and
pulling up at the Bank! with a flourish from the
driver, and a joke from the cad at the door.

Then the contributors to the daily papers: so many
hansoms bowling along that the moment may not be
lost, and the *à propos* gone for ever. The one or two
broughams solemnly rolling for reviews, while the
lighter bicycle zigzags irresponsibly in among them
for the happy Halfpennies.

What a commerce it all is, to be sure!

No sham in it either!—no " bigod nonsense!" they
are all " doing good "—yes, they all do good to Art.
Poor Art! what a sad state the slut is in, an these
gentlemen shall help her. The artist alone, by the
way, is to no purpose, and remains unconsulted; his
work is explained and rectified without him, by the
one who was never in it—but upon whom God, always
good, though sometimes careless, has thrown away
the knowledge refused to the author—poor devil!

The Attorney-General said, " There are some people
who would do away with critics altogether."

I agree with him, and am of the irrationals he

points at—but let me be clearly understood—the *art* critic alone would I extinguish. That writers should destroy writings to the benefit of writing is reasonable. Who but they shall insist upon beauties of literature, and discard the demerits of their brother *littérateurs* ? In their turn they will be destroyed by other writers, and the merry game goes on till truth prevail. Shall the painter then—I foresee the question—decide upon painting? Shall *he* be the critic and sole authority ? Aggressive as is this supposition, I fear that, in the length of time, his assertion alone has established what even the gentlemen of the quill accept as the canons of art, and recognise as the masterpieces of work.

Let work, then, be received in silence, as it was in the days to which the penmen still point as an era when art was at its apogee. And here we come upon the oft-repeated apology of the critic for existing at all, and find how complete is his stultification. He brands himself as the necessary blister for the health of the painter, and writes that he may do good to his art. In the same ink he bemoans the decadence about him, and declares that the best work was done when he was not there to help it. No ! let there be no critics ! they are not a " necessary evil," but an evil quite unnecessary, though an evil certainly.

Harm they do, and not good.

Furnished as they are with the means of furthering their foolishness, they spread prejudice abroad ; and through the papers, at their service, thousands are warned against the work they have yet to look upon.

And here one is tempted to go further, and show the crass idiocy and impertinence of those whose dicta are printed as law.

How he of the *Times* * has found Velasquez *June 6, 1874 "slovenly in execution, poor in colour—being little but a combination of neutral greys and ugly in its forms"—how he grovelled in happiness over a Turner—that was no Turner at all, as Mr. Ruskin wrote to show—Ruskin ! whom he has since defended. Ah ! Messieurs, what our neighbours call " la malice des choses " was unthought of, and the sarcasm of fate was against you. How Gerard Dow's broom was an example for the young ; and Canaletti and Paul Veronese are to be swept aside—doubtless with it. How Rembrandt is coarse, and Carlo Dolci noble—with more of this kind. But what does it matter ?

" What does anything matter ! " The farce will go on, and its solemnity adds to the fun.

Mediocrity flattered at acknowledging mediocrity,

and mistaking mystification for mastery, enters the
fog of dilettantism, and, graduating connoisseur,
ends its days in a bewilderment of bric-à-brac and
Brummagem !

" Taste" has long been confounded with capacity,
and accepted as sufficient qualification for the utter-
ance of judgment in music, poetry, and painting.
Art is joyously received as a matter of opinion;
and that it should be based upon laws as rigid and
defined as those of the known sciences, is a supposi-
tion no longer to be tolerated by modern cultivation.
For whereas no polished member of society is at
all affected at admitting himself neither engineer,
mathematician, nor astronomer, and therefore remains
willingly discreet and taciturn upon these subjects,
still would he be highly offended were he supposed to
have no voice in what is clearly to him a matter of
" Taste "; and so he becomes of necessity the backer
of the critic—the cause and result of his own ignor-
ance and vanity ! The fascination of this pose is too
much for him, and he hails with delight its justifica-
tion. Modesty and good sense are revolted at nothing,
and the millennium of " Taste " sets in.

The whole scheme is simple : the galleries are to be
thrown open on Sundays, and the public, dragged
from their beer to the British Museum, are to delight

in the Elgin Marbles, and appreciate what the early
Italians have done to elevate their thirsty souls! An
inroad into the laboratory would be looked upon as
an intrusion; but before the triumphs of Art, the
expounder is at his ease, and points out the doctrine
that Raphael's results are within the reach of any
beholder, provided he enrol himself with Ruskin or
hearken to Colvin in the provinces. The people are
to be educated upon the broad basis of " Taste,"
forsooth, and it matters but little what " gentleman
and scholar " undertake the task.

Eloquence alone shall guide them—and the readiest
writer or wordiest talker is perforce their professor.

The Observatory at Greenwich under the direction
of an Apothecary ! The College of Physicians with
Tennyson as President ! and we know that madness
is about. But a school of art with an accomplished
littérateur at its head disturbs no one! and is actually
what the world receives as rational, while Ruskin writes
for pupils, and Colvin holds forth at Cambridge.

Still, quite alone stands Ruskin, whose writing is
art, and whose art is unworthy his writing. To him
and his example do we owe the outrage of proffered
assistance from the unscientific—the meddling of the
immodest—the intrusion of the garrulous. Art, that
for ages has hewn its own history in marble, and

written its own comments on canvas, shall it suddenly
stand still, and stammer, and wait for wisdom from
the passer-by ?—for guidance from the hand that
holds neither brush nor chisel ? Out upon the shallow
conceit ! What greater sarcasm can Mr. Ruskin pass
upon himself than that he preaches to young men
what he cannot perform ! Why, unsatisfied with his
own conscious power, should he choose to become the
type of incompetence by talking for forty years of
what he has never done !

Let him resign his present professorship, to fill
the chair of Ethics at the university. As master of
English literature, he has a right to his laurels,
while, as the populariser of pictures he remains the
Peter Parley of painting.

The Art Critic of the " Times "

" SANS rancune," by all means, my dear Whistler ;
but you should not have quoted from my article, of
June 6th, 1874, on Velasquez, in such a way as to
give exactly the opposite impression to that which the
article, taken as a whole, conveys.

Mr. Tom Taylor's acknowledgment of presentation copy of Mr. Whistler's " Art and Art Critics," with " Sans rancune " inscribed upon fly-leaf by the author.

I appreciate and admire Velasquez as entirely, and
allow me to say, as intelligently, as yourself. I have
probably seen and studied more of his work than you
have. And I maintain that the article you have

The World,
Jan. 15, 1879.

garbled in your quotation gives a fair and adequate
account of the picture it deals with—" *Las Meninas* "
—and one which any artist who knows the picture
would, in essentials, subscribe to.

God help the artists if ever the criticism of pictures
falls into the hands of painters ! It would be a case
of vivisection all round.

Your pamphlet is a very natural result of your late

disagreeable legal experiences, though not a very wise one.

If the critics are not better qualified to deal with the painters than the painter in your pamphlet shows himself qualified to deal with the critics, it will be a bad day for art when the hands that have been trained to the brush lay it aside for the pen.* • ! ?

If you had read my article on Velasquez, I cannot but say that you have made an unfair use of it, in quoting a detached sentence, which, read with the context, bears exactly the opposite sense from that you have quoted it as bearing.

This is a bad "throw-off" in the critical line; whether it affect "*le premier littérateur venu*" or yours always,

TOM TAYLOR.

P.S.—*As your attack on my article is public, I reserve to myself the right of giving equal publicity to this letter.*

Lavender Sweep,
 Jan. 6, 1879.

The Position

The World,
Jan. 15, 1879.

DEAD for a ducat, dead! my dear Tom: and the rattle has reached me by post.

"*Sans rancune,*" say you? Bah! you scream unkind threats and die badly.

Why squabble over your little article? You *did* print what I quote, you know, Tom; and it is surely unimportant what more you may have written of the Master. That you should have written anything at all is your crime.

No; shrive your naughty soul, and give up Velasquez, and pass your last days properly in the Home Office.

Set your house in order with the Government for arrears of time and paper, and leave vengeance to the Lord, who will forgive my "garbling" Tom Taylor's writing.

THE WHITE HOUSE,
Jan. 8, 1879.

Serious Sarcasm

PARDON me, my dear Whistler, for having taken you *au sérieux* even for a moment.

I ought to have remembered that your penning, like your painting, belongs to the region of " chaff." I will not forget it again ; and meantime remain yours always,

<div align="right">TOM TAYLOR.</div>

Lavender Sweep,
 Jan. 9, 1879.

Final

WHY, my dear old Tom, I never *was* serious with you, even when you were among us. Indeed, I killed you quite, as who should say, without seriousness, " A rat! A rat!" you know, rather cursorily.

The World,
Jan. 15, 1879

Chaff, Tom, as in your present state you are beginning to perceive, was your fate here, and doubtless will be throughout the eternity before you. With ages at your disposal, this truth will dimly dawn upon you; and as you look back upon this life, perchance many situations that you took *au sérieux* (art-critic, who knows? expounder of Velasquez, and what not) will explain themselves sadly—chaff! Go back!

THE WHITE HOUSE,
Jan. 10, 1879.

"*Balaam's Ass*"

M R. WHISTLER has written a discord in black
and white. It is a strong saying, excellent in diction,
broadly and boldly set down in slashing words. *Vanity Fair,*
Jan. 11, 1870.

The point Mr. Whistler raises and enforces is
that criticism of painting other than by painters is
monstrous, and not to be tolerated. Mr. Rus-
kin's "high sounding empty things" would, he says,
"give Titian the same shock of surprise that was
Balaam's when the first great critic proffered his
opinion." The inference is that all the
world, competent and incompetent together, must re-
ceive the painter's work in silence, under pain of
being classed with Balaam's ass.

If, finding himself ill received or ill understood, he
has to say, "You cannot understand me," he must also
say, "I did not understand myself and you, to whom
I speak, sufficiently well to make you understand me."

There could be no better illustration of all this than

that Mr. Whistler has suggested of Balaam's ass. *For the Ass was right*, although, nay, because he was an ass. " What have I done unto thee," said he, " that thou hast smitten me these three times ? " " Because thou hast mocked me," replies Balaam—Whistler; whereupon the Angel of the Lord rebukes him and says, " *The ass saw me*," so that Balaam is constrained to bow his head and fall flat on his face. And thus indeed it is. The ass sees the Angel of the Lord there where the wise prophet sees nothing, and, by her seeing, saves the life of the very master who, for reward, smites her grievously and wishes he had a sword that he might kill her.

Let Balaam not forget that after all he rides upon the ass, that she has served him well ever since she was his until this day, and that even now he is on his way with her to be promoted unto very great honour by the Princes of Balak. And let him remember that whatever can speak may at any moment have a word to say to him which it were best he should hear.

RASPER.

The Point acknowledged

Vanity Fair,
Jan. 18, 1879.

WELL hit! my dear *Vanity*, and I find, on searching again, that historically you are right.

The fact, doubtless, explains the conviction of the race in their mission, but I fancy you will admit that this is the *only Ass on record* who ever *did* "see the Angel of the Lord!" and that we are past the age of miracles.

Yours always,

THE WHITE HOUSE,
Jan. 11, 1879.

Critic's Analysis

IN the "Symphony in White No. III." by Mr. Whist-
ler there are many dainty varieties of tint, but it is
not precisely a symphony in white. One lady has a *The Saturday
 Review,*
yellowish dress and brown hair and a bit of blue ribbon, June 1, 1867.
 P. G. Hamerton.
the other has a red fan, and there are flowers and
green leaves. There is a girl in white on a white
sofa, but even this girl has reddish hair; and of course
there is the flesh colour of the complexions.

The Critic's Mind Considered

HOW pleasing that such profound prattle should inevitably find its place in print! "Not precisely a symphony in white for there is a yellowish dress brown hair, etc. another with reddish hair and of course there is the flesh colour of the complexions."

Bon Dieu! did this wise person expect white hair and chalked faces? And does he then, in his astounding consequence, believe that a symphony in F contains no other note, but shall be a continued repetition of F, F, F.? Fool!

 CHELSEA,
June 1867.

A Troubled One

The World,
July 3, 1878.

T HE " Season Number " of *Vanity Fair* contains . . . Mr. Whistler's etching of " St. James's Street " is sadly disappointing.

Full Absolution

D EAR *World*—Atlas, overburdened with the world and its sins, may well be relieved from the weight of one wee error—a sort of last straw that bothers *The World*
July 10, 1878. his back. The impression in *Vanity Fair* that disappoints him is not an etching at all, but a reproduction for that paper by some transfer process.

Atlas has the wisdom of ages, and need not grieve himself with mere matters of art. " Il n'est pas nécessaire que vous sachiez ces choses-là, mon révérend père ! "

CHELSEA.

"Confidences" with an Editor

TO THE EDITOR OF THE *"HOUR."*

SIR—I have read the intelligent remarks of your critic upon my pictures, and am happy to be able to remove, I think, the "melancholy" impression left upon his mind by the supposition that "the best works are not of recent date." Permit me to reassure him, for the paintings he speaks of in glowing terms —notably "the full-length portrait of a young girl," which he overwhelms me by comparing to Velasquez, as well as the two life-size portraits in black, "in which there is an almost entire negation of colour" (though I, who am, he says, a colourist, did not know it)—are my latest works, and but just completed.

May I still farther correct a misconception? The etchings and dry-points in the gallery do not form a complete set. There are only fifty exhibited, making about half the number I have executed.

Again, it was from no feeling that "my works were

not seen to advantage when placed in juxtaposition with those of an essentially different kind," that I "determined to have an exhibition of my own, where no discordant elements should distract the spectator's attention." It is true that occasionally it has been borne in upon my mind that those whose "works are of an essentially different kind," are unwilling to place mine in juxtaposition with their own.

My wish has been, though, to prove that the place in which works of art are shown may be made as free from "discordant elements which distract the spectators' attention" as the works themselves.

Marvelling greatly that the "principle" that has led me (in his eyes at least) to paint so that he speaks of me in the same breath with Velasquez, should be "founded on fallacy,"—I remain, sir, your obedient servant,

June 10, 1874.

Critics "Copy"

The World,
Dec. 8, 1880.

AT the Gallery of the Fine Art Society in New Bond Street, an exhibition has been opened of the etchings of Venice, executed by Mr. Whistler. Exhibitions are sometimes of slender constitution nowadays. Mr. Whistler's etchings are twelve in number, of unimportant dimensions, and of the slightest workmanship. They convey a certain sense of distance and atmosphere, otherwise it cannot be said that they are of particular value or originality. They rather resemble vague first intentions, or memoranda for future use, than designs completely carried out. Probably every artist coming from Venice brings with him some such outlines as these in his sketch-books. Apparently, so far as his twelve etchings are to be considered as evidence in the matter, Venice has not deeply stirred either Mr. Whistler or his art.

A Proposal

ATLAS, *mon bon, méfiez-vous de vos gens!* Your art gentleman says that Mr. Whistler exhibits twelve etchings, " slight in execution and unimportant in size." Now the private assassin you keep, for us, need not be hampered by mere connoisseurship in the perpetration of his duty—therefore, *passe,* for the execution—but he should not compromise his master's reputation for brilliancy, and print things that he who runs may scoff at.

The World,
Dec. 29, 1880.

Seriously, then, my Atlas, an etching does not depend, for its importance, upon its size. " I am not arguing with you—I am telling you." As well speak of one of your own charming *mots* as unimportant in length !

Look to it, Atlas. Be, severe with your man. Tell him his " job" should be " neatly done." I could cut my own throat better; and if need be, in case of his dismissal, I offer my services.

Meanwhile, yours joyously,

The Painter-Etcher Papers

THE exhibition of etchings at the Hanover Gallery
has been the occasion of one of those squabbles which
amuse everybody — perhaps, even including the
quarrellers themselves. Some etchings, exceedingly
like Mr. Whistler's in manner, but signed "Frank
Duveneck," were sent to the Painter-Etchers' Exhibi-
tion from Venice. The Painter-Etchers appear to
have suspected for a moment that the works were
really Mr. Whistler's; and, not desiring to be the
victims of an easy hoax on the part of that gentleman,
three of their members—Dr. Seymour Haden, Dr.
Hamilton, and Mr. Legros—went to the Fine Art
Society's Gallery, in New Bond Street, and asked one
of the assistants there to show them some of Mr.
Whistler's Venetian plates. From this assistant they
learned that Mr. Whistler was under an arrangement
to exhibit and sell his Venetian etchings only at the
Fine Art Society's Gallery; but, even if these Painter-

" A Storm in an
Æsthetic Teapot."
The Cuckoo,
April 11, 1881.

Etchers really believed that " Frank Duveneck " was only another name for James Whistler, this information about the Fine Art Society's arrangement with him need not have shaken that belief, for the *nom de plume* might easily have been adopted with the concurrence of the society's leading spirits. Nor is it altogether certain that the Painter-Etchers did anything more than compare, for their own satisfaction as connoisseurs, the works of Mr. Whistler and "Frank Duveneck." The motive of their doing so may have been misunderstood by the Fine Art Society's assistant with whom they conferred.

Be that as it may, this assistant thought fit to repeat to Mr. Whistler what had passed, and also his own impressions as to the motive of the comparison and the inquiries which the Painter-Etchers had instituted. Whereupon Mr. Whistler has addressed a letter to Mr. Seymour Haden (who is, by the way, *his brother-in-law*), of which all that need be here said, is that it is extremely characteristic of Mr. Whistler.

Later

The Cuckoo,
April 30, 1881.

SOME time ago I referred to a storm in an " æsthetic tea-pot " that was brewed and had burst in the Fine Art Society's Gallery, in Bond Street, in *re* Mr. Whistler's Venice Etchings. It seems to me that Mr. Seymour Haden, Mr. Legros, and Mr. Hamilton stumbled on an artistic mare's nest, that they rashly suggested that Mr. Whistler had been guilty of gross misfeasance in publishing etchings in an assumed name, and that they are now trying to get out of the scrape as best they may. This is, however, simply an opinion formed on perusal of the following documents, which I here present to my readers to judge of :

The following paragraph was some time ago sent to me with this letter :—

" If the Editor of the ' *Cuckoo* ' should see his way to the publication of the accompanying paragraph as it stands, twenty copies may

be sent, for circulation among the Council of the Society of Painter-Etchers, to Mr. Piker, newsvendor, Shepherd's Market."

"MR. WHISTLER AND THE PAINTER-ETCHERS.—Our explanation of this 'Storm in a Tea-pot' turns out to have been in the main correct. It appears that not only were the three gentlemen who went to the Fine Art Society's Gallery to look at Mr. Whistler's etchings guiltless of offence, but that the object of their going there was actually less to show that Mr. Whistler *was* than that he was *not* the author of the etchings which for a moment had puzzled them.

"For this, indeed, they seem to have given each other—in the presence of the blundering assistant, of course—three very distinct reasons.

"Firstly, that, as already stated, Mr. Seymour Haden had quite seriously written to Mr. Duveneck to buy the etchings.

"Secondly, that they at once accepted as satisfactory and sufficient the explanation given them of Mr. Whistler's obligations to the Fine Art Society; and, thirdly, though this count appears to have somehow slipped altogether out of the indictment—they were one and all of opinion that, taken all round, the Duveneck etchings were the *best of the two* (*sic*) ! ! !

"It is a pity a clever man like Mr. Whistler is yet not clever enough to see that while habitual public attacks on a *near relative* cannot fail to be, to the majority of people, unpalatable, they are likely to be, when directed against a brother etcher, even *suspecte.*"

I did not at the time " see my way " to publishing the paragraph " as it stands," but, having subsequently received the following correspondence, I think it only right to give Mr. Piker's paragraph publicity, along with the letters subjoined :—

"THE FINE ART SOCIETY,"

148 NEW BOND STREET.

March 18, 1881.

"To Seymour Haden, Esq.—My dear Sir,—Mr. Whistler has called upon me respecting your visit here yesterday with Mr. Legros and Dr. Hamilton, the purport of which had been communicated to him by Mr. Brown."

Letter from Mr. Huish to Mr. Haden.

"He is naturally indignant that, knowing, as you apparently did, that he was under an engagement not to publish for a certain time any etchings of Venice except those issued by us, you should suggest that they were his work, and had been sent in by him under a *nom de plume*."

"He considers that it is damaging to his reputation in connection with us, and he requests me to write and ask you whether you adhere to your opinion or retract it."

"Believe me to remain, yours faithfully,

"MARCUS B. HUISH."

" 38 HERTFORD STREET, MAYFAIR, W.
March 21, 1881.

Letter from Mr. Haden to Mr. Huish.

"To M. Huish, Esq.—Dear Sir,—I am in receipt of a letter from you, dated the 18th inst., in which you first impute to me an opinion which I have never

held, and then call me to account for that opinion. To a peremptory letter so framed, I shall not be misunderstood if I simply decline to plead."

" Meanwhile, that I was *not* of opinion that the etchings in our hands were by Mr. Whistler is conclusively proved by the fact that on the day after their reception I had written to Mr. Duveneck to arrange for their purchase !"

"Be this, however, as it may, I can have no hesitation on the part both of myself and of the gentlemen engaged with me in a necessary duty, in expressing our sincere regret if, by a mistaken representation of our proceedings, Mr. Whistler has been led to believe that we had said or implied anything which could give him pain or reflect in any way on his reputation either with you or your directors."

" Faithfully yours,

"F. SEYMOUR HADEN."

"ARTS CLUB,"
HANOVER SQUARE.

"To Seymour Haden, Esq.—Sir—Mr. Huish handed me your letter of the 21st inst., since when I have waited in vain for the true version that, I doubted not, would follow the ' mistaken representation' you regret I should have received."

Letter from J. M'N. Whistler to Mr. Haden. March 20, 1881.

" Now I must ask that you will, if possible, without further delay, give me a thorough explanation of your visit to the Fine Art Society's Gallery on Friday evening, the 17th inst.,—involving, as it did, a discussion of my private affairs."

" Did you, accompanied by M. Legros and Dr. Hamilton, call at the Fine Art Society's rooms on that date, and ask to see Mr. Whistler's etchings ?"

" Did you there proceed to make a careful and minute examination of these, and then ask Mr. Brown if Mr. Whistler had done other etchings of Venice ? "

" Upon his answer in the affirmative, did you ask Mr. Brown if any of the other plates were large ones, and, notably, whether Mr. Whistler had done any other plate of the subject called ' The Riva ' ? "

" Did you ask to see the early states of Mr. Whistler's etchings ? "

" Did you say to Mr. Brown, ' Now, is not Mr. Whistler under an engagement with the Fine Art Society to publish no Venice etchings for a year ? ' or words to that effect ? and upon Mr. Brown's assurance that such was the case, did you request him to go with you to the Hanover Gallery ? "

" Did you there produce for his inspection three large Venice etchings, and among them the ' Riva ' subject ? "

" Did you then incite Mr. Brown to detect, in these works, the hand of Mr. Whistler ? "

" Did you point out details of execution which, in your opinion, betrayed Mr. Whistler's manner ? "

" Did you say, ' You see these etchings are signed " Frank Duveneck," and I have written to that name and address for their purchase, but I don't believe in the existence of such a person,' or words to that effect ? "

" If this be not so,

" Why did you take Mr. Brown over to the Hanover Gallery ? "

" Why did you show him Mr. Duveneck's Venice etchings ? "

" Why did you question him about my engagement with the Fine Art Society ? "

" Is it officially, as the Painter-Etchers' President, that you pry about the town ? "

" Does the Committee sanction your suggestions ? and have you permitted yourself these ' proceedings ' with the full knowledge and approval of the ' dozen or more distinguished men seated in serious council,' as described by yourself in the *Pall Mall Gazette ?* "

" Of what nature, pray, is the ' necessary duty ' that has led two medical men and a Slade Professor to fail as connoisseurs, and blunder as detectives ? "

" ' Vat shall de honest man do in my closet ? Dere is no honest man dat shall come in my closet ! ' "

" Copies of this correspondence will be sent to members of your Committee."

To this last letter, Mr. Seymour Haden has not as yet sent any answer, and here the matter rests. As requested, we have sent Mr. Piker the copies he requires for distribution.

THE EDITOR OF THE " CUCKOO."

La Suite

TO the Committee of the Painter-Etchers' Society :

Gentlemen,—I have hitherto, in vain, written to Sir William Drake, as secretary of the Painter-Etchers' Society, and feeling convinced that his elaborate silence cannot possibly be the expression of any intended discourtesy on the part of the Committee, as a body, but that it would rather indicate that they had not been consulted in the matter at all, I now address myself to you, and beg that you will kindly inform me whether the Committee, as represented by their officers, endorse the late acts of their President, or whether they intend taking any steps towards refusing to share the shame and ridicule that have accrued from certain "proceedings" described by Mr. Haden as a "necessary duty," in the exercise

Letter to the Committee of "Painter-Etchers' Society."

of which he was officially engaged in conjunction with Dr. Hamilton and M. Legros.

That you may clearly see how current the matter has become, I have the honour, Gentlemen, to send you herewith, for your serious consideration, extracts from the daily press, and thus, as you will read, carry out myself the first intention of a certain speculative Piker, newsvendor, Shepherd's Market, who had purposed circulating among you "twenty copies" of the enclosed literary venture—curtailed, it is true, to the original "Piker paragraph," and unaccompanied by the Piker twenty-penny prospect; the printing of which may—who knows ?—have caused a wavering on the part of Piker, and have left you deprived of his labour after all.

Piker offers matter with authority—and here I would point out the *close proximity of Shepherd's Market to Hertford Street, Mayfair !*—most suggestive is such contiguity. The newsvendor's stall and the doctor's office within hail of each other !

Surely I may, without indiscretion, congratulate the President upon Piker's English and also upon the Pecksniffian whine about the "brother-in-law"—rather telling in its way—but shallow ! shallow !—for after all, Gentlemen, a brother-in-law is *not* a connection calling for sentiment—in the abstract,

rather an intruder than "a near relation"—indeed, "near relation" is mere swagger!

Meanwhile, the insinuation of jealousy of the "brother-etcher" is, as Piker puts it, "*suspecte*"—very!—and modest!—and transparent!

To the last paper I have added the cutting from the former *Cuckoo* (Piker's earlier effort) so that you have the occasion of perceiving how the progressive Piker party have gained in courage—until, in direct contradiction to their first anxiety and hesitation, we reach the final *overwhelming certainty* of the three representative gentlemen, whose visit to the Fine Art Society's rooms, it would *now* appear, was absolutely to prove to the "blundering assistant" that some etchings he had never seen, and, consequently never had questioned;—of the very existence of which, in short, he was utterly unconscious,—were by a Mr. Duveneck, of whom he had never heard, and *not* by Mr. Whistler!—a fact that in his whole life he had never been in a position to dispute—and of which *the three Painter-Etchers themselves were the only people* who had ever had any doubt!

Really, they either doubted Duveneck, or they didn't doubt Duveneck!—Now, if the Piker party didn't doubt Duveneck, who the devil did the Piker party doubt? And why, may I ask, does Mr. Haden,

two days after the disastrous blunder in Bond Street, *volunteer* the following note of explanation to Mr. Brown, the assistant ?—

(COPY.)

"38 HERTFORD STREET, MAYFAIR, W.
March 19, 1881.

"To Ernest Brown, Esq.—Dear Sir,—We know all about Mr. Frank Duveneck, and are delighted to have his etchings.—Yours faithfully,"

"F. SEYMOUR HADEN."

It will be remembered that the little expedition to the Fine Art Society's Gallery took place on *Thursday evening, the* 17*th* of March. On Friday, the 18th, Mr. Huish wrote to Mr. Haden demanding an explanation; and on *Saturday, the* 19*th*, this over-diplomatic and criminating note was sent to Mr. Brown,—altogether unasked for, and curiously difficult to excuse !—" Methinks, he doth protest too much ! "

Further comment I believe to be unnecessary.

I refer you, Gentlemen, to my letter of March 29th, which Mr. Haden has never been able to answer— and merely point out that, the "blundering assistant " was the only one who did not blunder at all—since he alone, refrained from folly, and, notwithstanding all exhortation, steadily refused, in the presence of

cunning connoisseurs, to mistake the work of one man for that of another.

I have, Gentlemen, the honour to be,

Your obedient servant,

J. McNeill Whistler.

May 18, 1881.

To the Committee of
the Painter-Etchers' Society.

May I, without impertinence, ask what really does constitute the " Painter-Etcher " " all round," as Piker has it?—for, of these three gentlemen who have so markedly distinguished themselves in that character, two certainly are not painters—and one doesn't etch !

A Correction

The World,
Nov. 14, 1883.

A SUPPOSITITIOUS conversation in *Punch* brought about the following interchange of telegrams :—

From Oscar Wilde, Exeter, to J. McNeill Whistler, Tite Street.—*Punch* too ridiculous—when you and I are together we never talk about anything except ourselves.

From Whistler, Tite Street, to Oscar Wilde, Exeter. —No, no, Oscar, you forget—when you and I are together, we never talk about anything except me.

A Warning

The World,
June 1, 1881.

M Y dear James,—I see from a weekly paper that your late residence, the White House, in Tite Street, is now occupied by Mr. Harry Quilter, "the excellent art critic and writer on art," or words to that effect. This is the great man who has succeeded Mr. Tom Taylor on the *Times,* and whose vagaries in art criticism you and I, my dear James, have previously noticed. . .

ATLAS.

REFLECTION:
" A foolish ma'ns foot is soon in his neighbour's house ; but a man of experience is ashamed of him.'

Naïf Enfant

The Times,
May 2, 1881.

CLOSE to this is another portrait of extreme in-
terest, and, though of another kind, it is not inappro-
priately near Mr. Hunt's work. This is Mr. John
Ruskin, painted by Mr. Herkomer. It is difficult to
dissociate this picture, as regards the merit of its
painting, from the interest which attaches to it as
being the first oil portrait we have ever seen of our
great art critic. The picture remains a singu-
larly fine one, and is, in our opinion, Mr. Herkomer's
best portrait.

A Straight Tip

The World,
May 18, 1881.

" NE pas confondre intelligence avec gendarmes "—
but surely, dear Atlas, when the art critic of the
Times, suffering possibly from chronic catarrh, is wafted
in at the Grosvenor without guide or compass, and
cannot by mere sense of smell distinguish between oil
and water colour, he ought, like Mark Twain, " to
inquire."

Had he asked the guardian or the fireman in the
gallery, either might have told him not to say that
one of the chief interests of Mr. Herkomer's large
water-colour drawing of Mr. Ruskin " attaches to it
as being *the first oil portrait* we have ever seen of our
great art critic "! Adieu.

An Eager Authority

The World,
Feb. 9, 1881.

M R. WHISTLER knows how to defend himself so
perkily that it is a pleasure to attack him. I hasten,
therefore, with joy, to submit to you, dear Atlas,
who are growing so very clever at your languages,
the following crotchets and quavers—shall I call them?
for Mr. Whistler is just now full of " notes "—in
American-Italian; they are from his delightful brown-
paper catalogue. To begin with, " Santa Margharita "
is wrong; it must be either Margarita or Margherita;
the other is impossible Italian. Then who or what is
" San Giovanni *Apostolo et Evangelistæ* "? Does the
sprightly and shrill McNeill mean this for Latin?
And is the " Café Orientale " intended to be French or
Italian? It has an *e* too many for French, and an
too few for Italian. " Piazetta," furthermore, does
duty for " Piazzetta." Finally I give up " Campo Sta.
Martin." I don't know what that can be. The Italian
Calendar has a San Martino and a Santa Martina, but
Sta. Martin is very curious. The catalogue is exceed-
ingly short, but a few of the names are right.

An Admission

TOUCHÉ!—and my compliments to your "Correspondent," Atlas, *chéri*—far from me to justify spelling of my own! But who could possibly have supposed *The World,* Feb. 16, 1881 an orthographer loose! Evidently too "ung vieulx qui a moult roulé en Palestine et aultres lieux!"

What it is to be prepared, though! Atlas, *mon pauvre ami*, you know the story of the witness who, when asked how far he stood from the spot where the deed was done, answered unhesitatingly—"Sixty-three feet seven inches!" "How, sir," cried the prosecuting lawyer—"how can you possibly pretend to such accuracy?" "Well," returned the man in the box, "you see I thought some d——d fool would be sure to ask me, and so I measured."

'Arry in the Grosvenor

ATLAS—In spite of the Kyrle Society, I don't appeal to the middle classes; for I read in the *Times* that 'Arry won't have me. I am ranked with the *caviare* of his betters, and add not to the relish of his winkles and tea.

Also, why troubles he about many things?

But, alas! as is aptly remarked in one of the weekly papers, "'Arry has taken to going to the Grosvenor;" and "ce n'est pas tout que d'être honnête," he says, lightly paraphrasing Alfred de Musset, "il faut être joli garçon!"

The World,
May 17, 1882.

And so he blooms into an æsthete of his own order. To have seen him, O my wise Atlas, was my privilege and my misery; for he stood under one of my own "harmonies"—already with difficulty gasping its gentle breath—himself an amazing "arrangement" in strong mustard-and-cress, with bird's-eye belcher of

Reckitt's blue; and then and there destroyed absolutely, unintentionally, and once for all, my year's work!

Atlas, shall these things be?

Encouragement

TO OSCAR ON HIS " TOUR."

The World,
Feb. 15, 1882.

OSCAR—We, of Tite Street and Beaufort Gardens, joy in your triumphs and delight in your success; but we are of opinion that, with the exception of your epigrams, you talk like "S—— C—— in the provinces"; and that, with the exception of your knee-breeches, you dress like 'Arry Quilter.

CHELSEA.

A Remonstrance

A TLAS, how could you!

I know you carry the *World* on your back, and am not surprised that my note to Oscar, on its way, should have fallen from your shoulders into your dainty fingers; but why present it in the state of puzzle?

The World,
Feb. 22, 1882.

Besides, your caution is one-sided and unfair; for if you print S—— C——, why not A—— Q—— ? Why not X Y Z at once?

And how unlike me! Instead of the frank reck-lessness which has unfortunately become a charac-teristic, I am, for the first time, disguised in careful timidity, and discharge my insinuating initials from the ambush of innuendo.

My dear Atlas, if I may not always call a spade a spade, may I not call a Slade Professor, Sidney Colvin?

Propositions

I. THAT in Art, it is criminal to go beyond the means used in its exercise.

II. That the space to be covered should always be in proper relation to the means used for covering it.

III. That in etching, the means used, or instrument employed, being the finest possible point, the space to be covered should be small in proportion.

IV. That all attempts to overstep the limits insisted upon by such proportion, are inartistic thoroughly, and tend to reveal the paucity of the means used, instead of concealing the same, as required by Art in its refinement.

V. That the huge plate, therefore, is an offence— its undertaking an unbecoming display of determination and ignorance—its accomplishment a triumph of unthinking earnestness and uncontrolled energy— endowments of the " duffer."

VI. That the custom of " Remarque " emanates from

With compliments to the Committee of the " Hoboken" Etching Club upon the occasion of receiving an invitation to compete in an etching tournay whose first condition was that the plate should be at least two feet by three.

the amateur, and reflects his foolish facility beyond the border of his picture, thus testifying to his unscientific sense of its dignity.

VII. That it is odious.

VIII. That, indeed, there should be no margin on the proof to receive such " Remarque."

IX. That the habit of margin, again, dates from the outsider, and continues with the collector in his unreasoning connoisseurship—taking curious pleasure in the quantity of paper.

X. That the picture ending where the frame begins, and, in the case of the etching, the white mount, being inevitably, because of its colour, the frame, the picture thus extends itself irrelevantly through the margin to the mount.

XI. That wit of this kind would leave six inches of raw canvas between the painting and its gold frame, to delight the purchaser with the quality of the cloth.

An Unanswered Letter

PRÉ CHARMOY, AUTUN,
SAÔNE ET LOIRE, FRANCE,
Sept. 13, 1867.

SIR—I am at present engaged upon a book on etching
and should be glad to give a full account of what you
have done, but find a difficulty, which is that, although
I have seen many of your etchings, I have not fully
and fairly studied them. I wonder whether you
would object to lend me a set of proofs for a few
weeks. As the book is already advanced, I should be
glad of an early reply. My opinion of your work is,
*on the whole, so favourable that your reputation could
only gain* by your affording me the opportunity of
speaking of your work at length.

I remain, Sir,
Your obedient servant,

P. G. HAMERTON.

JAMES WHISTLER, Esq.

Inconsequences

JAMES WHISTLER is of American extraction, and studied painting in France. As a student he was capricious and irregular, and did not leave the impression amongst his fellow-pupils that his future would be in any way distinguished his artistic education seems to have been mainly acquired by private and independent study.

The " book on etching."

Mr. Whistler seems to be aware that etchings are usually sought as much for their rarity as their excellence, and to have determined that his own plates shall be rare already.

I have been told that, if application is made by letter to Mr. Whistler for a set of his etchings, he may, perhaps, if he chooses to answer the letter, do the applicant the favour to let him have a copy for about the price of a good horse.

Whistler's etchings are not generally remarkable for poetical feeling.

P. G. HAMERTON,*
Etching and Etchers.

* " If beauty were the only province of art, neither painters nor etchers would find anything to occupy them in the foul stream that washes the London wharfs "— P. G. HAMERTON, *Etching and Etchers.*

Uncovered Opinions

\mathbf{M}R. WHISTLER'S famous "Woman in White" is amongst the rejected pictures. The hangers must have thought her particularly ugly, for they have given her a sort of place of honour, before an opening through which all pass, so that nobody misses her.

I watched several parties, to see the impression the "Woman in White" made on them. They all stopped instantly, struck with amazement. This for two or three seconds; then they always looked at each other and laughed.

Here, for once, I have the happiness to be quite of the popular way of thinking.

*P. G. HAMERTON,
 Fine Arts Quarterly.*

* "Corot is one of the most celebrated landscape painters in France. The first impression of an Englishman, on looking at his works, is that they are the sketches of an amateur; it is difficult at first sight to consider them the serious performances of an artist. I *understand Corot now,* and think his reputation, if not well deserved, at least easily accounted for. Corot must be an early riser."—P. G. HAMERTON, *Fine Arts Quarterly.*

* "Doré (Gustave Paul) He is a great and marvellous genius—a poet such as a nation produces once in a thousand years. He is the most imaginative, the profoundest, the most productive poet that has ever sprung from the French race."—P. G. HAMERTON, *Fine Arts Quarterly.*

* "Daubigny (Charles François).—If landscape can be satisfactorily painted without either drawing or colour—Daubigny is the man to do it."—P. G. HAMERTON, *Fine Arts Quarterly.*

* "M. Courbet is looked upon as the representative of Realism in France. The truth is that Édouard Frère, the Bonheurs, and many others are to the full as realistic as Courbet but they produce beautiful pictures. It is difficult to speak of Courbet, without losing patience. Everything he touches becomes unpleasant."—P. G. HAMERTON, *Fine Arts Quarterly.*

The Fate of an Anecdote

TO THE EDITOR:

SIR—In *Scribner's Magazine* for this month there appears an article on Mr. Seymour Haden, the eminent surgeon etcher, by a Mr. Hamerton, and in this article I have stumbled upon a curious statement concerning, strangely enough, my own affairs, offered pleasantly in the disguise of an anecdote habitually "narrated" by the Doctor himself, and printed effectively in inverted commas, as here shown:

. . . . "A parallel anecdote is narrated by Mr. Haden: 'The most exquisite series of plates which Whistler ever did—his sixteen Thames subjects—were originally printed by a steel-plate printer, and so badly that the owner thought the plates were worn out, and sold them for a small sum in comparison to their real worth. The purchaser took them to Goulding, the best printer of etchings in England, and it was found that they were not only perfect, but that they pro-

New York Tribune
Sept. 12, 1880.

duced impressions which had never before been approached even by Delatre.'"

Putting gently aside the question of these plates being superior to all previous or subsequent work, and dealing merely with facts, I have to say that they were *not* "originally printed by a steel-plate printer"; that the impressions were *not* so bad that the owner thought the plates worn out; and, flattering as is the supposition that they were sold for a small sum in comparison to their real worth, I am obliged to reject even this palatable assertion, as I received for the plates the price that I asked, knowing full well their exact condition.

Instead of the "steel-plate printer," Delatre, then at his prime, had himself printed these etchings—a fact which, amusingly enough, Mr. Haden admits further on, in direct contradiction to his first broad statement. Moreover, I had myself pulled proofs of them all; indeed, one in the set of sixteen plates, a drypoint, called "The Forge" (for by the way they were not all of the Thames), I alone printed. When the plates left my hands they were *not* "taken to Goulding," who at that moment had, I fancy, barely begun his career as "the best printer of etchings in England" (and a capital printer he certainly is); and it was *not* "found that they produced impressions never before ap-

proached even by Delatre "—here we have the contra-
diction alluded to—no! this theatrical denouement I
must also put aside with sorrow.

The plates were brought out by Messrs. Ellis, who
had them printed by some one in London, whose work
was certainly not to be compared to that of Delatre,
whom I should undoubtedly have recommended; so
that *it was only long after the sale had been completed
and the plates had ceased to be in my possession,* that
inferior impressions were produced.

The understanding on my part with those publishers
was that the plates were to be destroyed after one
hundred impressions had been taken, but very re-
cently they reappeared, and were sold to their present
possessors, who *did* take them to Mr. Goulding. And
here I am obliged to explain away the last element of
astonishment, for Mr. Goulding naturally found the
etchings in their original perfect condition simply
because I had had them steeled in their full bloom
when I had satisfied myself by my own proofs.

Goulding's impressions of these plates are very
excellent, but to say they were quite unapproached by
Delatre is not only needless exaggeration, but an
unkindness to Mr. Goulding.

Surely there must be some misunderstanding be-
tween Mr. Haden and his biographer—a misdeal of

data—an accident with the anecdotes—because no one was more keenly alive to all relating to these plates and their various states than Mr. Haden himself, whose strong sense of the importance of printing was acquired while watching the progress of these same plates, and the previous French set, as they were proved by me and printed by Delatre, to whom I introduced him.

Far from me to spoil a good story; but for the life of me I cannot see what any sympathizing *raconteur* will regret in the destruction of this mere jumble of statistics that Mr. Hamerton calls " Mr. Haden's anecdote."

VENICE, Aug. 16, 1880.

[In Excelsis

In Excelsis

MR. HAMERTON presents his compliments to Mr. Whistler, and begs to inform him that he has read Mr. Whistler's very unbecoming and improper letter in the *New York Tribune*.

Mr. Hamerton in his article in *Scribner's Monthly* simply quoted a passage from one of Mr. Haden's lectures on Etching, published in Cassell's *Magazine of Art ;* consequently Mr. Hamerton did not offer matter to his readers under any disguise whatever. Mr. Hamerton has answered Mr. Whistler's letter in the same journal in which it appeared.

PRÉ CHARMOY, AUTUN, SAÔNE ET LOIRE,
Sept. 28, 1880.

A Suspicion

IT is possibly too much to expect—upon the prin-
ciple of "trumps not turning up twice"—but Mr.
Whistler does hope that Mr. Hamerton's letter to the
New York Tribune will be as funny as his note to
Mr. Whistler, which has just been forwarded from
London.

VENICE, Oct. 7.
CAFÉ FLORIAN, PLACE SAN MARC.

Pardon! Is Mr. Whistler right in supposing, from
the droll little irritation shown in Mr. Hamerton's
note, that Mr. Hamerton is perhaps—another "Art
Critic"?

Conviction

SIR—A friend in America has sent me the letter from Mr. Whistler which refers to my article in *Scribner* on Mr. Haden's etchings. The letter begins as follows :

New York Tribune,
Oct. 11, 1880.
In *Scribner's Magazine* for this month there appears an article on Mr. Seymour Haden, the eminent surgeon etcher by a Mr. Hamerton, and in this article I have stumbled upon a curious statement concerning — strangely enough — my own affairs, offered pleasantly in the disguise of an anecdote habitually 'narrated' by the Doctor himself, and printed effectively in inverted commas, as here shown.

Here Mr. Whistler accuses me of disguising something which I chose to tell, as if it came from Mr. Haden, by printing it in inverted commas. The statement is " offered pleasantly in the disguise of an anecdote," and " printed effectively in inverted

commas." I used inverted commas because it is the
custom to do so when making a quotation. I quoted
Mr. Haden's own words from one of his lectures on
etching, and they will be found printed, as I quoted
them, in Cassell's *Magazine of Art.* I beg to be per-
mitted to observe that a writer who quotes a passage,
as I did, in perfect good faith, ought not to be accused
of offering matter in disguise. There was no disguise
about it. Mr. Haden's words may be compared with
my quotation. Again, to prevent any possible in-
accuracy, a proof of the article in *Scribner* was sent
to Mr. Haden before it was published.* It is scarcely
necessary that I should allude to Mr. Whistler's
studied discourtesy in calling me " a Mr. Hamerton."
It does me no harm, but it is a breach of ordinary
good manners in speaking of a well-known writer !

<div style="margin-left:2em">

REFLECTION :
* Queen's evi-
dence.

</div>

REFLECTION :
Q.; E. D.

Yours obediently,

P. G. HAMERTON.

AUTUN, Sept. 29, 1880.

MR. WHISTLER

AND

HIS CRITICS

A CATALOGUE

" Out of their own mouths shall ye judge them."

"Who breaks a butterfly upon a wheel?"

Etchings and Dry-points

" His pictures form a dangerous precedent."

VENICE.

" Another crop of Mr. Whistler's little jokes."

Truth.

1.—MURANO—GLASS FURNACE.

" Criticism is powerless here."—*Knowledge.*

2.—DOORWAY AND VINE.

"He must not attempt to palm off his deficiencies upon us as manifestations of power."

Daily Telegraph.

3.—WHEELWRIGHT.

" Their charm depends not at all upon the technical qualities so striking in his earlier work."

St. James's Gazette.

4.—SAN BIAGIO.

" So far removed from any accepted canons of art as to be beyond the understanding of an ordinary mortal."—*Observer.*

5.—BEAD STRINGERS.

" ' Impressionistes,' *and of these the various schools are represented by* Mr. Whistler, Mr. Spencer Stanhope, Mr. Walter Crane, and Mr. Strudwick."

REFLECTION:
" Et voilà comme on écrit l'histoire.'

6.—FISH SHOP.

" Those who feel painfully the absence in these works of any feeling for the past glories of Venice."

' Arry in the Spectator.

" Whistler is eminently vulgar."—*Glasgow Herald.*

7.—TURKEYS.

" They say very little to the mind."—*F. Wedmore.*

" It is the artist's pleasure to have them there, and we can't help it."—*Edinburgh Courant.*

8.—NOCTURNE RIVA.

" The Nocturne is intended to convey an impression of night."—*P. G. Hamerton.*

" The subject did not admit of any drawing."

P. G. Hamerton.

" We have seen a great many representations of Venetian skies, but never saw one before consisting of brown smoke with clots of ink in diagonal lines."

9.—FRUIT STALL.

" The historical or poetical associations of cities have little charm for Mr. Whistler and no place in his art."

10.—SAN GIORGIO.

" An artist of incomplete performance."

F. Wedmore.

11.—THE DYER.

" By having as little to do as possible with tone and light and shade, Mr. Whistler evades great difficulties."—*P. G. Hamerton.*

" All those theoretical principles of the art, of which we have heard so much from Messrs. Haden, Hamerton (?) * and Lalauze, are abandoned."

St. James's Gazette.

* " Calling me 'a Mr. Hamerton' does me no harm —but it is a breach of ordinary good manners in speaking of a well-known writer."
Yours obediently,
P. G. HAMERTON.
Sept. 29, 1880.
To the Editor of the *New York Tribune.*

12.—NOCTURNE PALACES.

" Pictures in darkness are contradictions in terms."
Literary World.

13.—THE DOORWAY.

" There is seldom in his Etchings any large arrangement of light and shade."—*P. G. Hamerton.*

" Short, scratchy lines."—*St. James's Gazette.*

" The architectural ornaments and the interlacing bars of the gratings are suggested rather than drawn."
St. James's Gazette.

" Amateur prodige."—*Saturday Review.*

14.—LONG LAGOON.

" We think that London fogs and the muddy old Thames supply Mr. Whistler's needle with subjects more congenial than do the Venetian palaces and lagoons."—*Daily News.*

15.—TEMPLE.

" The work does not feel much."—*Times.*

16.—LITTLE SALUTE.—(Dry-point.)

" As for the lucubrations of Mr. Whistler, they come like shadows and will so depart, *and it is unnecessary to disquiet one's self about them.*"

17.—THE BRIDGE.

"These works have been done with a swiftness and dash that precludes anything like care and finish."

"These Etchings of Mr. Whistler's are nothing like so satisfactory as his earlier Chelsea ones; they neither convey the idea of space nor have they the delicacy of handling and treatment which we see in those."

"He looked at Venice never in detail."

F. Wedmore.

18.—WOOL CARDERS.

"They have a merit of their own, and I do not wish to understand it." *—F. Wedmore.*

* Mr. Wedmore is the lucky discoverer of the following :—
"Vigour and exquisiteness are denied —are they not ?— even to a Velasquez"!

19.—UPRIGHT VENICE.

"Little to recommend them save the eccentricity of their titles."

20.—LITTLE VENICE.

"The Little Venice is one of the slightest of the series."—*St. James's Gazette.*

"In the Little Venice and the Little Lagoon Mr. Whistler has attempted to convey impressions by lines far too few for his purposes."—*Daily News.*

"Our river is naturally full of effects in *black and white and bistre*. Venetian skies and marbles have colour you cannot suggest with a point and some printer's ink."—*Daily News*.

"It is not the Venice of a maiden's fancies."—*'Arry*.

21.—LITTLE COURT.

"Merely technical triumphs."—*Standard*.

22.—REGENT'S QUADRANT.

"There may be a few who find genius in insanity."

23.—LOBSTER POTS.

"So little in them."*—*P. G. Hamerton*.

* The same Critic holds :
" The Thames is beautiful from Maidenhead to Kew, but not from Battersea to Sheerness."

24.—RIVA No. 2.

"In all his former Etchings he was careful to give a strong foundation of firm drawing. In these plates, however, he has cast aside this painstaking method."

St. James's Gazette.

25.—ISLANDS.

"An artist who has never mastered the subtleties of accurate form."*—*F. Wedmore*.

* Elsewhere Mr. Wedmore is inspired to say—
" The true collector must *gradually* and *painfully* acquire the eye to judge of the impression."

REFLECTION :
This is possibly the process through which the preacher is passing.

26.—THE LITTLE LAGOON.

" Well, little new came of it, in etching; nothing new that was beautiful."—*F. Wedmore.*

27.—NOCTURNE SHIPPING.

" This Archimago of the iconographic aoraton, or graphiology of the Hidden."—*Daily Telegraph.* " Amazing ! "

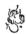

" Popularity is the only insult that has not yet been offered to Mr. Whistler."—*Oscar Wilde.*

28.—TWO DOORWAYS.

" It is trying to any sketch without tone to be hung upon a wall as these have been."—*P. G. Hamerton.*

29.—OLD WOMEN.

" He is never literary."—*P. G. Hamerton.*

30.—RIVA.

REFLECTION:
Like Eno's Fruit Salt or the "Anti-mal-de-Mer."

" He took from London to Venice his happy fashion of suggesting lapping water."—*F. Wedmore.*

" Even such a well-worn subject as the Riva degli Schiavoni is made original (?) by being taken from a high point of view, and looked at lengthwise, instead of from the canal."

31.—DRURY LANE.

"In Mr. Whistler's productions one might safely say that there is no culture."—*Athenæum.*

32.—THE BALCONY.

"His colour is subversive."—*Russian Press.*

33.—ALDERNEY STREET.

"The best art may be produced with trouble."

*F. Wedmore.**

* "I am not a Mede nor a Persian.'—F. WEDMORE.

34.—THE SMITHY.

"They produce a disappointing impression."

"His Etchings seem weak when framed." *

P. G. Hamerton.

* Mr. Hamerton does also say: " Indifference to beauty is however compatible with splendid success in etching, as the career of Rembrandt proved."—*Etching and Etchers.*

35.—STABLES.

" An unpleasing thing, and framed in Mr. Whistler's odd fashion."—*City Press.*

36.—THE MAST.

"The Mast and the Little Mast are dependent for much of their interest, on the drawing of festoons of cord hanging from unequal heights."

P. G. Hamerton.

REFLECTION:

At the service of critics of unequal sizes.

37.—TRAGHETTO.

"The artist's present principles seem to deny him any effective chiaroscuro."—*P. G. Hamerton.*

"Mr. Whistler's figure drawings, generally defective and always incomplete."

38.—FISHING BOAT.

Subjects unimportant in themselves."

P. G. Hamerton.

39.—PONTE PIOVAN.

"Want of variety in the handling."

St. James's Gazette.

40.—GARDEN.

"An art which is happier in the gloom of a doorway than in the glow of the sunshine, and turns with a pleasant blindness from whatsoever in Nature or Man is of perfect beauty or noble thought."—*'Arry.*

41.—THE RIALTO.

"Mr. Whistler has etched too much for his reputation."—*F. Wedmore.*

Scampering caprice."—*S. Colvin.*

"Mr. Whistler's drawing, which is sometimes that of a very slovenly master."

42.—LONG VENICE.

" After all, there are certain accepted canons about what constitutes good drawing, good colour, and good painting ; and when an artist deliberately sets himself to ignore or violate all of these, it is desirable that his work should not be classed with that of ordinary artists."—*'Arry.*

43.—NOCTURNE SALUTE.

" The utter absence, as far as my eye * may be trusted, of gradation."—*F. Wedmore.*

" There are many things in a painter's art which even a photographer cannot understand."

<div align="right">Laudatory notice in Provincial Press.</div>

44.—FURNACE NOCTURNE.

" There is no moral element in his chiaroscuro."

<div align="right">Richmond Eagle.</div>

45.—PIAZETTA.

" Whistler does not take much pains with his work."

<div align="right">New York Paper.</div>

" A sort of transatlantic impudence in his clever-ness."

" His pictures do not claim to be accurate."

46.—THE LITTLE MAST.

" Form and line are of little account to him."

47.—QUIET CANAL.

"Herr Whistler stellt ganz wunderbare Produc-
tionen aus, die auf Gesetze der Form und der Farbe
gegründet scheinen, die dem Uneingeweihten unver-
ständlich sind."—*Wiener Presse.*

" This new manner of Mr. Whistler's is no improve-
ment upon that which helped him to win his fame in
this field of art."

48.—PALACES.

" The absence, seemingly, of any power of drawing
the forms of water." *—*F. Wedmore.* *See No. 30,*
The Riva.

" He has never, so far as we know, attempted to
transfer to copper any of the more ambitious works of
the architect."—*Pall Mall Gazette.*

" He has been content to show us what his eyes can
see, and not what his hand can do."

St. James's Gazette.

49.—SALUTE DAWN.

" Too sensational."—*Athenæum.*

" Pushing a single artistic principle to the verge of
affectation."—*Sidney Colvin.*

50.—BEGGARS.

" In the character of humanity he has not time to be interested."—*Standard.*

" General absence of tone."—*P. G. Hamerton.*

51.—LAGOON : NOON.

" Years ago James Whistler was a person of high promise."—*F. Wedmore.*

" What the art of Mr. Whistler yields is a tertium quid."*—*Sidney Colvin.*

REFLECTION :
● The quid of sweet and bitter fancy.

" All of which gems, I am sincerely thankful to say, I cannot appreciate."

" As we have hinted, the series does not represent any Venice that we much care to remember ; for who wants to remember the degradation of what has been noble, the foulness of what has been fair ?"

'Arry * *in the " Times."*

**REFLECTION :*
The labour of the foolish wearieth every one of them because he knoweth not how to go to the City.

" Disastrous failures."—*F. Wedmore.*

" Failures that are complete and failures that are partial."—*F. Wedmore.*

" A publicity rarely bestowed upon failures at all."

F. Wedmore, Nineteenth Century.

" *Voilà ce que l'on dit de moi
Dans la Gazette de Hollande.*"

"Therefore is judgment far from us, neither doth justice overtake us. We wait for light, but behold obscurity; for brightness, but we walk in darkness."

"We grope for the wall like the blind, and we grope as if we had no eyes; we stumble at noonday as in the night."

"We roar all like bears."

Taking the Bait

The Academy,
Feb. 24, 1883.

BY the simple process of applying snippets of published sentences to works of art to which the original comments were never meant to have reference, and sometimes, too, by lively misquotation—as when a writer who " did not wish to understate" Mr. Whistler's merit is made to say he " did not wish to understand " it, Mr. Whistler has counted on good-humouredly confounding criticism. He has entertained but not persuaded; and if his literary efforts with the scissors and the paste-pot might be taken with any seriousness we should have to rebuke him for his feat. But we are far from doing so. He desired, it seems, to say that he and Velasquez were both above criticism. An artist in literature would have said it in fewer words; but indulgence may fairly be granted to the less assured methods of an amateur in authorship.

F. WEDMORE.

An Apology

The World,
Feb. 28, 1883.

ATLAS—There are those, they tell me, who have the approval of the people—and live ! For them the *succès d'estime;* for me, O Atlas, the *succès d'exécration* —the only tribute possible from the Mob to the Master ! This I have now nobly achieved. *Glissons !* In the hour of my triumph let me not neglect my ambulance.

Mr. Frederick Wedmore—a critic—one of the wounded—complains that by dexterously substituting " understand " for " understate," I have dealt unfairly by him, and wrongly rendered his writing. Let me hasten to acknowledge the error, and apologise. My carelessness is culpable, and the misprint without excuse; for naturally I have all along known, and the typographer should have been duly warned, that with Mr. Wedmore, as with his brethren, it is always a matter of understating, and not at all one of understanding.

Quant aux autres—well, with the exception of " 'Arry," who really is dead, they will recover. Scalped and disfigured, they are not mortally hurt; and— would you believe it?—possessed with an infinite capacity for continuing, they have already returned, nothing doubting, to their limited literature, of which I have exhausted the stock.—Yours, *en passant,*

Chelsea.

[" *Jeux Innocents* "

"*Jeux Innocents*" *in Tite Street*

The World,
Dec 26, 1883.

M R. WHISTLER'S final breakfast of the year was given on Sunday last. The hospitable master has fresh wonders in store for his friends in the new year; for, not content with treating his next-door critic after the manner that Portuguese sailors treat the Apostle Judas at Easter-tide, he is said to have perfected a new instrument of torture. This invention is of the nature of a camera obscura, whereby, by a crafty " arrangement " of reflectors, he promises to display in his own studio, to his friends, " 'Arry at the White House," under all the appropriate circumstances that might be expected of a " Celebrity at Home."

ATLAS.

A Line from the Land's End

DELIGHTFUL! Atlas—I have read here, to the idle miners—culture in their manners curiously, at this season, blended with intoxication—your brilliant and graphic description of 'Arry at the other end of my arrangement in telescopic lenses.

The World,
Jan. 2, 1884.

The sensitive sons of the Cornish caves, by instinct refined, revel in the writhing of the resurrected 'Arry.

Our natures are evidently of the same dainty brutality. Cruelty to the critic after demise, is a revelation, and the story of 'Arry pursued with post-mortem, and, for Sunday demonstration, kept by galvanism from his grave, is to them most fascinating.

I have, my sympathetic Atlas, the success that might have been Edgar Poe's, could he have read to such an audience the horrible "Case of Mr. Waldemar."

My invention and machinery, by the way, these warm-hearted people believe to be something after the fashion of their own sluice-boxes—and I dare not undeceive them.

Atlas, *je te la souhaite bonne et heureuse !*

ST. IVES, CORNWALL,
Dec. 27.

The Easy Expert

ATLAS—They have sent me the *Spectator*—a paper upon which our late 'Arry lingered to the last as art critic. In its columns I find a correspondent calling aloud for our kind intervention. Present me, brave Atlas, to the editor, that I may say to him:

The World,
Jan. 30, 1884.

" GOOD SIR,—' Your Reviewer' is doubtless my un-buried 'Arry. Why, then, should ' his mistaking a photogravure reproduction of a pen-and-ink drawing by Samuel Palmer for a finished etching by the same hand' seem, ' to say the least of it, astounding' ?

"Not at all! By this sort of thing was he known among us, poor chap—and so was he our fresh gladness and continued surprise."

" Did I not make historical his enchanting encounter with Mr. Herkomer's water-colour drawing of Mr. Ruskin at the Grosvenor, which he described as the ' first oil portrait we have of the great master' ? Amazing that, if you like!

"Do not all remember how we leaped for joy at the reading of it?"

"Even Atlas himself laughed aloud, and, handicapped as he is with the World, and weighted with wisdom, danced upon his plinth, a slow measure of reckless acquiescence, as I set down in the chronicles of all time that 'Arry, 'unable, by mere sense of smell, to distinguish between oil and water-colour, might at least have inquired; and that either the fireman or the guardian in the Gallery could have told him not to blunder in the *Times.*'"

"But no, he never would ask—he liked his potshots at things; it used to give a sort of sporting interest to his speculations upon pictures. And so he was ever obstinate—or any one at the Fine Art Society would have told him the difference between an etching and a photograph.—I am, good sir, yours, etc."

<div align="center">Atlas, à bientôt.</div>

St. Ives, Cornwall,
 Jan. 25, 1834.

Propositions—No. 2

A PICTURE is finished when all trace of the means used to bring about the end has disappeared.

To say of a picture, as is often said in its praise, that it shows great and earnest labour, is to say that it is incomplete and unfit for view.

Industry in Art is a necessity—not a virtue—and any evidence of the same, in the production, is a blemish, not a quality ; a proof, not of achievement, but of absolutely insufficient work, for work alone will efface the footsteps of work.

The work of the master reeks not of the sweat of the brow—suggests no effort—and is finished from its beginning.

The completed task of perseverance only, has never been begun, and will remain unfinished to eternity—a monument of goodwill and foolishness.

" There is one that laboureth, and taketh pains, and maketh haste, and is so much the more behind."

The masterpiece should appear as the flower to the painter—perfect in its bud as in its bloom—with no reason to explain its presence—no mission to fulfil—a joy to the artist—a delusion to the philanthropist—a puzzle to the botanist—an accident of sentiment and alliteration to the literary man.

[A Hint

A Hint

The World.
Feb. 17, 1886.

PLEASE to take note, my dear Mr. James McN. W., that your " dearest foe," 'Arry, is a candidate for the Slade Chair of Art in the University of Cambridge! This is said to be the age of testimonials. A few words from you, my dear James, addressed to the distinguished trustees, could not fail to give 'Arry a lift.

<div align="right">ATLAS.</div>

A Distinction

ATLAS, you provoke me! The wisdom of ages means but little—I have said it. *Faut être " dans le mouvement,"* you dear old thing, or you are absolutely out of it !

The World,
Feb. 24, 1886.
You are misled, and mistake mere fact for the fiction of history, which is truth—and instructs—and is beautiful.

Now, in truth, 'Arry is dead—very dead.

Did I not, from between your shoulders, sally forth and slay him ?—thereby instructing—and making history—and avenging the beautiful.

If within the distant Aïden, you can't descry, " with sorrow laden," the tiny soul of 'Arry, it is because you no longer read your own small print, my Atlas ! and the microbes of Eternity escape you.

Moreover, are not these things written in the chronicles of Chelsea, adown whose Embankment I still, Achilles-like, do drag the body of an afternoon ?

This practice has doubtless completed the confusion of the wearied ones of Slade—and they of the Schools, accustomed to the culture of Colvin, whose polished scalp I with difficulty collected, ceasing to distinguish between the quick and the dead, will probably prop up our late 'Arry as professor, long to remain undetected in the Chair!

Atlas, *tais-toi !*—Let us not interfere!

A Document

ATLAS—I have come upon the posthumous paper of 'Arry—his certificate of character, and printed pretension to the Professorship of Slade—and O! the shame of it—and the indiscretion of it!

Read, Atlas, and seek in your past for a parallel : *The World,* March 24, 1886.

" To the Electors of the Slade Professor of Fine Art "for the University of Cambridge.—My Lord and " Gentlemen,—I beg to submit my name as a candidate " for the Slade Professorship, and enclose herewith a "few testimonials. . . I have also received favourable "letters from the following gentlemen . . . Alma-"Tadema, R.A., Marcus Stone, R.A., Briton Rivière, " R.A., John Brett, A.R.A., . . . and others."

What ! is the Immaculate impure ?—and shall the Academy have coquetted with the unclean ?

Had Alma the classic aught in common with this 'Arry of commerce ?

Believe him not, Atlas !

O Alma ! O Ichabod ! forgive us the thought of it !
Surely also the pots of " the Forty " do boil before
the Lord, and the flames of the chosen were unfanned
by the feather of 'Arry's goose-quill.

Again :

" My experience in art matters has been briefly as
" follows :

" I have worked at the subject continually in Italy,
" having for that purpose travelled and stayed in that
" country—at least a dozen times. I have also painted
" in France, Germany, and Belgium, in which last-
" mentioned country I was in a portrait painter's
" studio."—(A portrait by 'Arry !)

" There are several pictures of mine being exhibited
" in London at the present time." (! ! !)

" I have also executed a good deal of distemper. . . .

" I have also travelled for a year in the East."
('Arry in the East ! !)

" I have had, as a lecturer upon Art, considerable
" experience—at working men's clubs— . . . and at
" the Rev. Stopford A. Brooke's College for men,
" women, and children.

" For the last ten years I have written *every article*
" *upon art* which has appeared in the *Spectator* news-
" paper '—a confession, Atlas, clearly a confession !

" In 1880, I wrote a critical life of Giotto "—he did

indeed, Atlas!—I saw it—a book in blue—his own, and Reckitt's—all bold with brazen letters :

<div align="center">

" GIOTTO BY 'ARRY "

</div>

—" of which two editions were published "—bless him —and then I killed him !

<div align="center">

and, " I am, Gentlemen,

" Your most obedient servant,

" 'ARRY, M.A.

" Trin. Coll. Camb., *Esquire.*"

The pride of it !

</div>

Sacrilege

O ATLAS! What of the "Society for the Preservation of Beautiful Buildings"?

Where *is* Ruskin? and what do Morris and Sir William Drake? Upon the Alterations of the " White House."

For, behold! beside the Thames, the work of desecration continues, and the "White House" swarms with the mason of contract. *The World.* Oct. 17, 1883.

The architectural *galbe* that was the joy of the few, and the bedazement of "the Board," crumbles beneath the pick, as did the north side of St. Mark's, and history is wiped from the face of Chelsea.

Shall no one interfere? Shall the interloper, even after his death, prevail?

Shall 'Arry, whom I have hewn down, still live among us by outrage of this kind, and impose his memory upon our pavement by the public perpetration of his posthumous philistinism?

Shall the birthplace of art become the tomb of its parasite in Tite Street?

See to it, Atlas! lest, when Time, the healer of all the wounds I have inflicted, shall for me have exacted those honours the prophet may not expect while alive, and the inevitable blue disc, imbedded in the walls, shall proclaim that "Here once dwelt" the gentle Master of all that is flippant and fine in Art, some anxious student, reading, fall out with Providence in his vain effort to reconcile such joyous reputation with the dank and hopeless appearance of this "model lodging," bequeathed to the people by the arrogance of 'Arry.

The Red Rag

" Mr. Whistler, Cheyne Walk."
The World,
May 22, 1878.

WHY should not I call my works " symphonies," " arrangements," " harmonies," and " nocturnes " ? I know that many good people think my nomenclature funny and myself " eccentric." Yes, " eccentric " is the adjective they find for me.

The vast majority of English folk cannot and will not consider a picture as a picture, apart from any story which it may be supposed to tell.

My picture of a " Harmony in Grey and Gold " is an illustration of my meaning—a snow scene with a single black figure and a lighted tavern. I care nothing for the past, present, or future of the black figure, placed there because the black was wanted at that spot. All that I know is that my combination of grey and gold is the basis of the picture. Now this is precisely what my friends cannot grasp.

They say, " Why not call it 'Trotty Veck,' and sell it for a round harmony of golden guineas ? "—naïvely acknowledging that, without baptism, there is no market!

But even commercially this stocking of your shop with the goods of another would be indecent—custom alone has made it dignified. Not even the popularity of Dickens should be invoked to lend an adventitious aid to art of another kind from his. I should hold it a vulgar and meretricious trick to excite people about Trotty Veck when, if they really could care for pictorial art at all, they would know that the picture should have its own merit, and not depend upon dramatic, or legendary, or local interest.

As music is the poetry of sound, so is painting the poetry of sight, and the subject-matter has nothing to do with harmony of sound or of colour.

The great musicians knew this. Beethoven and the rest wrote music—simply music ; symphony in this key, concerto or sonata in that.

On F or G they constructed celestial harmonies— as harmonies—as combinations, evolved from the chords of F or G and their minor correlatives.

This is pure music as distinguished from airs— commonplace and vulgar in themselves, but interesting from their associations, as, for instance, " Yankee Doodle," or " Partant pour la Syrie."

Art should be independent of all clap-trap—should stand alone, and appeal to the artistic sense of eye or ear, without confounding this with emotions entirely foreign to it, as devotion, pity, love, patriotism, and

the like. All these have no kind of concern with it ;
and that is why I insist on calling my works " arrange-
ments " and " harmonies."

Take the picture of my mother, exhibited at the
Royal Academy as an " Arrangement in Grey and
Black." Now that is what it is. To me it is in-
teresting as a picture of my mother ; but what can or
ought the public to care about the identity of the
portrait ?

The imitator is a poor kind of creature. If the man
who paints only the tree, or flower, or other surface
he sees before him were an artist, the king of artists
would be the photographer. It is for the artist to do
something beyond this : in portrait painting to put on
canvas something more than the face the model wears
for that one day ; to paint the man, in short, as well
as his features ; in arrangement of colours to treat a
flower as his key, not as his model.

This is now understood indifferently well—at least
by dressmakers. In every costume you see attention
is paid to the key-note of colour which runs through
the composition, as the chant of the Anabaptists
through the *Prophète,* or the Huguenots' hymn in the
opera of that name.

A Rebuke

NO Birmingham election, no Chamberlain speech, no *Reynolds* or *Dispatch* article, could bring the aristocracy more strongly into ridicule and contempt than does the coarsely coloured cartoon of "Newmarket" accompanying the winter number of *Vanity Fair*. From it one learns that the Dukes, Duchesses, and turf persons generally, frequenting the Heath, are a set of blob-headed stumpy dwarfs.

The World, Dec. 9, 1885.

<div align="right">ATLAS.</div>

"*Les points sur les i*"

I AGREE with you, O Atlas of ages, that complete- ness is a reason for ceasing to exist; but even indigna- *The World,* Dec. 16, 1885. tion might be less vague than is your righteous anger at *Vanity's* Christmas cartoon. Surely you might have helped the people, who scarcely distinguish between the original and impudent imitation, to know that this faded leaf is not from the book of Carlo Pellegrini, the master who has taught them all—that they can never learn?

MR. WHISTLER'S

" TEN O'CLOCK "

London, 1888

Delivered in London
Feb. 20, 1885

At Cambridge
March 24

At Oxford
April 30

LADIES AND GENTLEMEN:

It is with great hesitation and much misgiving that I appear before you, in the character of The Preacher.

If timidity be at all allied to the virtue modesty, and can find favour in your eyes, I pray you, for the sake of that virtue, accord me your utmost indulgence.

I would plead for my want of habit, did it not seem preposterous, judging from precedent, that aught save the most efficient effrontery could be ever expected in connection with my subject—for I will not conceal from you that I mean to talk about Art. Yes, Art— that has of late become, as far as much discussion and writing can make it, a sort of common topic for the tea-table.

Art is upon the Town!—to be chucked under the chin by the passing gallant—to be enticed within the gates of the householder—to be coaxed into company, as a proof of culture and refinement.

If familiarity can breed contempt, certainly Art—
or what is currently taken for it—has been brought
to its lowest stage of intimacy.

The people have been harassed with Art in every
guise, and vexed with many methods as to its en-
durance. They have been told how they shall love
Art, and live with it. Their homes have been
invaded, their walls covered with paper, their very
dress taken to task—until, roused at last, bewildered
and filled with the doubts and discomforts of senseless
suggestion, they resent such intrusion, and cast forth
the false prophets, who have brought the very name
of the beautiful into disrepute, and derision upon
themselves.

Alas! ladies and gentlemen, Art has been maligned.
She has naught in common with such practices. She
is a goddess of dainty thought—reticent of habit,
abjuring all obtrusiveness, purposing in no way to
better others.

She is, withal, selfishly occupied with her own per-
fection only—having no desire to teach—seeking and
finding the beautiful in all conditions and in all
times, as did her high priest Rembrandt, when he
saw picturesque grandeur and noble dignity in the
Jews' quarter of Amsterdam, and lamented not that
its inhabitants were not Greeks.

As did Tintoret and Paul Veronese, among the Venetians, while not halting to change the brocaded silks for the classic draperies of Athens.

As did, at the Court of Philip, Velasquez, whose Infantas, clad in inæsthetic hoops, are, as works of Art, of the same quality as the Elgin marbles.

No reformers were these great men—no improvers of the way of others! Their productions alone were their occupation, and, filled with the poetry of their science, they required not to alter their surroundings —for, as the laws of their Art were revealed to them they saw, in the development of their work, that real beauty which, to them, was as much a matter of certainty and triumph as is to the astronomer the verification of the result, foreseen with the light given to him alone. In all this, their world was completely severed from that of their fellow-creatures with whom sentiment is mistaken for poetry ; and for whom there is no perfect work that shall not be explained by the benefit conferred upon themselves.

Humanity takes the place of Art, and God's creations are excused by their usefulness. Beauty is confounded with virtue, and, before a work of Art, it is asked : " What good shall it do ? "

Hence it is that nobility of action, in this life, is hopelessly linked with the merit of the work that

portrays it; and thus the people have acquired the habit of looking, as who should say, not *at* a picture, but *through* it, at some human fact, that shall, or shall not, from a social point of view, better their mental or moral state. So we have come to hear of the painting that elevates, and of the duty of the painter—of the picture that is full of thought, and of the panel that merely decorates.

A favourite faith, dear to those who teach, is that certain periods were especially artistic, and that nations, readily named, were notably lovers of Art.

So we are told that the Greeks were, as a people, worshippers of the beautiful, and that in the fifteenth century Art was engrained in the multitude.

That the great masters lived in common understanding with their patrons—that the early Italians were artists—all—and that the demand for the lovely thing produced it.

That we, of to-day, in gross contrast to this Arcadian purity, call for the ungainly, and obtain the ugly.

That, could we but change our habits and climate —were we willing to wander in groves—could we be

roasted out of broadcloth—were we to do without haste, and journey without speed, we should again *require* the spoon of Queen Anne, and pick at our peas with the fork of two prongs. And so, for the flock, little hamlets grow near Hammersmith, and the steam horse is scorned.

Useless! quite hopeless and false is the effort!— built upon fable, and all because "a wise man has uttered a vain thing and filled his belly with the East wind."

Listen! There never was an artistic period.

There never was an Art-loving nation.

In the beginning, man went forth each day—some to do battle, some to the chase; others, again, to dig and to delve in the field—all that they might gain and live, or lose and die. Until there was found among them one, differing from the rest, whose pursuits attracted him not, and so he stayed by the tents with the women, and traced strange devices with a burnt stick upon a gourd.

This man, who took no joy in the ways of his brethren—who cared not for conquest, and fretted in the field—this designer of quaint patterns—this deviser of the beautiful—who perceived in Nature about him curious curvings, as faces are seen in the fire—this dreamer apart, was the first artist.

And when, from the field and from afar, there came back the people, they took the gourd—and drank from out of it.

And presently there came to this man another—and, in time, others—of like nature, chosen by the Gods—and so they worked together; and soon they fashioned, from the moistened earth, forms resembling the gourd. And with the power of creation, the heirloom of the artist, presently they went beyond the slovenly suggestion of Nature, and the first vase was born, in beautiful proportion.

And the toilers tilled, and were athirst; and the heroes returned from fresh victories, to rejoice and to feast; and all drank alike from the artists' goblets, fashioned cunningly, taking no note the while of the craftsman's pride, and understanding not his glory in his work; drinking at the cup, not from choice, not from a consciousness that it was beautiful, but because, forsooth, there was none other!

And time, with more state, brought more capacity for luxury, and it became well that men should dwell in large houses, and rest upon couches, and eat at tables; whereupon the artist, with his artificers, built palaces, and filled them with furniture, beautiful in proportion and lovely to look upon.

And the people lived in marvels of art—and ate and

drank out of masterpieces—for there was nothing else to eat and to drink out of, and no bad building to live in ; no article of daily life, of luxury, or of necessity, that had not been handed down from the design of the master, and made by his workmen.

And the people questioned not, *and had nothing to say in the matter.*

So Greece was in its splendour, and Art reigned supreme—by force of fact, not by election—and there was no meddling from the outsider. The mighty warrior would no more have ventured to offer a design for the temple of Pallas Athene than would the sacred poet have proffered a plan for constructing the catapult.

And the Amateur was unknown—and the Dilettante undreamed of !

And history wrote on, and conquest accompanied civilisation, and Art spread, or rather its products were carried by the victors among the vanquished from one country to another. And the customs of cultivation covered the face of the earth, so that all peoples continued to use what *the artist alone produced.*

And centuries passed in this using, and the world was flooded with all that was beautiful, until there

arose a new class, who discovered the cheap, and fore-saw fortune in the facture of the sham.

Then sprang into existence the tawdry, the common, the gewgaw.

The taste of the tradesman supplanted the science of the artist, and what was born of the million went back to them, and charmed them, for it was after their own heart; and the great and the small, the statesman and the slave, took to themselves the abomination that was tendered, and preferred it—and have lived with it ever since!

And the artist's occupation was gone, and the manufacturer and the huckster took his place.

And now the heroes filled from the jugs and drank from the bowls—with understanding—noting the glare of their new bravery, and taking pride in its worth.

And the people—this time—had much to say in the matter—and all were satisfied. And Birmingham and Manchester arose in their might—and Art was relegated to the curiosity shop.

Nature contains the elements, in colour and form, of all pictures, as the keyboard contains the notes of all music.

But the artist is born to pick, and choose, and group with science, these elements, that the result may be beautiful—as the musician gathers his notes, and forms his chords, until he bring forth from chaos glorious harmony.

To say to the painter, that Nature is to be taken as she is, is to say to the player, that he may sit on the piano.

That Nature is always right, is an assertion, artistically, as untrue, as it is one whose truth is universally taken for granted. Nature is very rarely right, to such an extent even, that it might almost be said that Nature is usually wrong : that is to say, the condition of things that shall bring about the perfection of harmony worthy a picture is rare, and not common at all.

This would seem, to even the most intelligent, a doctrine almost blasphemous. So incorporated with our education has the supposed aphorism become, that its belief is held to be part of our moral being, and the words themselves have, in our ear, the ring of religion. Still, seldom does Nature succeed in producing a picture.

The sun blares, the wind blows from the east, the sky is bereft of cloud, and without, all is of iron. The windows of the Crystal Palace are seen from

all points of London. The holiday-maker rejoices in the glorious day, and the painter turns aside to shut his eyes.

How little this is understood, and how dutifully the casual in Nature is accepted as sublime, may be gathered from the unlimited admiration daily produced by a very foolish sunset.

The dignity of the snow-capped mountain is lost in distinctness, but the joy of the tourist is to recognise the traveller on the top. The desire to see, for the sake of seeing, is, with the mass, alone the one to be gratified, hence the delight in detail.

And when the evening mist clothes the riverside with poetry, as with a veil, and the poor buildings lose themselves in the dim sky, and the tall chimneys become campanili, and the warehouses are palaces in the night, and the whole city hangs in the heavens, and fairy-land is before us—then the wayfarer hastens home; the working man and the cultured one, the wise man and the one of pleasure, cease to understand, as they have ceased to see, and Nature, who, for once, has sung in tune, sings her exquisite song to the artist alone, her son and her master— her son in that he loves her, her master in that he knows her.

To him her secrets are unfolded, to him her lessons

have become gradually clear. He looks at her flower, not with the enlarging lens, that he may gather facts for the botanist, but with the light of the one who sees in her choice selection of brilliant tones and delicate tints, suggestions of future harmonies.

He does not confine himself to purposeless copying, without thought, each blade of grass, as commended by the inconsequent, but, in the long curve of the narrow leaf, corrected by the straight tall stem, he learns how grace is wedded to dignity, how strength enhances sweetness, that elegance shall be the result.

In the citron wing of the pale butterfly, with its dainty spots of orange, he sees before him the stately halls of fair gold, with their slender saffron pillars, and is taught how the delicate drawing high upon the walls shall be traced in tender tones of orpiment, and repeated by the base in notes of graver hue.

In all that is dainty and lovable he finds hints for his own combinations, and *thus* is Nature ever his resource and always at his service, and to him is naught refused.

Through his brain, as through the last alembic, is distilled the refined essence of that thought which began with the Gods, and which they left him to carry out.

Set apart by them to complete their works, he produces that wondrous thing called the masterpiece, which surpasses in perfection all that they have contrived in what is called Nature; and the Gods stand by and marvel, and perceive how far away more beautiful is the Venus of Melos than was their own Eve.

For some time past, the unattached writer has become the middleman in this matter of Art, and his influence, while it has widened the gulf between the people and the painter, has brought about the most complete misunderstanding as to the aim of the picture.

For him a picture is more or less a hieroglyph or symbol of story. Apart from a few technical terms, for the display of which he finds an occasion, the work is considered absolutely from a literary point of view; indeed, from what other can he consider it? And in his essays he deals with it as with a novel—a history —or an anecdote. He fails entirely and most naturally to see its excellences, or demerits—artistic—and so degrades Art, by supposing it a method of bringing about a literary climax.

It thus, in his hands, becomes merely a means of perpetrating something further, and its mission is made a secondary one, even as a means is second to an end.

The thoughts emphasized, noble or other, are inevitably attached to the incident, and become more or less noble, according to the eloquence or mental quality of the writer, who looks the while, with disdain, upon what he holds as "mere execution"—a matter belonging, he believes, to the training of the schools, and the reward of assiduity. So that, as he goes on with his translation from canvas to paper, the work becomes his own. He finds poetry where he would feel it were he himself transcribing the event, invention in the intricacy of the *mise en scène*, and noble philosophy in some detail of philanthropy, courage, modesty, or virtue, suggested to him by the occurrence.

All this might be brought before him, and his imagination be appealed to, by a very poor picture—indeed, I might safely say that it generally is.

Meanwhile, the *painter's* poetry is quite lost to him —the amazing invention that shall have put form and colour into such perfect harmony, that exquisiteness is the result, he is without understanding—the nobility of thought, that shall have given the

artist's dignity to the whole, says to him absolutely nothing.

So that his praises are published, for virtues we would blush to possess—while the great qualities, that distinguish the one work from the thousand, that make of the masterpiece the thing of beauty that it is —have never been seen at all.

That this is so, we can make sure of, by looking back at old reviews upon past exhibitions, and reading the flatteries lavished upon men who have since been forgotten altogether—but, upon whose works, the language has been exhausted, in rhapsodies—that left nothing for the National Gallery.

A curious matter, in its effect upon the judgment of these gentlemen, is the accepted vocabulary of poetic symbolism, that helps them, by habit, in dealing with Nature: a mountain, to them, is synonymous with height—a lake, with depth—the ocean, with vastness —the sun, with glory.

So that a picture with a mountain, a lake, and an ocean—however poor in paint—is inevitably " lofty," " vast," " infinite," and " glorious "—on paper.

There are those also, sombre of mien, and wise with the wisdom of books, who frequent museums and

burrow in crypts; collecting—comparing—compiling
—classifying—contradicting.

Experts these—for whom a date is an accomplish-
ment—a hall mark, success!

Careful in scrutiny are they, and conscientious of
judgment—establishing, with due weight, unimportant
reputations—discovering the picture, by the stain on
the back—testing the torso, by the leg that is missing
—filling folios with doubts on the way of that limb—
disputatious and dictatorial, concerning the birthplace
of inferior persons—speculating, in much writing,
upon the great worth of bad work.

True clerks of the collection, they mix memoranda
with ambition, and, reducing Art to statistics, they
"file" the fifteenth century, and "pigeon-hole" the
antique!

Then the Preacher "appointed"!

He stands in high places—harangues and holds
forth.

Sage of the Universities—learned in many matters,
and of much experience in all, save his subject.

Exhorting—denouncing—directing.

Filled with wrath and earnestness.

Bringing powers of persuasion, and polish of lan-
guage, to prove—nothing.

Torn with much teaching—having naught to impart.

Impressive—important—shallow.

Defiant—distressed—desperate.

Crying out, and cutting himself—while the gods hear not.

Gentle priest of the Philistine withal, again he ambles pleasantly from all point, and through many volumes, escaping scientific assertion—"babbles of green fields."

So Art has become foolishly confounded with education—that all should be equally qualified.

Whereas, while polish, refinement, culture, and breeding, are in no way arguments for artistic result, it is also no reproach to the most finished scholar or greatest gentleman in the land that he be absolutely without eye for painting or ear for music—that in his heart he prefer the popular print to the scratch of Rembrandt's needle, or the songs of the hall to Beethoven's " C minor Symphony."

Let him have but the wit to say so, and not feel the admission a proof of inferiority.

Art happens—no hovel is safe from it, no Prince may depend upon it, the vastest intelligence cannot

bring it about, and puny efforts to make it universal
end in quaint comedy, and coarse farce.

This is as it should be—and all attempts to make it
otherwise are due to the eloquence of the ignorant,
the zeal of the conceited.

The boundary line is clear. Far from me to propose
to bridge it over—that the pestered people be pushed
across. No! I would save them from further fatigue.
I would come to their relief, and would lift from their
shoulders this incubus of Art.

Why, after centuries of freedom from it, and indif-
ference to it, should it now be thrust upon them by
the blind—until wearied and puzzled, they know no
longer how they shall eat or drink—how they shall
sit or stand—or wherewithal they shall clothe them-
selves—without afflicting Art.

But, lo ! there is much talk without !

Triumphantly they cry, " Beware! This matter
does indeed concern us. We also have our part in all
true Art !—for, remember the ' one touch of Nature '
that ' makes the whole world kin.' "

True, indeed. But let not the unwary jauntily
suppose that Shakespeare herewith hands him his
passport to Paradise, and thus permits him speech

among the chosen. Rather, learn that, in this very sentence, he is condemned to remain without—to continue with the common.

This one chord that vibrates with all—this "one touch of Nature" that calls aloud to the response of each—that explains the popularity of the "Bull" of Paul Potter—that excuses the price of Murillo's "Conception"—this one unspoken sympathy that pervades humanity, is—Vulgarity!

Vulgarity—under whose fascinating influence " the many have elbowed " the few," and the gentle circle of Art swarms with the intoxicated mob of mediocrity, whose leaders prate and counsel, and call aloud, where the Gods once spoke in whisper!

And now from their midst the Dilettante stalks abroad. The amateur is loosed. The voice of the æsthete is heard in the land, and catastrophe is upon us.

The meddler beckons the vengeance of the Gods, and ridicule threatens the fair daughters of the land.

And there are curious converts to a weird *culte*, in which all instinct for attractiveness—all freshness and sparkle—all woman's winsomeness—is to give way to a strange vocation for the unlovely—and this desecration in the name of the Graces!

Shall this gaunt, ill-at-ease, distressed, abashed

mixture of *mauvaise honte* and desperate assertion
call itself artistic, and claim cousinship with the
artist—who delights in the dainty, the sharp, bright
gaiety of beauty?

No!—a thousand times no! Here are no connec-
tions of ours.

We will have nothing to do with them.

Forced to seriousness, that emptiness may be hidden,
they dare not smile—

While the artist, in fulness of heart and head, is
glad, and laughs aloud, and is happy in his strength,
and is merry at the pompous pretension—the solemn
silliness that surrounds him.

For Art and Joy go together, with bold openness,
and high head, and ready hand—fearing naught, and
dreading no exposure.

Know, then, all beautiful women, that we are with
you. Pay no heed, we pray you, to this outcry of
the unbecoming—this last plea for the plain.

It concerns you not.

Your own instinct is near the truth—your own wit
far surer guide than the untaught ventures of thick
heeled Apollos.

What! will you up and follow the first piper that
leads you down Petticoat Lane, there, on a Sabbath,
to gather, for the week, from the dull rags of

ages wherewith to bedeck yourselves? that, beneath
your travestied awkwardness, we have trouble to
find your own dainty selves? Oh, fie! Is the
world, then, exhausted? and must we go back
because the thumb of the mountebank jerks the
other way?

Costume is not dress.

And the wearers of wardrobes may not be doctors
of taste!

For by what authority shall these be pretty masters?
Look well, and nothing have they invented—nothing
put together for comeliness' sake.

Haphazard from their shoulders hang the garments
of the hawker—combining in their person the motley
of many manners with the medley of the mummers'
closet.

Set up as a warning, and a finger-post of danger,
they point to the disastrous effect of Art upon the
middle classes.

Why this lifting of the brow in deprecation of the
present—this pathos in reference to the past?

If Art be rare to-day, it was seldom heretofore.

It is false, this teaching of decay.

The master stands in no relation to the moment at

which he occurs—a monument of isolation—hinting at sadness—having no part in the progress of his fellow men.

He is also no more the product of civilisation than is the scientific truth asserted dependent upon the wisdom of a period. The assertion itself requires the *man* to make it. The truth was from the beginning.

So Art is limited to the infinite, and **beginning** there cannot progress.

A silent indication of its wayward independence from all extraneous advance, is in the absolutely unchanged condition and form of implement since the beginning of things.

The painter has but the same pencil—the sculptor the chisel of centuries.

Colours are not more since the heavy hangings of night were first drawn aside, and the loveliness of light revealed.

Neither chemist nor engineer can offer new elements of the masterpiece.

False again, the fabled link between the grandeur of Art and the glories and virtues of the State, for Art feeds not upon nations, and peoples may be wiped from the face of the earth, but Art *is*.

It is indeed high time that we cast aside the weary weight of responsibility and co-partnership, and know that, in no way, do our virtues minister to its worth, in no way do our vices impede its triumph!

How irksome! how hopeless! how superhuman the self-imposed task of the nation! How sublimely vain the belief that it shall live nobly or art perish.

Let us reassure ourselves, at our own option is our virtue. Art we in no way affect.

A whimsical goddess, and a capricious, her strong sense of joy tolerates no dulness, and, live we never so spotlessly, still may she turn her back upon us.

As, from time immemorial, she has done upon the Swiss in their mountains.

What more worthy people! Whose every Alpine gap yawns with tradition, and is stocked with noble story; yet, the perverse and scornful one will none of it, and the sons of patriots are left with the clock that turns the mill, and the sudden cuckoo, with difficulty restrained in its box!

For this was Tell a hero! For this did Gessler die!

Art, the cruel jade, cares not, and hardens her heart, and hies her off to the East, to find, among the opium-eaters of Nankin, a favourite with whom she lingers fondly—caressing his blue porcelain, and painting his

coy maidens, and marking his plates with her six marks of choice—indifferent in her companionship with him, to all save the virtue of his refinement !

He it is who calls her—he who holds her !

And again to the West, that her next lover may bring together the Gallery at Madrid, and show to the world how the Master towers above all; and in their intimacy they revel, he and she, in this knowledge; and he knows the happiness untasted by other mortal.

She is proud of her comrade, and promises that in after-years, others shall pass that way, and understand.

So in all time does this superb one cast about for the man worthy her love—and Art seeks the Artist alone.

Where he is, there she appears, and remains with him—loving and fruitful—turning never aside in moments of hope deferred—of insult—and of ribald misunderstanding; and when he dies she sadly takes her flight, though loitering yet in the land, from fond association, but refusing to be consoled.*

With the man, then, and not with the multitude, are her intimacies; and in the book of her life the names inscribed are few—scant, indeed, the list of those who have helped to write her story of love and beauty.

* And so have we the ephemeral influence of the Master's memory—the afterglow, in which are warmed, for a while, the worker and disciple.

From the sunny morning, when, with her glorious Greek relenting, she yielded up the secret of repeated line, as, with his hand in hers, together they marked in marble, the measured rhyme of lovely limb and draperies flowing in unison, to the day when she dipped the Spaniard's brush in light and air, and made his people live within their frames, and *stand upon their legs,* that all nobility and sweetness, and tenderness, and magnificence should be theirs by right, ages had gone by, and few had been her choice.

Countless, indeed, the horde of pretenders! But she knew them not.

A teeming, seething, busy mass, whose virtue was industry, and whose industry was vice!

Their names go to fill the catalogue of the collection at home, of the gallery abroad, for the delectation of the bagman and the critic.

Therefore have we cause to be merry!—and to cast away all care—resolved that all is well—as it ever was—and that it is not meet that we should be cried at, and urged to take measures!

Enough have we endured of dulness! Surely are we weary of weeping, and our tears have been cozened from us falsely, for they have called out woe! when there was no grief—and, alas! where all is fair!

We have then but to wait—until, with the mark of
the Gods upon him—there come among us again the
chosen—who shall continue what has gone before.
Satisfied that, even were he never to appear, the story
of the beautiful is already complete—hewn in the
marbles of the Parthenon—and broidered, with the
birds, upon the fan of Hokusai—at the foot of Fusi-
yama.

" Rengaines ! "

LAST night, at Prince's Hall, Mr. Whistler made his first public appearance as a lecturer on Art. There were some arrows shot off and (O, *mea culpa !*) at dress reformers most of all. That an artist will find beauty in ugliness, *le beau dans l'horrible*, is now a commonplace of the schools. I differ entirely from Mr. Whistler. An Artist is not an isolated fact ; he is the resultant of a certain *milieu* and a certain *entourage*, and can no more be born of a nation that is devoid of any sense of beauty than a fig can grow from a thorn or a rose blossom from a thistle. The poet is the supreme Artist, for he is the master of colour and of form, and the real musician besides, and is lord over all life and all arts ; and so to the poet beyond all others are these myste-ries known ; to Edgar Allan Poe and Baudelaire, not to Benjamin West and Paul Delaroche.

OSCAR WILDE.

Pall Mall Gazette,
Feb 21, 1885.

REFLECTION:
It is not enough that our simple Sunflower thrive on his " thistle "—he has now grafted Edgar Poe on the " rose " tree of the early American Market in " a cer-tain milieu " of dry goods and sym-pathy ; and " a cer-tain entourage " of worship and wooden nutmegs.
Born of a Nation, not absolutely " devoid of any sense of beauty "— Their idol—cherished—listened to—and understood !
Foolish Baudelaire !—Mistaken Mallarmé !

Tenderness in Tite Street

TO THE POET:

OSCAR—I have read your exquisite article in the *Pall Mall.* Nothing is more delicate, in the flattery of " the Poet " to " the Painter," than the *naïveté* of " the Poet," in the choice of his Painters—Benjamin West and Paul Delaroche !

The World.

You have pointed out that "the Painter's" mission is to find " *le beau dans l'horrible*," and have left to "the Poet" the discovery of "*l'horrible*" *dans* "*le beau*" !

CHELSEA.

TO THE PAINTER:

The World.

DEAR Butterfly—By the aid of a biographical dictionary, I made the discovery that there were once two painters, called Benjamin West and Paul Delaroche, who rashly lectured upon Art. As of their works nothing at all remains, I conclude that they explained themselves away.

Be warned in time, James; and remain, as I do, incomprehensible. To be great is to be misunderstood.—*Tout à vous,*

OSCAR WILDE.

REFLECTION:

I do know a bird, who, like Oscar, with his head in the sand, still believes in the undiscovered!

If to be misunderstood is to be great, it was rash in Oscar to reveal the source of his inspirations: the "*Biographical Dictionary!*"

⊥o the Committee of the "National Art Exhibition"

The World,
Nov. 17, 1888.

Letter read at a
meeting of this
Society, associated
for purposes of **Art**
reform.

GENTLEMEN—I am naturally interested in any effort made among Painters to prove that they are alive—but when I find, thrust in the van of your leaders, the body of my dead 'Arry, I know that putrefaction alone can result. When, following 'Arry, there comes on Oscar, you finish in farce, and bring upon yourselves the scorn and ridicule of your *confrères* in Europe.

What has Oscar in common with Art? except that he dines at our tables and picks from our platters the plums for the pudding he peddles in the provinces. Oscar—the amiable, irresponsible, esurient Oscar—with no more sense of a picture than of the fit of a coat, has the courage of the opinions . . . of others!

With 'Arry and Oscar you have avenged the Academy.

I am, Gentlemen, yours obediently,

Enclosed to the
Poet, with a line :
" Oscar, you must
really keep outside
' the radius ' !"

Quand même !

The World,
Nov. 24, 1886.

A TLAS, this is very sad! With our James vulgarity begins at home, and should be allowed to stay there. —*A vous,*

OSCAR WILDE

TO WHOM:

A poor thing," Oscar!—" but," for once, I suppose " your own."

Philanthropy and Art

THE *Saturday Review* has not thought it disgraceful to once more justify its title to be called the " Saturday Reviler." This time it is not to break upon the wheel some poor butterfly of a lady traveller or novelist, but to scoff at an aged painter of the highest repute—Mr. Herbert—upon his retirement to the rank of " Honorary Academician," after a career such as few, if any, painters living can boast. This it pleases the " Reviler" to congratulate artists upon as " good news," without a word or a thought of what the retiring Academician has done in art, except to utter the contemptible untruth that "his resignation means that he has found out that he is beaten," *not* by the natural failing of old age, but because he failed to impress such a writer as this with the special exhibition of the works of his long life, that was made some few years back to mark the completion of his last great picture for the House of Lords, " The

Judgment of Daniel." That exhibition, which most
people, who know anything about painting in its
highest style of religious and monumental art,
thought a most interesting display of a painter's
career, is described by this most genial of critics as
"acres of pallid purple canvases, with wizened saints
and virgins in attitudinizing groups."

Whether that collection of Mr. Herbert's works
had merit or not is matter of opinion which I am not
concerned to dispute; but, as a matter of fact, there
were only *three* small pictures in which the virgin or
any saints appeared; the other pictures, besides the
two large works of "The Delivery of the Law" and
"The Judgment of Daniel," painted for the nation,
being historical subjects, such as the "Lear Disin-
heriting Cordelia," a fresco of which is in the House
of Lords; "The Acquittal of the Seven Bishops,"
which the Corporation of Salford purchased for their
gallery of art; and several fine works of his youth,
such as the "Brides of Venice," a "Procession in
Venice, 1528," and others, which won for him his
election to the Academy forty-five years ago, when
he had to compete with such men as are, unfortu-
nately, not to be found now among the candidates—
Etty—Maclise—Dyce—Egg—and Elmore.

But the "*Saturday's*" art critic, if he ever saw this

exhibition at all, didn't go to see these pictures. As
Goethe says, "the eye sees what it came to see," and
he went to see the "acres of purple canvases, with
their wizened saints," which were not there. No
matter—it suits his purpose to declare that they
were, just as it does to cram into a paragraph more
ignorance, insolence, and false assertions combined
than is often to be met with even in this locality of
literature, where the editor seems to be surrounded
with all the prigs, and the pumps, and the snobs of
the literary profession.

Truth, Aug. 19, 1886.

"*Nous avons changé tout cela !*"

HOITY-TOITY ! my dear Henry !—What is all this ? How can you startle the " Constant Reader," of this cold world, by these sudden dashes into the unexpected ?

Truth,
Sept. 2, 1886.

Perceive also what happens.

Sweet in the security of my own sense of things, and looking upon you surely as the typical " *Sapem* " of modern progress and civilization, here do I, in full Paris, *à l'heure de l'absinthe*, upon mischievous discussion intent, call aloud for " *Truth.*"

" *Vous allez voir,*" I say to the brilliant brethren gathered about my table, "you shall hear the latest beautiful thing and bold, said by our great Henry— ' *capable de tout,*' beside whom ' *ce coquin d'Habacuc* ' was mild indeed and usual !" And straightway to my stultification, I find myself translating paragraphs of pathos and indignation, in which a colourless old gentleman of the Academy is sympathized with, and

made a doddering hero of, for no better reason than that he *is* old—and those who would point out the wisdom and comfort of his withdrawal into the wigwam of private life, sternly reproved and anathematized and threatened with shame—until they might well expect to find themselves come upon by the bears of the aged and irascible, though bald-headed, Prophet, whom the children had thoughtfully urged to "go up."

Fancy the Frenchmen's astonishment as I read, and their placid amusement as I attempted to point out that it was "meant drolly—that *enfin* you were a *mystificateur !* "

Henry, why should I thus be mortified? Also, why this new *pose*, this cheap championship of senility?

How, in the name of all that is incompetent, do you find much virtue in work spreading over more time ! What means this affectation of *naïveté*.

We all know that work excuses itself only by reason of its quality.

If the work be foolish, it surely is not less foolish because an honest and misspent lifetime has been passed in producing it.

What matters it that the offending worker has grown old among us, and has endeared himself to

many by his caprices as ratepayer and neigh-
bour?

Personally, he may have claims upon his sur-
roundings; but, as the painter of poor pictures, he is
damned for ever.

You see, my Henry, that it is not sufficient to be,
as you are in wit and wisdom, among us, amazing and
astute; a very Daniel in your judgment of many
vexed questions; of a frankness and loyalty withal in
your crusade against abuses, that makes of the keen
litigator a most dangerous Quixote.

This peculiar temperament gives you that superb
sense of right, *outside the realms of art,* that amounts
to genius, and carries with it continued success and
triumph in the warfare you wage.

But here it helps you not. And so you find your-
self, for instance, pleasantly prattling in print of
" English Art."

Learn, then, O ! Henry, that there is no such thing
as English Art. You might as well talk of English
Mathematics. Art is Art, and Mathematics is Mathe-
matics.

What you call English Art, is not Art at all, but
produce, of which there is, and always has been, and
always will be, a plenty, whether the men producing
it are dead and called ——, or (I refer you to your

own selection, far be it from me to choose)—or alive and called ——, whosoever you like as you turn over the Academy catalogue.

The great truth, you have to understand, is that it matters not at all whom you prefer in this long list. They all belong to the excellent army of mediocrity; the differences between them being infinitely small —merely microscopic—as compared to the vast distance between any one of them and the Great.

They are the commercial travellers of Art, whose works are their wares, and whose exchange is the Academy.

They pass and are forgotten, or remain for a while in the memory of the worthies who knew them, and who cling to their faith in them, as it flatters their own place in history—famous themselves—the friends of the famous!

Speak of them, if it please you, with uncovered head—even as in France you would remove your hat as there passes by the hearse—but remember it is from the conventional habit of awe alone, this show of respect, and called forth generally by the casual corpse of the commonest kind.

PARIS, Aug. 21, 1886.

The Inevitable

WHEN I suggested you as the " Sapeur of modern progress," my dear Henry, I thought to convey delicately my appreciation, wrapped in graceful compliment. *Truth,*
Sept. 9, 1896.

When I am made to say that you are the " Sapem " of civilisation—whatever that may mean—I would seem to insinuate an impertinence clothed in classic error.

I trust that, if you forgive me, you will never pardon the printer.—Always,

"Noblesse oblige"

The World,
Dec. 31, 1884.

ATLAS, look at this! It has been culled from the
Plumber and Decorator, of all insidious prints, and
forwarded to me by the untiring people who daily
supply me with the thinkings of my critics.

Read, Atlas, and let me execute myself :

" The ' Peacock ' drawing-room of a well-to-do ship-
owner, of Liverpool, at Queen's Gate, London,
is hand-painted, representing the noble bird with
wings expanded, painted by an Associate of the
Royal Academy, at a cost of £7000, and fortunate
in claiming his daughter as his bride, and is one
of the finest specimens of high art in decoration
in the kingdom. The mansion is of modern con-
struction."

He is not guilty, this honest Associate ! It was *I*,
Atlas, who did this thing—"alone I did it"—*I*
" hand-painted " this room in the " mansion of modern
construction."

Woe is me! *I* secreted, in the provincial ship-owner's home, the "noble bird with wings expanded"—*I* perpetrated, in harmless obscurity, "the finest specimen of high-art decoration"—and the Academy is without stain in the art of its member. Also the immaculate character of that Royal body has been falsely impugned by this wicked "*Plumber*"!

Mark these things, Atlas, that justice may be done, the innocent spared, and history cleanly written.

 Bon soir !

CHELSEA.

Early Laurels

SIR—In your report of the Graham sale of pictures at Messrs. Christie and Manson's rooms, I read the *The Observer,* April 11, 1886. following :

" The next work, put upon the easel, was a 'Nocturne in blue and silver,' by J. M. Whistler. It was received with hisses."

May I beg, through your widely spread paper, to acknowledge the distinguished, though I fear unconscious, compliment so publicly paid.

It is rare that recognition, so complete, is made during the lifetime of the painter, and I would wish to have recorded my full sense of this flattering exception in my favour.

CHELSEA.

A Further Proposition

THE notion that I paint flesh lower in tone than it is in nature, is entirely based upon the popular superstition as to what flesh really is—when seen on *Art Journal,* 1887. canvas ; for the people never look at nature with any sense of its pictorial appearance—for which reason, by the way, they also never look at a picture with any sense of nature, but, unconsciously from habit, with reference to what they have seen in other pictures.

Now, in the usual " pictures of the year " there is but one flesh, that shall do service under all circumstances, whether the person painted be in the soft light of the room or out in the glare of the open. The one aim of the unsuspecting painter is to make his man " stand out " from the frame—never doubting that, on the contrary, he should really, and in truth absolutely does, stand *within* the frame—and at a depth behind it equal to the distance at which

the painter sees his model. The frame is, indeed, the
window through which the painter looks at his model,
and nothing could be more offensively inartistic than
this brutal attempt to thrust the model on the hither-
side of this window !

Yet this is the false condition of things to which
all have become accustomed, and in the stupendous
effort to bring it about, exaggeration has been
exhausted—and the traditional means of the incom-
petent can no further go.

Lights have been heightened until the white of the
tube alone remains—shadows have been deepened
until black alone is left. Scarcely a feature stays in
its place, so fierce is its intention of " firmly " coming
forth ; and in the midst of this unseemly struggle for
prominence, the gentle truth has but a sorry chance,
falling flat and flavourless, and without force.

The Master from Madrid, himself, beside this
monster success of mediocrity, would be looked upon
as mild : *beau bien sure, mais pas "dans le mouve-
ment* " !

Whereas, could the people be induced to turn their
eyes but for a moment, with the fresh power of com-
parison, upon their fellow-creatures as they pass in
the gallery, they might be made dimly to perceive
(though I doubt it, so blind is their belief in the bad,

how little they resemble the impudent images on the walls! how "quiet" in colour they are! how "grey!" how "low in tone." And then it might be explained to their riveted intelligence how they had mistaken meretriciousness for mastery, and by what mean methods the imposture had been practised upon them.

An Opportunity

CHER Monsieur — M. —— m'a remis votre petite planche—port d'Amsterdam avec une epreuve. Elle est charmante et je serais fort heureux de la faire paraître dans l'article consacré à vos eaux fortes. Seulement, je crois que vous avez mal interprété ma demande et que par le fait nous ne nous entendons pas bien. Vous me demandez 63 guinées pour cette planche, soit plus de 2000 francs, outre que le prix dépasse celui de la planche la plus chère parue dans la *Gazette* de puis sa fondation, y compris les chefs-d'œuvre de Jacquemart et de Gaillard, il n'est pas dans les habitudes de la maison, de payer les planches d'artistes qui accompagnent un compte-rendu de leur œuvre. C'est ainsi que nous avons agi avec Méryon, Seymour Haden, Edwards, Evershed, Legros, &c.

Du reste, la planche pourrait rester votre propriété. Nous vous la remettrions apres avoir fait notre tirage. Il est entendu qu'elle serait acierée.

Si ces conditions vous agréent, cher monsieur, je me ferai un vrai plaiser de faire dans la *Gazette* un article sur votre beau talent d'aquafortiste. Dans le cas contraire, je me verais avec mille regrets, dans la necessité de vous renvoyer la planche que je me fusse fait cependant un véritable honneur de publier.

Veuillez agréer, cher monsieur, l'expression de mes meilleurs sentiments.

> LE DIRECTEUR de la
> *Gazette des Beaux-Arts.*

Paris, le 12 Juin 1878.

The Opportunity Neglected

CHER Monsieur—Je regrette infiniment que mes moyens ne me permettent pas de naître dans votre Journal.

L'article que vous me proposez, comme berceau, me couterait trop cher.

Il me faudrait donc reprendre ma planche et rester inconnu jusqu'à la fin des choses, puisque je n'aurais pas été inventé par la *Gazette des Beaux Arts*.—Recevez, Monsieur,

Nostalgia

. . . . " QUITE true—now that it is established as an improbability, it becomes true!

Extract from a letter *à propos* of Mr. Whistler's contemplated visit to his native land.

They tell me that December has been fixed upon, by the Fates, for my arrival in New York—and, if I escape the Atlantic, I am to be wrecked by the reporter on the pier.

The World,
Oct. 13, 1886.

I shall be in his hands, even as is the sheep in the hands of his shearer—for I have learned nothing from those who have gone before—and been lost too!

What will you! I know Matthew Arnold, and am told that he whispered Truth exquisite, unheeded in the haste of America.

And these others who have crossed the seas, that they might fasten upon the hurried ones at home and gird at them with wisdom, hysterically acquired, and administered, unblushingly, with a suddenness of purpose that prevented their ever being listened to here,—must I follow in their wake, to be met with

suspicion by my compatriots, and resented as the invading instructor?

Heavens!—who knows!—also in the papers, where naturally I read only of myself, I gather a general impression of offensive aggressiveness, that, coupled with Chase's monstrous lampoon, has prepared me for the tomahawk on landing.

How dared he, Chase, to do this wicked thing?— and I who was charming, and made him beautiful on canvas—the Masher of the Avenues.

However, I may not put off until the age of the amateur has gone by, but am to take with me some of those works which have won for me the execration of Europe, that they may be shown to a country in which I cannot be a prophet, and where I, who have no intention of being other than joyous—improving no one—not even myself—will say again my "Ten o'Clock," which I refused to repeat in London—*J'ai dit!*

This is no time for hesitation—one cannot continually disappoint a Continent!

An Insinuation

TO THE EDITOR:

M Y attention has been directed to a paragraph that has gone the round of the papers, to the effect that Mr. John Burr and Mr. Reid have " withdrawn from the Society of British Artists." This tardy statement acquires undue significance at this moment, with a tendency to mislead, implying, as it might, that these resignations were in consequence of, and intended as a marked disapproval of, the determined stand made by the Society in excluding from their coming exhibition the masses of commonplace work hitherto offered to the public in their galleries. No such importance attaches, however, to their resignations, as these two gentlemen left Suffolk Street six months ago.

The Daily News,
Nov. 22, 1886.

An Imputation

SIR—Mr. Whistler denies that the recent policy of the Society of British Artists was the cause of the secession of Messrs. Burr and Reid from the ranks of that Society, and mentions in proof of his correction that their resignation took place six months ago. He might have gone further, and added that their secession corresponded in time with his own election as president. It is well known to artists that one, if not both, of these gentlemen left the Society knowing that changes of policy, of which they could not approve, were inevitable under the presidency of Mr. Whistler. It will be for the patrons of the Suffolk Street Gallery to decide whether the more than half-uncovered walls which will be offered to their view next week are more interesting than the work of many artists of more than average merit which will be conspicuous by its absence, owing to the selfish policy inaugurated.

A BRITISH ARTIST.

The Daily News,
Nov. 24, 1886:

"Autre Temps autre Mœurs"

TO THE EDITOR:

SIR — The anonymous "British Artist" says that " Mr. Whistler denies that the recent policy of the Society of British Artists was the cause of the seces- sion of Messrs. Reid and Burr from the ranks of that Society."

The Daily News,
Nov. 26, 1886.

Far from me to propose to penetrate the motives of such withdrawal, but what I did deny was that it could possibly be caused—as its strangely late announce- ment seemed sweetly to insinuate—by the strong determination to tolerate no longer the mediocre work that had hitherto habitually swarmed the walls of Suffolk Street.

This is a plain question of date, and I pointed out that these two gentlemen left the Society six months

ago—long before the supervising committee were
called upon to act at all, or make any demonstration
whatever. Your correspondent regrets that I do not
" go further," and straightway goes further himself,
and scarcely fares better, when, with a quaintness of
naïveté rare at this moment, he proposes that " it will
be for the patrons of the gallery to decide whether
the more than half-uncovered walls are more interest-
ing than the works of many artists of more than the
average merit."

Now it will be for the patrons to decide absolutely
nothing. It is, and will always be, for the gentlemen
of the hanging committee alone, duly chosen, to decide
whether empty space be preferable to poor pictures—
whether, in short, it be their duty to cover walls,
merely that walls may be covered—no matter with
what quality of work.

Indeed, the period of the patron has utterly passed
away, and the painter takes his place—to point out
what he knows to be consistent with the demands of
his art—without deference to patrons or prejudice
to party. Beyond this, whether the "policy of
Mr. Whistler and his following" be " selfish or

no," matters but little; but if the policy of your
correspondent's "following" find itself among the
ruthlessly rejected, his letter is more readily ex-
plained.

Talent in a Napkin

IF those who talk and write so glibly as to the desirability of artists devoting themselves to the representation of the naked human form, only knew a tithe of the degradation enacted before the model is sufficiently hardened to her shameful calling, they would for ever hold their tongues and pens in supporting the practice. Is not clothedness a distinct type and feature of our Christian faith? All art representations of nakedness are out of harmony with it.

Lecture before the
Church Congress,
Oct. 7, 1885.

<div align="center">J. C. HORSLEY, R.A.</div>

The Critic "Catching on"

MR. WHISTLER is again, in a sense, the mainstay of the Society (British Artists), partly through his own individuality and partly through the innovations he has introduced. He has several oil and pastel pictures, very slight in themselves, of the female nude, dignified and graceful in line and charmingly chaste, entitled " Harmony," " Caprice," and " Note." Beneath the latter Mr. Whistler has written, " Horsley *soit qui mal y pense."*

Pall Mall Gaz
Dec. 8, 1885.

" This is not," said the artist, " what people are sure to call it, ' Whistler's little joke.' On the contrary, it is an indignant protest against the idea that there is any immorality in the nude."

REFLECTION:
Meant " friendly."

Ingratitude

NO, kind sir—*trop de zèle* on the part of your re-
presentative—for I surely never explain, and Art
certainly requires no " indignant protest " against the
unseemliness of senility. " Horsley *soit qui mal y
pense* " is meanwhile a sweet sentiment—why more—
and why " morality " ?

Pall Mall Gazette,
Dec. 10, 1885.

The Complacent One

M R. WHISTLER has issued a brown-paper port-
folio of half a dozen "Notes," reproduced in mar- *Magazine of Art*
Dec. 1887.
vellous facsimile. These "Notes" are delightful
sketches in Indian ink and crayon, masterly so far as
they go—but, then, they go such a little way . . .
the "Notes" can only be regarded as painter's raw
material, interesting as correct sketches, but unworthy
the glories of facsimile reproduction, and imposing
margin. . . . The chief honours of the portfolio
belong to the publishers. . . .

The Critic-flaneur

SIR—You, who are, I perceive, in your present brilliant incarnation, an undaunted and undulled pursuer of pleasing truths, listen, I pray you, while again I indicate, with sweet argument, the alternative *Sunday Times,*
Jan. 15, 1888. of the bewildered one.

Notably, it is not necessary that the "Art Critic" should distinguish between the real and the "reproduction," or otherwise understand anything of the matter of which he writes—for much shall be forgiven him—yet surely, as I have before now pointed out, he might inquire.

Had the expounder of exhibitions, travelling for the *Magazine of Art*, asked the Secretary in the galleries of the Royal Society of British Artists, he would have been told that the "Notes" on the staircase, and in the vestibule, are not "delightful sketches in Indian ink and crayon *reproduced in marvellous facsimile* by Boussod, Valadon & Co. unworthy

the glories of facsimile reproduction, and imposing margin " while " the chief honours of the portfolio, however, belong to the publishers "—but are, disconcerting as I acknowledge it to be, *themselves the lithographs from nature,* drawn on the stone upon the spot.

Thus easily provided with paragraph, he would also have been spared the mortification of rebuke from his well-meaning and embarrassed employers.

Let the gentleman be warned—let him learn that the foolish critic only,—*looks*—and brings disaster, upon his paper—the safe and well-conducted one " informs himself."

> Yours, Sir, gently,

A Played-out Policy

Pall Mall Gazette
Dec. 9, 1886.

TO THE EDITOR
OF THE "*PALL MALL GAZETTE*":

SIR—In your courageous crusade against the Demon
Dulness and his preposterous surroundings, I think
it well that there should be delivered into your hands
certain documents for immediate publication, that
your readers may be roused quickly, and hear again
how well fenced in are the foolish in strong places—
and how greatly to be desired is their exposure, dis-
comfiture, and death—that Truth may prevail.

It happened in this way. The criticism in the *Times*
called for instant expostulation, and my answer was
consequently sent in to the Editor, who forthwith
returned it, regretting "that its tone prevented its
appearance in the paper." I thereupon with-
drew to write the following note to the Editor in
person :—

"Dear Sir—Permit me to call your courteous atten-
tion to the fact that the enclosed letter to the Editor

of the *Times* is in reply to an article that appeared in your paper—and that, as I sign my name in full, I alone am responsible for its tone or form; indeed, that such is its tone and form, is because it is my letter.

" In common fairness the answer to, or comment upon, any statements made in your paper should be published in your paper, as proper etiquette prevents its insertion in any other journal.

" Also, you surely would not propose to dictate certain forms or styles in which alone the columns of the *Times* are to be approached—as who should say all other savour of sacrilege !—or acquiescence alone would do, and you would have to write all your letters yourselves.

" My letter concerns the effect produced by criticism of a commonplace and inferior kind, wholly unworthy the first paper in England—and I am startled to learn, and still unwilling to believe, that the *Times* would shun all ventilation and refuse to publish any letter as its sole means of screening its staff or protecting its writers.

" I submit that the tone of my letter sins against no laws that are accepted in antagonism—that it offends in no way the etiquette of attack known to gentlemen.

"I beg, therefore, again, that if there be still time for its insertion, you will have it printed in your issue of to-morrow, or will say that it shall appear in the *Times* of Thursday morning.

<div style="text-align: center;">

"I am, dear Sir,

"Very faithfully,

"J. McNeill Whistler."

</div>

I was now told, "with the Editor's compliments," "that my letter should be considered." Taking this in complete good faith, I left the office, to discover the next day in print a remnant of the letter in question; that, by itself, entirely did away with sufficient reason for its being there at all. The two ensuing notes explain themselves:

<div style="text-align: center;">

To J. McN. Whistler, Esq. :

</div>

" The Editor of the *Times* has inserted in to-day's paper the only portion of Mr. Whistler's letter of November 30 which appears to have any claim to publication.

"Printing House Square, Dec. 1, 1886."

" To the Editor of the *Times*:

" Dear Sir—I beg to acknowledge the consummate sense of opportunity displayed by the Editor of the *Times*, in his cunning production of a part of my letter.

"Amazing ! *Mes compliments !*"

Without further comment I hand you a copy of the rejected letter.

" To the Editor of the *Times*.—Sir—In his article upon the Society of British Artists, your Art gentleman ventures the opinion of the ' plain man.'

" That such opinion is out of place and stultifying in a question of Art never occurs to him, and it is therefore frankly cited as, in a way, conclusive.

" The *naïf* train of thought that justified the importance attached to this poor ' plain ' opinion at all would seem to be the same that pervades the writing throughout; until it becomes difficult to discover where the easy effrontery and self-sufficiency of the ' plain one,' nothing doubting, cease, and the wit and wisdom of the experienced expert begin—so that one unconsciously confounds the incautious critic with the plausible plain person, who finally becomes the same authority.

" Blind plainness certainly is the characteristic of the solemn censure upon the fine work of Mr. Stott, of Oldham—plain blindness the omission of all mention of Mr. Ludovici's dainty dancing-girl.

" Bewilderment among paintings is naturally the fate of the ' plain man,' but, when put forth in the *Times*, his utterances, however empty, acquire a semblance of sense ; so that while he gravely descants with bald

assurance upon the engineering of the light in the galleries, and the decoration of the walls, the reader stands a chance of being misled, and may not discover at once that the 'plain' writer is qualified by ignorance alone to continue.

" Permit me, therefore, to rectify inconsequent impressions, and tell your readers that there is nothing 'tentative' in the 'arrangement' of colour, walls, or drapery—that the battens should *not* ' be removed ' —that they are meant to remain, not only for their use, but as bringing parallel lines into play that subdivide charmingly the lower portion of the walls and add to their light appearance—that the whole ' combination ' is complete—and that the 'plain man' is, as usual, ' out of it.'—I am, Sir, etc.,

" J. McNeill Whistler."

The question of fair dealing and good manners in this matter I could not leave in better hands than your own, and I will only add that hitherto I have always met with the utmost readiness on the part of the press to receive into their columns any reply, however opposed to assertions of their own.

Surely it is but poor policy this peremptory attempt to maintain in authority the weak and blundering one,

that he may destroy himself and bring sorrow upon his people.

Rather let him be thrust from his post, that he may be " brayed in a mortar among wheat with a pestle "—that the Just be assuaged and foolishness depart from among us.

An Interview with an ex-President

THE adverse vote by which the Royal Society of British Artists transferred its oath of allegiance from Mr. Whistler is for the time the chief topic of con- *Pall Mall Gazette,* June 11, 1888. versation in artistic circles. We instructed our representative to visit Mr. Whistler to obtain his explanation of the affair.

"The state of affairs?" said Mr. Whistler, in his light and airy way, raising his eyebrows and twinkling his eyes, as if it were all the best possible fun in the world; "why, my dear sir, there's positively *no* state of affairs at all. Contrary to public declaration, there's actually nothing chaotic in the whole business; on the contrary, everything is in order, and just as it should be. The survival of the fittest as regards the presidency, don't you see, and, well—Suffolk Street is itself again! A new government has come in, and, as I told the members the other night, I congratulate the Society on the result of their vote, for no longer

can it be said that the right man is in the wrong place. No doubt their pristine sense of undisturbed somnolence will again settle upon them after the exasperated mental condition arising from the unnatural strain recently put upon the old ship. Eh? what? Ha! ha!"

"You do not then consider the Society as out of date? You do not think, as is sometimes said, that the establishment of the Grosvenor took away the *raison d'être* and original intention of the Society— that of being a foil to the Royal Academy?"

"I can hardly say what was originally intended, but I do know that it was originally full of hope, and even determination; shown in a manner by their getting a Royal Charter—the only art society in London, I believe, that has one.

"But by degrees it lapsed into a condition of incapacity—a sort of secondary state,—do you see, till it acknowledged itself a species of *crêche* for the Royal Academy. Certain it is that when I came into it the prevalent feeling among all the men was that their best work should go to 'another place.'

"I felt that this sense of inferiority was fatal to the well-being of the place.

"For that reason I attempted to bring about a sense of *esprit de corps* and ambition, which culminated

in what might be called 'my first offence'—by my proposition that members belonging to other societies should hold no official position in ours. I wanted to make it an art centre," continued Mr. Whistler, with a sudden vigour and an earnestness for which the public would hardly give credit to this Master of Badinage and Apostle of Persiflage; " they wanted it to remain a shop, although I said to them, 'Gentlemen, don't you perceive that as shopmen you have already failed, don't you see, eh?' But they were under the impression that the sales decreased under my methods and my *régime*, and ignored the fact that sales had declined all over the country from all sorts of causes, commercial, and so on.

Their only chance lay in the art tone of the place, for the old-fashioned pictures had ceased to become saleable wares—buyers simply wouldn't buy them. But members' work I *couldn't*, by the rules, eliminate—only the bad outsiders were choked off."

" Then how do you explain the bitterness of all the opposition ? "

" A question of 'pull devil, pull baker,' and the devil has gone and the bakers remain in Suffolk Street ! Ha! ha! Here is a list of the fiendish party who protested against the thrusting forth of their president in such an unceremonious way :—

"Alfred Stevens, Theodore Roussel, Nelson Maclean, Macnab, Waldo Story, A. Ludovici, jun., Sidney Starr, Francis James, W. A. Rixon, Aubrey Hunt, Moffatt P. Lindner, E. G. Girardot, Ludby, Arthur Hill, Llewellyn, W. Christian Symons, C. Wyllie, A. F. Grace, J. E. Grace, J. D. Watson, Jacomb Hood, Thornley, J. J. Shannon, and Charles Keen. Why, the very flower of the Society! and whom have they left—*bon Dieu!* whom have they left?"

"It was a hard fight then?"

"My dear sir, they brought up the maimed, the halt, the lame, and the blind—literally—like in Hogarth's 'Election;' they brought up everything but corpses, don't you know!—very well!"

"But all this hardly explains the bitterness of the feud and personal enmity to you."

"What? Don't you see? My presidential career had in a manner been a busy one. When I took charge of the ship I found her more or less water-logged. Well, I put the men to the pumps, and thoroughly shook up the old vessel; had her re-rigged re-cleaned, and painted—and finally I was graciously permitted to run up the Royal Standard to the mast-head, and brought her fully to the fore, ready for action—as became a Royal flagship! And as a natural result mutiny at once set in!

" Don't you see," he continued, with one of his strident laughs, " what might be considered, by the thoughtless, as benefits, were resented, by the older and wiser of the crew, as innovations and intrusions of an impertinent and offensive nature. But the immediate result was that interest in the Society was undeniably developed, not only at home, but certainly abroad. Notably in Paris all the art circle was keenly alive to what was taking place in Suffolk Street; and, although their interest in other institutions in this country had previously flagged, there was the strong willingness to take part in its exhibitions.

For example, there was Alfred Stevens, who showed his own sympathy with the progressive efforts by becoming a member. And look at the throngs of people that crowded our private views—eh? ha! ha! what! But what will you!—the question is, after all, purely a parochial one—and here I would stop to wonder, if I do not seem pathetic and out of character, why the Artist is naturally an object of vituperation to the Vestryman?—Why am *I*—who, of course, as you know, am charming—why am *I* the pariah of my parish?

" Why should these people do other than delight in me?—Why should they perish rather than forgive the one who had thrust upon them honour and success ?"

"And the moral of it all?"

Mr. Whistler became impressive—almost imposing —as he stroked his moustache, and tried to hide a smile behind his hand.

"The organisation of this 'Royal Society of British Artists,' as shown by its very name, tended perforce to this final convulsion, resulting in the separation of the elements of which it was composed. They could not remain together, and so you see the 'Artists' have come out, and the 'British' remain—and peace and sweet obscurity are restored to Suffolk Street!— Eh? What? Ha! ha!"

Statistics

SINCE our interview with Mr. Whistler curious statements have been set afloat concerning the question of finance giving circumstantial evidence of the disaster brought upon the Society by the enforcement of the Whistlerian policy :— *Pall Mall Gazette,* July 6, 1888.

This evidence, which is very interesting, is as follows :—The sales of the Society during the year 1881 were under £5000; 1882, under £6000; 1883, under £7000; 1884, under £8000; 1885 (the first year of Mr. Whistler's rule), they fell to under £4000; 1886, under £3000; 1887, under £2000; and the present year, under £1000.

On the other hand, the fact of the Society having made itself responsible to Mr. Whistler for a loan raised by him to meet a sudden expenditure for repairs, is also true; but the unwisdom of the president and members of any society having money transac-

tions between them need hardly be commented upon
here.

Mr. Wyke Bayliss, the new president, strikes one
as being " a strong man "—shrewd, logical, and self-
restrained. The author of several books and pamphlets
on the more imaginative realm of art, he is, one would
say, as much permeated by religion as he is by art; to
both of these qualities, curiously enough, his canvases,
which usually deal with cathedral interiors of cheery
hue, bear witness.

The hero of three Bond Street " one-man exhibi-
tions," a Board-school chairman, a lecturer, champion
chess-player of Surrey, a member of the Rochester
Diocesan Council, a Shaksperian student, a Fellow of
the Society of Cyclists, a Fellow of the Society of
Antiquarians, and public orator of Noviomagus
he is surely one of the most versatile men who ever
occupied a presidential chair.

A Retrospect

TO THE EDITOR
OF THE "PALL MALL GAZETTE:"

SIR—The Royal Society of British Artists is, perhaps, by this time again unknown to your agitated readers—but I would recall a brilliant number of the *Pall Mall Gazette* (July 1888), in which mischievous amusement was sought, with statistics from a newly elected President—Mr. Bayliss (Wyke).

Believing it to be, in an official and dull way, more becoming that the appointed Council of this same Society should deal with the resulting chaos, I have, until now, waited for a slight washing of hands, as who should say, on their part as representing the gentle deprecation of, I assure you, the respectable body in Suffolk Street

Well, no!—It was doubtless adjudged wiser, or milder, to "live it down," and now it, I really believe,

behoves me, in a weary way, to remind you of the
document in question, and, for the sake of common-
place, uninteresting, and foolish fact, to lift up my
parable and declare fallacious that which was supposed
to be true, and generally to bore myself, and perhaps
even you, the all-patient one, with what, I fear, we
others care but little for—parish matters.

In the article, then, entitled "The Royal Society
of British Artists and its Future—An Interview with
the New President"—a most appalling volley of
figures was fired off at *brûle-pour-point* distance.
Under this deafening detonation I, having no habit,
sat for days incapable—dreaming vaguely that when
a President should see fit to wash his people's linen
in the open, there must be indeed crime at least on
the part of the offender at whose instigation such
official sacrifice of dignity could come about. *I* was
the offender, and for a while I sincerely believed that
disaster had been brought upon this Royal Society
by my own casual self. But behold, upon closer
inspection, these threatening figures are meretricious
and misleading, as was the building account of the
early Philanthropist who, in the days of St. Paul,
meant well, and was abruptly discouraged by that
clear-headed apostle.

Mr. Bayliss tells us that : " The sales of the Society

during the year 1881 were under," whatever that may mean, "£5000; 1882, under £6000; 1883, under £7000; 1884, under £8000; in 1885 ('the first year of Mr. Whistler's rule') they fell to under £4000; 1886, under £3000; 1887, under £2000; and the present year, under £1000."

But also Mr. Bayliss takes this rare occasion of attention, to assert his various qualifications for his post as head of painters in the street of Suffolk, and so we learn that he is :—

"Chairman of the Board-school in his own district," "Champion chess-player of Surrey," "A member of the Diocesan Council of Rochester," "Fellow of the Society of Cyclists," and "Public Orator of Noviomagus."

As chess-player he may have intuitively bethought himself of a move—possibly the happy one,—who knows?—which in the provinces obtained him a cup; as Diocesan Councilman he may have supposed Rochester indifferent to the means used for an end; but as Public Cyclist of the Royal Society of Noviomagus his experience must be opposed to any such bluff as going his entire pile on a left bower only!

When I recovered my courage—what did I find? —first my unimpaired intelligence, and then my memory.

Now, to my intelligence, it becomes patent that the chairman of a Clapham School-board, proposes by his figures to prove, that the income of the sacrificed Society had of late years steadily increased :—" In 1881, under £5000 ; 1882, under £6000 ; 1883, under £7000 ; 1884, under £8000," until, under the baneful reign of terror and Whistler in 1885—" the first year" of the sacrilegious era—the receipts fell to £4000—and have continued to decrease until, in this present year, they fall to the miserable sum of under a thousand pounds—a revelation! discreet, statesmanlike, and worthy the orator at his best!

Unfortunately for the triumph of such audacious demonstration, my revived memory points out that Mr. Whistler was only elected President in June 1886, and, in conformity with the ancient rules and amusing customs of the venerable body, only came into office six months afterwards—that is, practically, in January 1887. Again, with this last exhibition, he, as everybody knows, had nothing whatever to do.

Immediately, therefore, the conclusion is " quite other " than that put forth by the Cyclist of his suburb, and we arrive at the, for once, not unamusing " fact " that the disastrous and simple Painter Whistler only took in hand the reins of government at least a year after the former driver had been

pitched from his box, and half the money-bags had been already lost!—from £8000 to £4000 at one fatal swoop! and the beginning of the end had set in! Indeed, this may have been one of the strong reasons for his own election by an overwhelming minority of hysterical and panic-stricken passengers.

Now, though he did his best, and cried aloud that the coach was safe, and called it Royal, and proposed to carry the mail, confidence, difficult to restore, waited for proof, and although fresh paint was spread upon the panels, and the President coachman wore his hat with knowing air, on one side and handled the ribbons lightly, and dandled the drag, inviting jauntily the passer-by, the public recognized the ramshackle old "conveyance," and scoffingly refused to trust themselves in the hearse.

"Four thousand pounds!" down it went—£3000 —£2000—the figures are Wyke's—and this season, the ignominious "£1000 or under," is none of my booking! and when last I saw the mad machine it was still cycling down the hill.

The New Dynasty

SIR—Pray accept my compliments, and be good enough to inform me at once by whose authority, and upon what pretence, the painting, designed and executed by myself, upon the panel at the entrance of the galleries of Suffolk Street, has been defaced. Tampering with the work of an artist, however obscure, is held to be, in what might be called the international laws of the whole Art world, so villainous an offence, that I must at present decline to entertain the responsibility of the very distinguished and Royal Society of British Artists, for what must be due to the rash, and ill-considered, zeal of some enthusiastic and untutored underling.

The Morning Post.

Awaiting your reply, I have the honour to be, Sir, your obedient, humble servant,

TO THE HON. SECRETARY
OF THE ROYAL SOCIETY OF BRITISH ARTISTS.

March 30, 1889.

Telegram to Council of Royal Society of British Artists :
" Congratulations upon dignity maintained as Artists left in charge of a brother Artist's work, and upon graceful bearing as officers toward their late President.—WHISTLER.

An Embroidered Interview

" WELL, Mr. Whistler, they say they only painted
out your butterfly from the signboard, and changed
the date. What do you say ? "

Pall Mall Gazette,
April 3, 1889.

" What do I say ? That they have been guilty of
an act of villainous Vandalism."

" Will you tell me the history of the Board ? "

" When I was elected to the presidency of the
Society I offered to paint a signboard which should
proclaim to the passer-by the name and nature of the
Society. My offer was accepted, and the Board was
sent down to my studio, where I treated it as I should
a most distinguished sitter—as a picture or an etching
—throwing my artistic soul into the Board, which
gradually became a Board no longer, as it grew into a
picture. You say they say it was only a butterfly.
Mendacity could go no further. I painted a *lion* and
a butterfly. The lion lay with the butterfly—a har-
mony in gold and red, with which I had taken as

much trouble as I did with the best picture I ever painted. And now they have clothed my golden lion clumsily, awkwardly, and timorously with a dirty coat of black. My butterfly has gone, the checks and lines, which I had treated decoratively, have disappeared. Am I not justified in calling it a piece of gross Vandalism?"

"What course would you have recommended? You had gone; the Board remained: perhaps it was weather-beaten—what could they do?"

"They should have taken the Board down, sir, taken the Board down, not dared to destroy my work —taken the Board down, returned it to me, and got another Board of their own to practise on. Good heavens! You say to my face it was only a Board. You say they *only* painted out my butterfly. It is as if you were condoling with a man who had been robbed and stripped, and said to him, 'Never mind. It is well it is no worse. You have escaped easily. Why, you might have had your throat cut.'"

And Mr. Whistler's Mephistophelian form disappeared into the black of the night.

The " *Pall Mall* " *Puzzled*

MR. WHISTLER begs me to insert the following note exactly as it stands. 1 haven't the slightest idea what it means, but here it is with "*mes compliments*" :— *Pall Mall Gazette,* April 4, 1889.

"To the INTERVIEWER OF THE *Pall Mall Gazette :*

"Good! very good! Prettily put, as becomes the *Pall Mall*, and yet you cannot be reproached with being 'too fine for your audience !'

"I wish I *could* say these things as you do for me, even at the risk of, at last, being understood. *Mes Compliments !*"

Official Bumbledom

SIR —As you have considered Mr. Whistler's letter
worthy of publication, I ask you to complete the pub-
lication by inserting this simple statement of the facts
as they occurred. The notice board of the Royal
To the Editor of
The Morning Post Society of British Artists bears on a red ground, in
letters of gold, the title of the Society. To this Mr.
Whistler, during his presidency, added with his own
hand a decorative device of a lion and a butterfly.
On the eve of our private view it was found that,
while the title of the Society, being in pure gold,
remained untarnished, Mr. Whistler's designs, being
executed in spurious metals, had nearly disappeared,
and what little remained of them was of a dirty
brown. The board could not be put up in that state.
The lion, however, was not so badly drawn as to make
it necessary to do anything more than restore it in
permanent colour, and that has accordingly been done.
But as the notice board was no longer the actual work

of Mr. Whistler, it would manifestly have been improper to have left the butterfly (his well-known signature) attached to it, even if it had not appeared in so crushed a state. The soiled butterfly was therefore effaced.

Yours, &c.,

WYKE BAYLISS,
CLAPHAM.

April 1, 1889.

" Aussi que diable allait-il faire dans cette galère ? "

SIR—I have read Mr. Bayliss's letter, and am disarmed. I feel the folly of kicking against the parish pricks. These things are right in Clapham, by the
The Morning Post. common.

> *" V'là ce que c'est, c'est bien fait—*
> *Fallait pas qu'il y aille ! fallait pas qu'il y aille !"*

And when, one of these days, all traces of history shall, by dint of much turpentine, and more Bayliss, have been effaced from the board that "belongs to us," I shall be justified, and it will be boldly denied by some dainty student that the delicate butterfly was *ever* " soiled " in Suffolk Street.

Yours, &c.,

The Royal Society of British Artists and their Signboard

The Athenæum,
April 27, 1889.

SIR—The moment has now arrived when, it seems to me proper that, in your journal, one of the recognized Art organs of the country, should be recorded the details of an incident in which the element of grave offence is, not unnaturally, quite missed by the people in their indignation at the insignificance of the object to which public attention has so unwarrantably been drawn—a " notice board " !—the common sign of commerce !

Now, however slight might be the value of the work in question destroyed, it is surely of startling interest to know that *work may be destroyed*, or worse still, defaced and tampered with, at the present moment in full London, with the joyous approval of the major part of the popular press.

I leave to your comment the fact that in this instance the act is committed with the tacit consent of a body of gentlemen officially styled " artists," at

the instigation of their president, as he unblushingly
acknowledges, and will here distinctly state that the
" notice board of the Royal Society of British Artists "
did not " bear on a red ground, in letters of gold, the
title of the Society," and that " to this Mr. Whistler,
during his presidency," *did not* " add with his own
hand a decorative device of a lion and a butterfly."
This damning evidence, though in principle irrele-
vant—for what becomes of the soul of a " Diocesan
member of the Council of Clapham " is, artistically,
a matter of small moment—I nevertheless bring for-
ward as the only one that will at present be at all
considered or even understood.

The " notice board " was of the familiar blue
enamel, well known in metropolitan use, with white
lettering, announcing that the exhibition of the Incor-
porated Society of British Artists was held above, and
that for the sum of one shilling the public might enter.

I myself mixed the " red ground," and myself
placed, " in letters of gold, the " *new* " title " upon it
—in proper relation to the decorative scheme of the
whole design, of which it formed naturally an all-
important feature. The date was that of the Society's
Royal grant, and in commemoration of its new birth.
With the offending Butterfly, it has now been effaced
in one clean sweep of independence, while the lion,

" not so badly drawn," was differently dealt with—
it was found not " necessary to do anything more
than restore it in permanent colour, and that," with
a bottle of Brunswick black, " has accordingly been
done ; " and, as Mr. Bayliss adds, with unpremedi-
tated truth, in the thoughtless pride of achieve-
ment, " the notice board was no longer the actual
work of Mr. Whistler ! "

This exposure of Mr. Bayliss's direct method I
have wickedly withheld, in order that the Philis-
tine impulse of the country should declare itself
in all its freshness of execration before it could be
checked by awkward discovery of mere mendacity,
and a timid sense of danger, called justice.

Everything has taken place as I pleasantly fore-
saw, and there is by this time, with the silent ex-
ception of one or two cautious dailies, scarcely a lay
paper in the land that has been able to refrain from
joining in the hearty yell of delight at the rare chance
of coarsely, publicly, and safely insulting an artist !
In this eagerness to affront the man they have irre-
trievably and ridiculously committed themselves to
open sympathy with the destruction of his work.

I wish coldly to chronicle this fact in the archives
of the *Athenæum* for the future consideration of the
cultured New Zealander.

An Official Letter

SIR—I beg to acknowledge the receipt of your letter, officially informing me that the Committee award me a second-class gold medal.

Pray convey my sentiments of tempered and respectable joy to the gentlemen of the Committee, and my complete appreciation of the second-hand compliment paid me.

<div align="center">And I have, Sir,</div>

<div align="center">The honour to be</div>

<div align="center">Your most humble, obedient servant,</div>

<div align="center">J. McNEILL WHISTLER.</div>

To the 1st Secretary,
Central Committee,
International Art Exhibition, Munich.

The Home of Taste

The Ideas of Mr. Blankety Blank on House Decoration

THE other day I happened to call on Mr. Blank,—
Japanese Blank, you know, whose house is in far
Fulham. The garden door flew open at my summons,
and my eye was at once confronted with a house, the Pall Mall Gazette, Dec. 1, 1888.
hue of whose face reminded me of a Venetian palazzo,
for it was of a subdued pink. If the ex-
terior was Venetian, however, the interior was a
compound of Blank and Japan. Attracted by the
curiously pretty hall, I begged the artist to explain
this—the newest style of house decoration.

I need not say that Blank, being a man of an
original turn of mind, with the decorative bump
strongly developed, holds what are at present peculiar
views upon wall papers, room tones, and so on. The
day is dark and gloomy, yet once within the halls of
Blank there is sweetness and light.

You must look through the open door into a luminous little chamber covered with a soft wash of lemon yellow.

From the antechamber we passed through the open door into a large drawing-room, of the same soft lemon-yellow hue. The blinds were down, the fog reigned without, and yet you would have thought that the sun was in the room.

Here let me pause in my description, and put on record the gist of our conversation concerning the Home of Taste.

" Now, Mr. Blank, would you tell me how you came to prefer tones to papers ? "

" Here the walls used to be covered with a paper of a sombre green, which oppressed me and made me sad," said Blank. ' Why cannot I bring the sun into the house,' I said to myself, ' even in this land of fog and clouds ? ' Then I thought of my experiment and invoked the aid of the British house-painter. He brought his colours and his buckets, and I stood over him as he mixed his washes.

" One night, when the work was nearing completion, one of them caught sight of himself in the mirror, and remarked with astonishment upon the loveliness of his own features. It was the lemon-yellow beautifying the British workman's flesh tones.

" I assure you the effect of a room full of people in evening dress seen against the yellow ground is extraordinary, and," added Blank, " perhaps flattering."

" Then do I understand that you would remove all wall papers ? "

" A good ground for distemper," chuckled Mr. Blank.

" But you propose to inaugurate a revolution."

" I don't go so far as that, but I am glad to be able to introduce my ideas of house furnishing and house decoration to the public," said Blank, " and I may tell you that when I go to America with my Paris pictures, I shall try and decorate a house according to my own ideas, and ask the Americans to think about the matter."

Another Poacher in the Chelsea Preserves

ATLAS—Nothing matters but the unimportant; so, at the risk of advertising an Australian immigrant of Fulham—who, like the Kangaroo of his country, is born with a pocket and puts everything into it— and, in spite of much wise advice, we ought not to resist the joy of noticing how readily a hurried contemporary has fallen a prey to its superficial knowledge of its various departments, and, culminating in a " Special Edition " last week to embody a lengthy interview headed " The Home of Taste," has discovered again the nest of the mare that was foaled years ago!

How, by the way, so smart a paper should have printed its *naïf* emotions of ecstasy before the false colours which the " Kangaroo " has hoisted over his bush, defies all usual explanation, but clearly the jaunty reporter whose impudent familiarity, on a former memorable occasion, achieved my wondering admiration, must have been, in stress of business, replaced

The World,
Dec. 26, 1888.

by a novice who had never breakfasted with you and
me, Atlas, and the rest of the world, in the "lemon-
yellow," of whose beautiful tone he now, for the first
time, is so completely convinced.

The "hue" on the "face" of the Fulham
"Palazzo" he moreover calls "Venetian," and is
pleased with it—and so was I, Atlas—*for I mixed it
myself!*

And yet, O Atlas, they say that I cannot keep a
friend—my dear, I cannot afford it—and *you* only
keep for me their scalps!

"Many, when a thing was lent them, reckoned it
to be found, and put them to trouble that helped
them."

A Suggestion

A CERTAIN painter has given himself away to an American journalist, unless that gentleman has romanced, in the *Philadelphia Daily News*. According to him this person explained how he managed the press, and how he claimed to be the inventor of the system associated with the name of Mr. Whistler. The Art clubs and the studios have been flooded with the *Philadelphia Daily News*. Mr. Whistler sent on his own copy to the pretender, with the following note :—

Truth,
March 28, 1889:

" You will blow your brains out, of course. Pigott has shown you what to do under the circumstances, and you know your way to Spain. Good-bye ! "

The Habit of Second Natures

M OST Valiant *Truth* — Among your ruthless ex-
posures of the shams of to-day, nothing, I confess,
have I enjoyed with keener relish than your late tilt
at that arch-impostor and pest of the period—the all- *Truth,*
Jan. 2, 1890:
pervading plagiarist !

I learn, by the way, that in America he may, under
the "Law of '84," as it is called, be criminally prose-
cuted, incarcerated, and made to pick oakum, as he
has hitherto picked brains—and pockets !

How was it that, in your list of culprits, you omitted
that fattest of offenders—our own Oscar ?

His methods are brought again freshly to my mind,
by the indefatigable and tardy Romeike, who sends
me newspaper cuttings of " Mr. Herbert Vivian's
Reminiscences," in which, among other entertaining
anecdotes, is told at length, the story of Oscar simu-
lating the becoming pride of author, upon a certain
evening, in the club of the Academy students, and

arrogating to himself the responsibility of the lecture, with which, at his earnest prayer, I had, in good fellowship, crammed him, that he might not add deplorable failure to foolish appearance, in his anomalous position, as art expounder, before his clear-headed audience.

He went forth, on that occasion, as my St. John—but, forgetting that humility should be his chief characteristic, and unable to withstand the unaccustomed respect with which his utterances were received, he not only trifled with my shoe, but bolted with the latchet!

Mr. Vivian, in his book, tells us, further on, that lately, in an article in the *Nineteenth Century* on the " Decay of Lying," Mr. Wilde has deliberately and incautiously incorporated, " without a word of comment," a portion of the well-remembered letter in which, after admitting his rare appreciation and amazing memory, I acknowledge that " Oscar has the courage of the opinions of others!"

My recognition of this, his latest proof of open admiration, I send him in the following little note, which I fancy you may think *à propos* to publish, as an example to your readers, in similar circumstances, of noble generosity in sweet reproof, tempered, as it should be, to the lamb in his condition :—

"Oscar, you have been down the area again, I see!

"I had forgotten you, and so allowed your hair to grow over the sore place. And now, while I looked the other way, you have stolen *your own scalp!* and potted it in more of your pudding.

"Labby has pointed out that, for the detected plagiarist, there is still one way to self-respect (besides hanging himself, of course), and that is for him boldly to declare, 'Je prends mon bien là ou je le trouve.'

"You, Oscar, can go further, and with fresh effrontery, that will bring you the envy of all criminal *confrères,* unblushingly boast, 'Moi, je prends *son* bien là ou je le trouve!'"

CHELSEA.

In the Market Place

Truth,
Jan. 9, 1890.

SIR—I can hardly imagine that the public are in the very smallest degree interested in the shrill shrieks of "Plagiarism" that proceed from time to time out of the lips of silly vanity or incompetent mediocrity.

However, as Mr. James Whistler has had the impertinence to attack me with both venom and vulgarity in your columns, I hope you will allow me to state that the assertions contained in his letters are as deliberately untrue as they are deliberately offensive.

The definition of a disciple as one who has the courage of the opinions of his master is really too old even for Mr. Whistler to be allowed to claim it, and as for borrowing Mr. Whistler's ideas about art, the only thoroughly original ideas I have ever heard him express have had reference to his own superiority as a painter over painters greater than himself.

It is a trouble for any gentleman to have to notice the lucubrations of so ill-bred and ignorant a person as Mr. Whistler, but your publication of his insolent letter left me no option in the matter.—I remain, Sir, faithfully yours,

OSCAR WILDE.

Panic

O TRUTH!—Cowed and humiliated, I acknowledge that our Oscar is at last original. At bay, and sublime *Truth,* Jan. 16, 1890. in his agony, he certainly has, for once, borrowed from no living author, and comes out in his own true colours—as his own "gentleman."

How shall I stand against his just anger, and his damning allegations! for it must be clear to your readers, that, beside his clean polish, as prettily set forth in his epistle, I, alas! am but the "ill-bred and ignorant person," whose "lucubrations" "it is a trouble" for him "to notice."

Still will I, desperate as is my condition, point out that though "impertinent," "venomous," and "vulgar," he claims me as his "master"—and, in the dock, bases his innocence upon such relation between us.

In all humility, therefore, I admit that the out come of my "silly vanity and incompetent mediocrity," must be the incarnation: "Oscar Wilde.'

Mea culpa! the Gods may perhaps forgive and forget.

To you, *Truth*—champion of the truth—I leave the brave task of proclaiming again that the story of the lecture to the students of the Royal Academy was, as I told it to you, no fiction.

In the presence of Mr. Waldo Story did Oscar make his prayer for preparation; and at his table was he entrusted with the materials for his crime.

You also shall again unearth, in the *Nineteenth Century Review* of Jan. 1889, page 37, the other appropriated property, slily stowed away, in an article on "The Decay of Lying"—though why Decay!

To shirk this matter thus is craven, doubtless; but I am awe-stricken and tremble, for truly, "the rage of the sheep is terrible!"

Just Indignation

OSCAR—How dare you! What means this disguise?

Restore those things to Nathan's, and never again let me find you masquerading the streets of my Chelsea in the combined costumes of Kossuth and Mr. Mantalini!

Upon perceiving the Poet, in Polish cap and green overcoat, befrogged, and wonderfully befurred.

An Advanced Critic

TO THE EDITOR:

SIR—I find myself obliged to notice the critical review of the "Ten o'Clock," that appeared in your paper (March 6).

In the interest of my publishers, I beg to state formally that the work has not as yet been issued at all—and I would point out that what is still in the hands of the printer, cannot possibly have fallen into the fingers of your incautious contributor!

Pall Mall Gazette,
March 28, 1888.

The early telegram is doubtless the ambition of this smart, though premature and restless one—but he is wanting in habit, and unhappy in his haste!—What will you? The *Pall Mall* and the people have been imposed upon.

Be good enough, Sir, to insert this note, lest the public suppose, upon your authority, that the "Ten o'Clock," as yet unseen in the window of Piccadilly, has, in consequence of this sudden summing up, been hurriedly withdrawn from circulation.—I am, Sir,

The Advantage of Explanation

TO THE EDITOR:

SIR—Just three weeks after publication Mr. Whistler "finds himself obliged to notice the critical review of the 'Ten o'Clock' that appeared in your paper." He points out that "what is still in the hands of the printer cannot possibly have fallen into the fingers of your incautious contributor." I do not pretend to be acquainted with the multitudinous matters that may be in the hands of his publishers' printers. But I can declare—and you, Sir, will corroborate me—that a printed copy of Mr. Whistler's smart but misleading lecture was placed in my hands for review, and, moreover, that the notice did not appear until the pamphlet was duly advertised by Messrs. Chatto and Windus as ready. It is, of course, a matter of regret to me if, as Mr. Whistler suggests, his publishers' interests are likely to suffer from the review; but if

Pall Mall Gazette
March 31, 1888.

an author's work, in the reviewer's opinion, be full of rash statement and mischievous doctrine, the publishers must submit to the risk of frank criticism. But it will be observed that Mr. Whistler is merely seeking to create an impression that your Reviewer never saw the work he criticized, which is surely not a creditable position to take up, even by a sensitive man writhing under adverse criticism.—I am, Sir, most obediently,

YOUR REVIEWER.

Testimony

TO THE EDITOR:

SIR—My apologies, I pray you, to the much disturbed gentleman, "Your Reviewer," who complains that I have allowed "just three weeks" to go by without noticing his writing. *Pall Mall Gazette.*
April 7, 1888.

Let me hasten, lest he be further offended, to acknowledge his answer, in Saturday's paper.

After much matter, he comes unexpectedly upon a clear understanding of my letter—"It will be observed," he says naïvely, "that Mr. Whistler is merely seeking to create an impression that your Reviewer never saw the work he criticized,"—herein he is completely right, this is absolutely the impression I did seek to create—"which," he continues, "is surely not a creditable position to take up"—again I agree with him, and admit the sad spectacle a "Reviewer" presents in such position.

He further "declares," and calls upon you, Sir, to "corroborate" him, "that a printed copy of Mr. Whistler's misleading lecture was placed in my hands for review"—and moreover, that "the notice did not appear until the pamphlet was duly advertised by Messrs. Chatto and Windus as ready."

Pausing to note that if the lecture had not seemed misleading to him, it would surely not have been worth uttering at all, I come to the copy in question—this could only have been a printed proof, quaintly acquired—as will be seen by the following letter from Messrs. Chatto and Windus, which I must beg you Sir, to publish, with this note—as it deals also with the remaining point, the advertisement of the pamphlet,

And, I am, Sir,

The following is the letter from Mr. Whistler's publishers:—

DEAR SIR—In reply to your question we have to say that we certainly have not sent out any copy of the "Ten o'Clock" to the press, or to anybody else excepting yourself. The work is still in the

printers' hands, and we have for a long time past been advertising it only as "shortly" to be published ; indeed, only a few proofs have so far been taken from the type.

Yours faithfully,

CHATTO AND WINDUS.

An Apostasy

TO speak the truth, the whole truth, and nothing but the truth may justly be required of the average witness; it cannot be expected, it should not be exacted, of any critical writer or lecturer on any form of art.

Mr. Whistler's Lecture on Art, by Algernon Charles Swinburne.

Fortnightly Review, June 1888.

. . . . And it appears to one at least of those unfortunate "outsiders" for whose judgment or whose "meddling" Mr. Whistler has so imperial and Olympian a contempt.

Let us begin at the end, as all reasonable people always do: we shall find that Mr. Whistler concedes to Greek art a place beside Japanese. Now this, on his own showing, will never do; it crosses, it contravenes, it nullifies, it pulverizes his theory or his principle of artistic limitation. If Japanese art is right in confining itself to what can be "broidered upon the fan"—and the gist of the whole argument is in favour of this assumption—

REFLECTION

" f " indeed !

then the sculpture which appeals, indeed, first of all to our perception of beauty, to the delight of the eye, to the wonder and the worship of the instinct or the sense, but which in every possible instance appeals also to far other intuitions and far other sympathies than these, is as absolutely wrong, as demonstrably inferior, as any picture or as any carving which may be so degenerate and so debased as to concern itself with a story or a subject.

REFLECTION:
* Because the Bard is blind, shall the Painter cease to see?

Assuredly Phidias thought of other things than "arrangements"* in marble—as certainly as Æschylus thought of other things than "arrangements" in metre. Nor, I am sorely afraid, can the adored Velasquez be promoted to a seat "at the foot of Fusi-yama." Japanese art is not merely the incomparable achievement of certain harmonies in colour; *it is the negation, the immolation, the annihilation of everything else.* By the code which accepts as the highest of models and of masterpieces the cups

REFLECTION:
"Cups and fans and screens," and Hamilton vases, and figurines of Tanagra, and other "waterflies."

and fans and screens with which "the poor world" has been as grievously "pestered" of late years as ever it was in Shakespeare's time "with such waterflies—"diminutives of nature"—as excited the scorn of his moralizing cynic, Velasquez is as unquestionably condemned as is Raphael or Titian. It is true that this miraculous power of hand (?)† makes beautiful

REFLECTION:
† Quite hopeless!

for us the deformity of dwarfs, and dignifies the
degradation of princes; but that is not the question.
It is true, again, that Mr. Whistler's own merest
" arrangements " in colour are lovely and effective ;*
but his portraits, to speak of these alone, are liable
to the damning and intolerable imputation of pos-
sessing not merely other qualities than these, but
qualities which actually appeal—I blush to remember
and I shudder to record it—which actually appeal to
the intelligence † and the emotions, to the mind and
heart of the spectator. It would be quite useless for
Mr. Whistler to protest—if haply he should be so
disposed—that he never meant to put study of
character and revelation of intellect into his portrait
of Mr. Carlyle, or intense pathos of significance and
tender depth of expression into the portrait of his
own venerable mother. The scandalous fact re-
mains, that he has done so; and in so doing has
explicitly violated and implicitly abjured the creed
and the canons, the counsels and the catechism of
Japan.

And when Mr. Whistler informs us that "there
never was an artistic period," we must reply that the
statement, so far as it is true, is the flattest of all
possible truisms; for no mortal ever maintained that
there ever was a period in which all men were either

REFLECTION:
Whereby it would
seem that, for the
Bard, the lovely is
not necessarily
" effective."

REFLECTION:
† The "lovely,"
therefore, con-
fessedly does not
appeal to the in-
telligence, emo-
tions, mind, and
heart of the Bard
even when aided by
the "effective."

good artists or good judges of art. But when we pass
from the positive to the comparative degree of historic
or retrospective criticism, we must ask whether the
lecturer means to say that there have not been times

REFLECTION:
Of course I do
mean this thing—
though most impru-
dent was the saying
of it!—for this Art
truth the Poet re-
sents with the
people.—June 1888.

when the general standard of taste and judgment,
reason and perception, was so much higher than at
other times and such periods may justly and accu-
rately be defined as artistic. If he does mean to say

this, he is beyond answer and beneath confutation;
in other words, he is where an artist of Mr. Whistler's
genius and a writer of Mr. Whistler's talents can by
no possibility find himself. If he does not mean to
say this, what he means to say is exactly as well worth
saying, as valuable and as important a piece of infor-
mation, as the news that Queen Anne is no more, or
that two and two are not generally supposed to make
five.

But if the light and glittering bark of this brilliant
amateur in the art of letters is not invariably steered
with equal dexterity of hand between the Scylla and
Charybdis of paradox and platitude, it is impossible
that in its course it should not once and again touch
upon some point worth notice, if not exploration.
Even that miserable animal the " unattached writer "
may gratefully and respectfully recognize his accurate
apprehension and his felicitous application of well-

nigh the most hackneyed verse in all the range of
Shakespeare's—which yet is almost invariably mis-
construed and misapplied—"One touch of nature
makes the whole world kin;" and this, as the poet
goes on to explain, is that all, with one consent, prefer
worthless but showy novelties to precious but familiar
possessions. "This one chord that vibrates with
all," says Mr. Whistler, who proceeds to cite artistic
examples of the lamentable fact, "this one unspoken
sympathy that pervades humanity, is—Vulgarity."
But the consequence which he proceeds to indicate
and to deplore is calculated to strike his readers with
a sense of mild if hilarious astonishment. It is that
men of sound judgment and pure taste, quick feelings
and clear perceptions, most unfortunately and most
inexplicably begin to make their voices "heard in the
land." Porson, as all the world knows, observed of
the Germans of his day that "in Greek" they were
"sadly to seek." It is no discredit to Mr. Whistler if
this is his case also; but then he would do well to
eschew the use of a Greek term lying so far out of
the common way as the word "æsthete." Not merely
the only accurate meaning, but the only possible mean-
ing, of that word is nothing more, but nothing less, than
this—an intelligent, appreciative, quick-witted person;
in a word, as the lexicon has it, "one who perceives."

REFLECTION:
Je reviens donc
de Pontoise!

The man who is no æsthete stands confessed, by the logic of language and the necessity of the case, as a thick-witted, tasteless, senseless, and impenetrable blockhead. I do not wish to insult Mr. Whistler, but I feel bound to avow my impression that there is no man now living who less deserves the honour of enrolment in such ranks as these—of a seat in the synagogue of the anæsthetic.

. . . . Such abuse of language is possible only to the drivelling desperation of venomous or fangless duncery: it is in higher and graver matters, of wider bearing and of deeper import, that we find it necessary to dispute the apparently serious propositions or assertions of Mr. Whistler. *How far the witty tongue may be thrust into the smiling cheek* when the lecturer pauses to take breath between these remarkably brief paragraphs it would be certainly indecorous and possibly superfluous to inquire. But his theorem is unquestionably calculated to provoke the loudest and the heartiest mirth that ever acclaimed the advent of Momus or Erycina. For it is this—that * " Art and Joy go together," *and that* † *tragic art is not art at all.*

. . . . The laughing Muse of the lecturer, " quam Jocus circumvolat," must have glanced round in expectation of the general appeal, " After that let us take

REFLECTION:

* Is not, then, the funeral hymn a gladness to the singer, if the verse be beautiful ?

Certainly the funeral monument, to be worthy the Nation's sorrow buried beneath it, must first be a joy to the sculptor who designed it.

The Bard's reasoning is of the People. His Tragedy is *theirs.* As one of them, the *man* may weep—yet will the artist rejoice—for to him is not " A thing of beauty a joy for ever " ?

† At what point of my " *O'clock* " does Mr. Swinburne find this last—his own inconsequence ?

breath." And having done so, they must have remembered that they were not in a serious world; that they were in the fairyland of fans, in the paradise of pipkins, in the limbo of blue china, screens, pots, plates, jars, josshouses, and all the fortuitous frippery of Fusi-yama.

REFLECTION:
Before the marvels of centuries, silence, the only tribute of the outsider, is by him refused—and the dignity of ignorance lost in speech.

It is a cruel but an inevitable Nemesis which reduces even a man of real genius, keen-witted and sharp-sighted, to the level of the critic Jobson, to the level of the *dotard and the dunce,* when paradox is discoloured by personality and merriment is distorted by malevolence.(!) No man who really knows the qualities of Mr. Whistler's best work will imagine that he really believes the highest expression of his art to be realized in reproduction of the grin and glare, the smirk and leer, of Japanese womanhood as represented in its professional types of beauty; but to all appearance he would fain persuade us that he does.

REFLECTION:
If an æsthete, the Bard is no collector!

In the latter of the two portraits to which I have already referred there is an expression of living character. This, however, is an exception to the general rule of Mr. Whistler's way of work: an exception, it may be alleged, which proves the rule. A single infraction of the moral code, a single breach of artistic law, suffices to vitiate the position of the preacher. And this is no slight escapade, or casual aberration; it is a full and frank defiance, a deliberate and elaborate

denial, hurled right in the face of Japanese jocosity,
flung straight in the teeth of the theory which con-
demns high art, under penalty of being considered
intelligent, to remain eternally on the grin.

If it be objected that to treat this theorem gravely
is "to consider too curiously" the tropes and the
phrases of *a jester* of genius, I have only to answer
that it very probably may be so, but that the excuse
for such error must be sought in the existence of the
genius. A man of genius is scarcely at liberty to choose
whether he shall or shall not be considered as a serious
figure—one to be acknowledged and respected as an
equal or a superior, not applauded and dismissed as
a tumbler or a clown. And if the better part of Mr.
Whistler's work as an artist is to be accepted as the
work of a serious and intelligent creature, it would
seem incongruous and preposterous to dismiss the more
characteristic points of his theory as a lecturer with
the chuckle or the shrug of mere amusement or
amazement. Moreover, if considered as a joke, a mere
joke, and nothing but a joke, this gospel of the grin
has hardly matter or meaning enough in it to support
so elaborate a structure of paradoxical rhetoric. It
must be taken, therefore, as something serious in the
main ; and if so taken, and read by the light reflected
from Mr. Whistler's more characteristically brilliant

R

canvases, it may not improbably recall a certain phrase
of Molière's which at once passed into a proverb—
" Vous êtes orfèvre, M. Josse." That worthy trades-
man, it will be remembered, was of opinion that
nothing could be so well calculated to restore a droop-
ing young lady to mental and physical health as the
present of a handsome set of jewels. *Mr. Whistler's*

REFLECTION:
A keen commer-
cial summing up—
excused by the
"Great Emperor!"
*opinion that there is nothing like leather—of a jovial
and Japanese design—savours somewhat of the Oriental
cordwainer.*

" Et tu, Brute ! "

WHY, O brother! did you not consult with me
before printing, in the face of a ribald world, *that
you also misunderstand,* and are capable of saying so,
with vehemence and repetition.

Have I then left no man on his legs?—and have I
shot down the singer in the far off, when I thought
him safe at my side?

Cannot the man who wrote *Atalanta*—and the
Ballads beautiful,—can he not be content to spend his
life with *his* work, which should be his love,—and has
for him no misleading doubt and darkness—that he
should so stray about blindly in his brother's flower-
beds and bruise himself!

Is life then so long with him, and *his* art so
short, that he shall dawdle by the way and wander
from his path, reducing his giant intellect—garru-
lous upon matters to him unknown, that the scoffer
may rejoice and the Philistine be appeased while he

takes up the parable of the mob and proclaims himself their spokesman and fellow-sufferer? O Brother! where is thy sting! O Poet! where is thy victory!

How have I offended! and how shall you in the midst of your poisoned page hurl with impunity the boomerang rebuke? "Paradox is discoloured by personality, and merriment is distorted by malevolence."

Who are you, deserting your Muse, that you should insult my Goddess with familiarity, and the manners of approach common to the reasoners in the market-place. "Hearken to me," you cry, "and I will point out how this man, who has passed his life in her worship, is a tumbler and a clown of the booths—how he who has produced that which I fain must acknowledge—is a jester in the ring!

Do we not speak the same language? Are we strangers, then, or, in our Father's house are there so many mansions that you lose your way, my brother, and cannot recognize your kin?

Shall I be brought to the bar by my own blood, and be borne false witness against before the plebeian people? Shall I be made to stultify myself by what I never said—and shall the strength of your testimony turn upon me? "If"—"If Japanese Art is right in confining itself to what can be broidered upon the

fan " and again " that he really believes
the highest expression of his art to be realized in re-
production of the grin and glare, the smirk and leer "
. . . . and further " the theory which con-
demns high art, under the penalty of being considered
intelligent, to remain eternally on the grin "
and much more !

"Amateur writer ! " Well should I deserve the
reproach, had I ventured ever beyond the precincts
of my own science—and fatal would have been the
exposure, as you, with heedless boldness, have un-
wittingly proven.

Art tainted with philanthropy—that better Art
result !—Poet and Peabody !

You have been misled—you have mistaken the pale
demeanour and joined hands for an outward and
visible sign of an inward and spiritual earnestness.
For you, these are the serious ones, and, for them,
you others are the serious matter. Their joke is their
work. For me—why should I refuse myself the grim
joy of this grotesque tragedy—and, with them now,
you all are my joke !

Freeing a Last Friend

BRAVO! Bard! and exquisitely written, I suppose, as becomes your state.

The scientific irrelevancies and solemn popularities, less elaborately embodied, I seem to have met with before—in papers signed by more than one serious and unqualified sage, whose mind also was not narrowed by knowledge.

The World,
June 3, 1888,
Letter to Mr.
Swinburne.

I have been " personal," you say ; and, faith ! you prove it !

Thank you, my dear ! I have lost a *confrère ;* but, then, I have gained an acquaintance—one Algernon Swinburne—" outsider "—Putney.

An Editor's Anxiety

IT is reported that Mr. Whistler, having received word that a drawing of his had been rejected by the Committee of the Universal Exhibition, arrived yesterday in Paris and withdrew all his remaining works, including an oil painting and six drawings. The French consider that he has been guilty of a breach of good manners. The *Paris*, for instance, points out that, after sending his works to the jury, he should have accepted their judgment, and appealed to the public by other methods.

Pall Mall Gazette,
April 26, 1889.

Rassurez vous !

TO THE EDITOR:

SIR—You are badly informed—a risk you con- *Pall Mall Gazette,*
April 27, 1889. stantly run in your haste for pleasing news.

I have not "withdrawn" my works "from the forthcoming Paris Exhibition."

I transported my pictures from the American department to the British section of the "Exposition Internationale," where I prefer to be represented.

"The French" have nothing, so far, to do with English or American exhibits.

A little paragraph is a dangerous thing.

And I am, Sir,

CHELSEA.

Whistler's Grievance

AN ENTRAPPED INTERVIEW.

THE *Herald* correspondent saw Mr. Whistler at the Hôtel Suisse, and asked the artist about his affairs with the American Art Jury of the Exhibition.

"I believe the *Herald* made the statement," said Mr. Whistler, "that I had withdrawn all my etchings and a full-length portrait from the American section. It all came about in this way: In the first place, before the pictures were sent in, I received a note from the American Art Department asking me to contribute some of my work. It was at that time difficult for me to collect many of my works; but I borrowed what I could from different people, and sent in twenty-seven etchings and the portrait."

*New York Herald,
Paris Edition,
Oct. 3, 1889.*

"You can imagine that a few etchings do not have any effect at all; so I sent what I could get together. Shortly afterwards I received a note saying : ' Sir—

Ten of your exhibits have not received the approval of the jury. Will you kindly remove them ? ' "

" At the bottom of this note was the name ' Hawkins '—General Hawkins, I believe—a cavalry officer, who had charge of the American Art Department of the Exhibition.

" Well! the next day I went to Paris and called at the American headquarters of the Exhibition. I was ushered into the presence of this gentleman, Hawkins, to whom I said :—' I am Mr. Whistler, and I believe this note is from you. I have come to remove my etchings ' ; but I did not mention that my work was to be transferred to the English Art Section."

" ' Ah ! ' said the gentleman—the officer—' we were very sorry not to have had space enough for all your etchings, but we are glad to have seventeen and the portrait."

" ' You are too kind,' I said, ' but really I will not trouble you.' "

" Mr. Hawkins was quite embarrassed, and urged me to reconsider my determination, but I withdrew every one of the etchings, and they are now well hung in the English Department."

" I did not mind the fact that my works were criticized, but it was the discourteous manner in which it was done. If the request to me had been

made in proper language, and they had simply said:
—'Mr. Whistler, we have not space enough for
twenty-seven etchings. Will you kindly select those
which you prefer, and we shall be glad to have them,'
I would have given them the privilege of placing
them in the American Section."

" Whacking Whistler "

IN an interview in yesterday's *Herald* the eccentric
artist, Mr. J. McNeill Whistler, " jumped " in a most
emphatic manner upon General Hawkins, Commis-
sioner of the American Art Department at the Exhi- *New York Herald,*
Paris Edition,
Oct. 4, 1889.
bition. He objects to the General for being a cavalry
officer; refers to him sarcastically as " Hawkins," and
declares him ignorant of the most elementary prin-
ciples alike of art and politeness—all this because he,
Whistler, was requested by the Commissioner to re-
move from the Exhibition premises some ten of his
rejected etchings.

In a spirit of fair play a correspondent called upon
General Hawkins, giving him an opportunity, if he
felt so disposed, of " jumping," in his turn, on his
excitable opponent. The General did feel " so dis-
posed," and proceeded, in popular parlance, to " see "
Mr. J. McNeill Whistler and " go him one better."
In this species of linguistic gymnastics, by the way, the

military Commissioner asks no odds of any one. He began by gently remarking that Mr. Whistler, in his published remarks, had soared far out of the domain of strict veracity. This was not bad for a " starter," and was ably supported by the following detailed statement :—

" Mr. Whistler says he received a note from me. That is a mistake. I have never in my life written a line to Mr. Whistler.* What he did receive was a circular with my name printed at the bottom. These circulars were sent to all the artists who had pictures refused by the jury, and contained a simple request that such pictures be removed.

" Our way of doing business was not, it seems, up to Mr. Whistler's standard of politeness, so he got angry and took away, not only the ten rejected etchings, but seventeen others which had been accepted. It is a little singular that among about one hundred and fifty artists who received this circular, Mr. Whistler should have been the only one to discover its latent discourtesy. How great must be Mr. Whistler's capacity for detecting a snub where none exists ! "

" In any case, there is not the slightest reason for Mr. Whistler's venting his ire upon me. I had no more to do with either accepting or rejecting his

* The official memory : " DEAR SIR — I wish by return mail you would send description for oils ; and if you desire to have titles to etchings printed, you will have to furnish the necessary material for copy.— Yours faithfully, RUSH C. HAWKINS, Commissariat Général, Paris, March 29, 1889. (*Autograph.*) To Mr. Whistler."

pictures than I had with painting them. What he sent us was judged on its merits by a competent and impartial jury of his peers. If there were ten etchings rejected it only shows that there were ten etchings not worthy of acceptance. A few days after the affair a trio of journalists—not all men either—came to me, demanding that I reverse this 'iniquitous decision,' as they styled it. I told these three prying scribblers in a polite way that if they would kindly attend to their own affairs I would try to attend to mine. In this connection, I may remark that there are in Paris a number of correspondents who ought not to be allowed within gun-shot of a newspaper office."

"The next mis-statement in Mr. Whistler's interview is in regard to the ultimate disposal of his important etchings. His words are:—' Mr. Hawkins was quite embarrassed, and urged me to reconsider my determination, but I withdrew every one of the etchings, and they are now well hung in the English department.'"

"Now, I leave it to any fair-minded person if the plain inference from this statement is not that the whole twenty-seven etchings were accepted by the English department. If not, what in heaven's name is he crowing about? But the truth is that while we

rejected only *ten* of his etchings, the English department rejected *eighteen* of them, and of the nine accepted only hung two on the line. Had Mr. Whistler been the possessor of a more even temper and a little more common sense, he would have had five or six of his works on the line in the American department, and nearly twice as many on exhibition than is actually the case. Really, I fail to see what he gained by the exchange, unless it was a valuable experience. He says I was embarrassed when I saw him; I fancy he will be embarrassed when he sees these facts in ' cold type.' "

" *Whistler's Grievance* "

SIR—I beg that you will kindly print immediately these, my regrets, that General Rush Hawkins should have been spurred into unwonted and unbecoming expression by what I myself read with considerable *New York Herald.* bewilderment in the *New York Herald*, October 3, under the head of " Whistler's Grievance."

I can assure the gallant soldier that I have no grievance.

Had I known that, when—over what takes the place of wine and walnuts in Holland—I remembered lightly the military methods of the jury, I was being "interviewed," I should have adopted as serious a tone as the original farce would admit of ; or I might have even refused to be a party at all to the infliction upon your readers of so old and threadbare a story as that of the raid upon the works of art in the American section of the Universal Exhibition.

Your correspondent, I fancy, felt much more warmly, than did I, wrongs that—who knows?—are doubtless rights in the army; and my sympathies, I confess, are completely with the General, who did only, as he complains, his duty in that state of life in which it had pleased God, and the War Department, to call him, when, according to order, he signed that naïvely authoritative note, circular, warrant, or what not—for he did irretrievably fasten his name to it, whether with pen or print, thereby hopelessly making the letter his own. Thus have we responsibility, like greatness, sometimes thrust upon us.

On receipt of the document I came—I saw the commanding officer, who, until now, I fondly trusted, would ever remember me as pleasantly as I do himself—and, knowing despatch in all military matters to be of great importance, I then and there relieved him of the troublesome etchings, and carried off the painting.

It is a sad shock to me to find that the good General speaks of me without affection, and that he evinces even joy when he says with a view to my entire discomfiture:—" While we rejected only ten of his etchings, the English department rejected eighteen of them, and of the nine accepted, only hung two on the line."

Now, he is wrong!—the General is wrong.

The etchings now hanging in the English section—

and perfect is their hanging, notwithstanding General Hawkins's flattering anxiety—are the only ones I sent there.

In the haste and enthusiasm of your interviewer, I have, on this point, been misunderstood.

There was moreover here no question of submitting them to a "competent and impartial jury of his peers" —one of whom, by the way, I am informed upon undoubted authority, had never before come upon an "etching" in his hitherto happy and unchequered Western career.

We all knew that the space allotted to the English department was exceedingly limited, and each one refrained from abusing it. Here I would point out again, hoping this time to be clearly understood, that, had the methods employed in the American camp been more civil, if less military, all further difficulties might have been avoided. Had I been properly advised that the room was less than the demand for place, I would, of course, have instantly begged the gentlemen of the jury to choose, from among the number, what etchings they pleased. So the matter would have ended, and you, Sir, would have been without this charming communication !

The pretty embarrassment of General Hawkins on the occasion of my visit, I myself liked, thinking it

seemly, and part of the good form of a West Point man, who is taught that a drum-head court martial—and what else in the experience of this finished officer should so fit him for sitting in judgment upon pictures?—should be presided at with grave and softened demeanour.

If I mistook the General's manner, it is another illusion the less.

And I have, Sir,
the honour to be,
Your obedient servant,

AMSTERDAM, Oct. 6.

The Art-Critic's Friend

MR. WHISTLER has many things to answer for,
and not the least of them is the education of the British
Art-Critic. That, at any rate, is the impression left by
a little book made up—apparently against the writer's
will—of certain of the master's letters and *mots*.
It is useful and pleasant reading ; for not only does
it prove the painter to have a certain literary talent—
of aptness, unexpectedness, above all impertinence—
but also it proves him never to have feared the face
of art-critical man. To him the art-critic is
nothing if not a person to be educated, with or against
the grain ; and when he encounters him in the ways of
error, he leaps upon him joyously, scalps him in print
before the eyes of men, kicks him gaily back into the
paths of truth and soberness, and resumes his avocation
with that peculiar zest an act of virtue does un-
doubtedly impart. Indeed, Mr. Whistler, so far from
being the critic's enemy, is on the contrary the best

The Scots Observer,
April 5, 1890.

friend that tradesman has ever had. For his function
is to make him ridiculous.

. . . . Yes, Mr. Whistler is often "rowdy" and
unpleasant; in his last combat with Mr. Oscar Wilde
—(" Oscar, you have been down the area again ")—he
comes off a palpable second; his treatment of 'Arry
dead and "neglected by the parish" goes far to prove
that his sense of smell is not so delicate nor so perfectly
trained as his sense of sight.

A Question

SIR—It is, I suppose, to your pleasant satisfaction in "The Critic's Friend" that I owe the early copy of the *Scots Observer*, pointed with proud mark, in the blue pencil of office, whereby the impatient author hastened to indicate the pithy personal paragraphs, that no time should be wasted upon other matter with which the periodical is ballasted.

The Scots Observer,
April 19, 1890.

Exhilarated by the belief that I had been remembered—for vanity's sake let me fancy that you have bestowed upon me your own thought and hand—I plunged forthwith into the underlined article, and read with much amusement your excellent appreciation.

Having forgotten none of your professional manner as art arbiter, may I say that I can picture to myself easily the sad earnestness with which you now point

the thick thumb of your editorial refinement in deprecation of my choicer "rowdyism"? And knowing your analytical conscientiousness, I can even understand the humble comfort you take in Oscar's meek superiority; but, for the life of me, I cannot follow your literary intention when you say that my care of "''Arry,' dead and neglected by the parish," goes far to prove that my "sense of smell is not so delicate nor so perfectly trained as" my "sense of sight."

Do you mean that my discovery of the body is the result of a cold in the head? and that, with a finer scent, I should have missed it altogether? or were you only unconsciously remembering and dreamily dipping your pen into the ink of my former description of "'Arry's" chronic catarrh? In any case, I am charmed with what I have just read, and only regret that the ridiculous "Romeike" has not hitherto sent me your agreeable literature.—Also I am, dear Sir, your obedient servant,

[The End of the Piece

The End of the Piece

SIR—I beg to draw your attention to the contents of your letter to the *Scots Observer*, dated April 12th, in which you state that you " regret the ridiculous Romeike has not hitherto sent me your agreeable literature."

This statement, had it been true, was spiteful and injurious, but being untrue (entirely) it becomes malicious, and I must ask you at once to apologise.

And at the same time to draw your attention to the fact that we have supplied you with 807 cuttings.

We have written to the *Scots Observer* for an ample apology, or the matter will be placed in our solicitor's hands, and we demand the same of you.

Yours obediently,

ROMEIKE & CURTICE.

J. McN. WHISTLER, Esq.
April 25, 1890.

Exit the Prompter

SIR—If it be not actionable, permit me to say that you *really are delightful ! !*

Naïveté, like yours, I have never met—even in my long experience with all those, some of whose " agreeable literature " may be, I suppose, in the 807 cuttings you charge me for.

Who, in Heaven's name, ever dreamed of you as an actual person ?—or one whom one would mean to insult ?

My good Sir, no such intention—believe me—did I, in my wildest of moments, ever entertain.

Your scalp—if you have such a thing—is safe enough !—and I even think—however great my willingness to assist you—could not possibly appear in the forthcoming Edition.

To Mr. ROMEIKE,
 April 25.

L'Envoi

WHEN the Chairman, in a singularly brilliant and felicitous speech led up to the toast of the evening, Mr. Whistler rose to his feet.

"You must feel that, for me," said Mr. Whistler, "it is no easy task to reply under conditions of which I have so little habit. We are all even too conscious that mine has hitherto, I fear, been the gentle answer that sometimes turneth not away wrath."

Report of a reply to the toast of the evening at the complimentary dinner given to Mr. Whistler, London, May 1, 1889.

Sunday Times,
May 5, 1889.

"Gentlemen," said he, "this is an age of rapid results, when remedies insist upon their diseases, that science shall triumph and no time be lost; and so have we also rewards that bring with them their own virtue. It would ill become me to question my fitness for the position it has pleased this distinguished company to thrust upon me."

"It has before now been borne in upon me, that in surroundings of antagonism, I may have wrapped myself, for protection, in a species of misunderstand-

ing—as that other traveller drew closer about him the folds of his cloak the more bitterly the winds and the storm assailed him on his way. But, as with him, when the sun shone upon him in his path, his cloak fell from his shoulders, so I, in the warm glow of your friendship, throw from me all former disguise, and, making no further attempt to hide my true feeling, disclose to you my deep emotion at such unwonted testimony of affection and faith."

[*Auto-Biographical*

Auto-Biographical

TO THE EDITOR :

SIR,—May I request that you allow me to make *Pall Mall Gazette* known, through your influential paper, the fact that July 28, 1891. the canvas, now shown as a completed work of mine, at Messrs. Dowdeswell's, representing three draped figures in a conservatory, is a painting long ago barely begun, and thrown aside for destruction ?

Also I am in no way responsible for the taste of the frame with its astonishments of plush! and varied gildings.

I think it not only just to myself to make this statement, but right that the public should be warned against the possible purchase of a picture in no way representative, and, in its actual condition, absolutely worthless.—I am, Sir, your obedient servant,

Chelsea, July 27, 1891.

Mr. Whistler "had on his own Toast"

TO THE EDITOR :

SIR,—I have read with interest Mr. Whistler's letter
in your issue of July 28. I happened to be at Messrs.
Dowdeswell's galleries the other day and saw the *Pall Mall Gazette,*
Aug. 1, 1891.
picture he refers to. It was not on public exhibition,
but was in one of their private rooms, and was brought
out for my inspection *à propos* of a conversation we
were having. Now, so far from Messrs. Dowdeswell
showing it as a "completed work," they distinctly
spoke of it as unfinished; nor can I imagine any
one acquainted with Mr. Whistler's works speaking
of any of them as "completed!" In "L'Envoi"
of the catalogue of his exhibition held at Messrs.
Dowdeswell's a short time ago I find the following
paragraph from his pen :—"The work of the master
reeks not of the sweat of the brow—suggests no
effort—and *is finished from its beginning.*" The only
inference possible is either that Mr. Whistler is not a

master, or that the work is finished ! He has, however, spent what time he could spare from his literary labours in endeavouring to induce the world to believe that the slightest scratch from his pen is worthy to rank with " Las Lanzas," and I am therefore surprised to learn that he has altered his opinion. Still, I quite agree with him when he tells us that some of his work is " absolutely worthless !"—I am, sir, more in sorrow than in anger, your obedient servant,

W. C.

July 31, 1891.

What " Mr. Whistler had on his own Toast "

TO THE EDITOR :

SIR,—My letter should have met with no reply at all. It was a statement—authoritative and unanswer- *Pall Mall Gazette,*
Aug. 4, 1891. able, if there ever were one.

Because of the attention drawn to it, in the press, I felt called upon to advise the Public that one of *my own works* is condemned *by myself.* Final this, one would fancy!

That the accidental owners of the Gallery should introduce themselves to the situation, is of a most marked irrelevancy. They come in *comme un cheveu sur la soupe*, to be removed at once.

The dealer's business is to buy and sell. In the course of such traffic, these same busy picture bodies, without consulting me, put upon the market a painting that I, the author, intended to efface—and, thanks to your courtesy, I have been enabled to say so effectually in your journal.

All along have I carefully destroyed plates, torn up proofs, and burned canvases, that the truth of the quoted word shall prevail, and that the future collector shall be spared the mortification of cataloguing his pet mistakes.

To destroy, is to remain.

What is commercial irritation beside a clean canvas ?

What is a gentlemanly firm in Bond Street beside Eternity ?—I am, sir, your obedient servant,

Chelsea, August 1, 1891.

NOCTURNES, MARINES,

AND

CHEVALET PIECES

A CATALOGUE

SMALL COLLECTION

KINDLY LENT

THEIR OWNERS

" THE VOICE OF A PEOPLE "

> " I do not know when so much amusement has been afforded to the British public as by Mr. Whistler's pictures."
>
> *Speech of the Attorney-General of England.*
> *Westminster, Nov.* 16, 1878.

1.—NOCTURNE.

GREY AND SILVER—CHELSEA EMBANKMENT—WINTER.

Lent by F. G. Orchar, Esq.

" With the exception, perhaps, of one of Mr. Whistler's meaningless canvases, there is nothing that is actually provocative of undue mirth or ridicule."

City Press.

" In some of the Nocturnes the absence, not only of definition, but of gradation, would point to the conclusion that they are but engaging sketches. In them

we look in vain for all the delicate differences of light
and hue which the scenes depicted present."

> *F. Wedmore, " Four Masters of Etching."*

2.—SYMPHONY IN WHITE, No. III.

> *Lent by Louis Huth, Esq.*

" It is not precisely a symphony in white—one lady
has a yellowish dress and brown hair and a bit of blue
ribbon, the other has a red fan, and there are flowers
and green leaves. There is a girl in white on a white
sofa, but even this girl has reddish hair ; and of course
there is the flesh colour of the complexions."

> *P. G. Hamerton, " Saturday Review."*

" Mr. Whistler appears as eccentrically as ever.
Art is not served by freaks of resentment. We
hold him deeply to blame that these figures are badly
drawn.

" ' Taste,' which is mind working in Art,
would, even if it could at all conceive them, utterly
reject the vulgarities of Mr. Whistler with regard to
form, and never be content with what suffices him in
composition."—*Athenæum.*

"Painting, or art generally, as such, with all its tech-
nicalities, difficulties, and particular ends, is nothing

but a noble and expressive language, invaluable as the
vehicle of thought, but by itself nothing."

> *John Ruskin, Esq., Art Professor,*
> *"Modern Painters."*

3.—CHELSEA IN ICE.

Lent by Madame Venturi.

"We are not sure but that it would be something
like insult to our readers to say more about these
'things.' They must surely be meant in jest ; but
whether the public have chiefly to thank Mr. Whistler
or the Managers of the Grosvenor Gallery for playing
off on them this sorry joke we do not know, nor
greatly care. *Meliora canamus !"—Knowledge.*

4.—NOCTURNE.

BLUE AND GOLD—OLD BATTERSEA BRIDGE.

Lent by Robert H. C. Harrison, Esq.

"His Nocturne in Blue and Gold, No. 3, might have
been called, with a similar confusion of terms: A
Farce in Moonshine, with half-a-dozen dots."—*Life.*

"The picture representing a night scene on Batter-
sea Bridge has no composition and detail. A day, or
a day and a half, seems a reasonable time within

which to paint it. It shows no finish—it is simply a sketch."

Mr. Jones, R.A.—Evidence in Court,
Nov. 16, 1878.

5.—THE LANGE LEIZEN—OF THE SIX MARKS.

PURPLE AND ROSE.

Lent by J. Leathart.

"Mr. Whistler paints subjects sadly below the merit of his pencil."—*London Review.*

"A worse specimen of humanity than could be found on the oldest piece of china in existence."

Reader.

"The hideous forms we find in his Chinese vase painteress an ostentatious slovenliness of execution objects as much out of perspective as the great blue vase in the foreground, *&c... &c...*

"It is Mr. Whistler's way to choose people and things for painting which other painters would turn from, and to combine these oddly chosen materials as no other painter would choose to combine them. He should learn that eccentricity is not originality, but the caricature of it."—*Times.*

6.—NOCTURNE.

TRAFALGAR SQUARE—SNOW.

Lent by Albert Moore, Esq.

" The word ' impressionist ' has come to have a bad meaning in art. Visions of Whistler come before you when you hear it. Such visions are not of the best possible augury, for who loves a nightmare ? "

Oracle.

" Like the landscape art of Japan, they are harmonious decorations, and a dozen or so of such engaging sketches placed in the upper panels of a lofty apartment would afford a justifiable and welcome alternative even to noble tapestries or Morris wallpapers."—*F. Wedmore, " Four Masters of Etching."*

7.—NOCTURNE—BLACK AND GOLD.

THE FIRE WHEEL.

" Mr. Whistler has ' a sweet little isle of his own ' in the shape of an ample allowance of wall space all to himself for the display of his six most noticeable works : ' Nocturnes ' in black and gold, in blue and silver, ' Arrangements ' in black and brown, and ' Harmonies ' in amber and black.

" These weird productions—enigmas sometimes so

occult that Œdipus might be puzzled to solve them—
need much subtle explanation."—*Daily Telegraph.*

8.—ARRANGEMENT IN BLACK AND BROWN.

The Fur Jacket.

" Mr. Whistler has whole-length portraits, or rather
the shadows of people, shapes suggestive of good
examples of portraiture *when completed.* They are
exhibited to illustrate a theory peculiar to the artist.
One is entitled An Arrangement in ' Black and
Brown.' "—*Daily Telegraph.*

" Mr. Whistler is anything but a robust and bal-
anced genius."—*Times.*

" Whistler, with three portraits which he is pleased
to call ' Arrangements,' and which look like ghosts."
Truth.

" Some figure pieces, which this artist exhibits as
' harmonies ' in this, that, or the other, being, as
they are, mere rubs-in of colour, have no claim to be
regarded as pictures."—*Scotsman.*

" We are threatened with a Whistler exhibition.
The periodical inflictions with which this gentleman
tries the patience of a long-suffering public generally

take some fantastic form to attract attention. It is
an evidence of the painter's worldly acuteness that
this should be so, for public attention may be drawn
by such outbursts of eccentricity to such work as
would never impress sensible people on its bare
merit."—*Oracle.*

<div align="center">

9.—NOCTURNE.

BLUE AND SILVER.

Lent by Mrs. Leyland.

</div>

"It seems to us a pity that an artist of Mr.
Whistler's known ability should exhibit such an extra-
ordinary collection of pictile nightmares."—*Society.*

"MR. BOWEN: 'Do you consider detail and composi-
tion essential to a work of art?'

"MR. JONES: 'Most certainly I do.'

"MR. BOWEN: 'Then what detail and composition
do you find in this "Nocturne"?'

"MR. JONES: 'Absolutely none.'

"MR. BOWEN: 'Do you think two hundred guineas
a large price for that picture?'

"MR. JONES: 'Yes, when you think of the amount
of earnest work done for a smaller sum.'"

<div align="right">

Evidence of Mr. Jones, R.A.,

Westminster, Nov. 16, 1878.

</div>

10.—NOCTURNE.

IN BLACK AND GOLD—THE FALLING ROCKET.

" A dark bluish surface, with dots on it, and the faintest adumbrations of shape under the darkness, is gravely called a Nocturne in Black and Gold."

Knowledge.

" His Nocturne, black and gold, ' The Falling Rocket,' shows such wilful and headlong perversity that one is almost disposed to despair of an artist who, in a sane moment [*sic*], could send such a daub to any exhibition."—*Telegraph.*

" For Mr. Whistler's own sake, no less than for the protection of the purchaser, Sir Coutts Lindsay ought not to have admitted works into the gallery in which the ill-educated conceit of the artist so nearly approached the aspect of wilful imposture. I have seen, and heard, much of cockney impudence before now, but never expected to hear a coxcomb ask two hundred guineas for flinging a pot of paint in the public's face."

Professor John Ruskin,

July 2, 1877.

" The ' Nocturne in black and gold ' is not a serious work to me."

Mr. Firth, R.A.—Evidence at Westminster,

Nov. 16, 1878.

" The ' Nocturne in black and gold,' I do not think
a serious work of art."

The Art Critic of the " Times."

Evidence at Westminster, Nov. 16, 1878.

" The Nocturne in black and gold has not the merit
of the other two pictures, and it would be impossible
to call it a serious work of art. Mr. Whistler's
picture is only one of the thousand failures to paint
night. The picture is not worth two hundred
guineas."

Evidence of Mr. Jones, R.A.

Westminster, Nov. 16, 1878.

II.—NOCTURNE—OPAL AND SILVER.

Lent by H. Theobald, Esq.

" With what feelings must we regard the mad new
style, the Nocturnes in ' Blue and Silver,' the Har-
monies in Flesh-colour and Pink, the Notes in Blue
and Opal."—*Knowledge.*

" The blue and black smudges which purport to
depict the ' Thames at Night.' "—*Life.*

12.—HARMONY IN GREEN AND ROSE.

The Music Room.

Lent by Madame Reveillon.

" He paints in soot-colours and mud-colours, but, far from enjoying primary hues, has little or no perception of the loveliness of secondary or tertiary colour."—*Merrie England.*

13.—CREPUSCULE IN FLESH COLOUR AND GREEN.

Valparaiso.

Lent by Graham Robertson, Esq.

"Now, the best achievement of The Impressionist School, to which Mr. Whistler belongs [*sic*], is the rendering of air—not air made palpable and comparatively easy to paint, by fog—but atmosphere which is the medium of light."—*Merrie England.*

14.—CAPRICE IN PURPLE AND GOLD.

The Gold Screen.

Lent by Cyril Flower, Esq., M.P.

" I take it to be admitted by those who do not conclude that art is necessarily great which has the misfortune to be unacceptable, that it is not by his paintings so much as by his etchings that Mr. Whistler's name may aspire to live."—*F. Wedmore.*

15.—SYMPHONY IN GREY AND GREEN.

THE OCEAN.

Lent by Mrs. Peter Taylor.

" In Mr. Whistler's picture, 'Symphony in Grey and Green : The Ocean,' the composition is ugly, the sky opaque, the suggestion of sea leaden and without light or motion."—*Times.*

" Mr. Whistler continues these experiments in colour which are now known as 'Symphonies.' It may be questioned whether these performances are to be highly valued, except as feats accomplished under needless and self-imposed restrictions—much as writing achieved by the feet of a penman who has not been deprived of the use of his hands."—*Graphic.*

"We can paint a cat or a fiddle, so that they look as if we could take them up ; but we cannot imitate the Ocean or the Alps. We can imitate fruit, but not a tree ; flowers, but not a pasture ; cutglass, but not the rainbow."—*John Ruskin, Esq., Teacher of Art.*

16.—NOCTURNE.

GREY AND GOLD—CHELSEA SNOW.

Lent by Alfred Chapman, Esq.

" Mr. Whistler sends two of his studies of moonlight, in which form is eschewed for harmonies of

'Grey and Gold' and 'Blue and Silver;' and which, for the crowd of exhibition visitors, resolve themselves into riddles or mystifications. In a word, painting to Mr. Whistler is the exact correlative of music, as vague, as purely emotional, as released from all functions of representation.

" He is really building up art out of his own imperfections [*sic !*] instead of setting himself to supply them."—*Times.*

17.—NOCTURNE.

BLUE AND SILVER—BATTERSEA REACH.

Lent by W. G. Rawlinson, Esq.

" J. M. Whistler is here again with his nocturnes."
Scotsman.

18.—NOCTURNE.

BLUE AND SILVER—CHELSEA.

Lent by W. C. Alexander, Esq.

" Mr. Whistler confines himself to two small canvases of the nocturne kind. One is covered with smudgy blue and the other with dirty black."
Saturday Review.

" A reputation, for a time, imperilled by original absurdity"—*F. Wedmore, " Academy."*

" I think Mr. Wedmore takes the Nocturnes and Arrangements too seriously. They are merely first beginnings of pictures, differing from ordinary first beginnings in having no composition. The great originality was in venturing to exhibit them."

P. G. Hamerton, " Academy."

19.—NOCTURNE.

GREY AND GOLD—WESTMINSTER BRIDGE.

Lent by the Hon. Mrs. Percy Wyndham.

"Two of Mr. Whistler's 'colour symphonies'—a 'Nocturne in Blue and Gold,' and a 'Nocturne in Black and Gold.' If he did not exhibit these as pictures under peculiar and, what seems to most people, pretentious titles, they would be entitled to their due meed of admiration [*sic !*]. But they only come one step nearer pictures than delicately graduated tints on a wall-paper do.

"He must not attempt, with that happy, half-humorous audacity which all his dealings with his own works suggests, to palm off his deficiencies upon us as manifestations of power."—*Daily Telegraph.*

20.—NOCTURNE.

BLUE AND GOLD—SOUTHAMPTON WATER.

Lent by Alfred Chapman, Esq.

" There is always danger that efforts of this class
may degenerate into the merely tricky and meretri-
cious; and already a suspicion arises that the artist's
eccentricity is somewhat too premeditated and self-
conscious."—*Graphic.*

21.—BLUE AND SILVER.

BLUE WAVE—BIARRITZ.

Lent by Gerald Potter, Esq.

" Mr. Whistler is possessed of much audacity and
eccentricity, and these are useful qualities in an artist
who desires to be talked about. When he comes out
into the open, and deals with daylight, we find these
studies to be only the first washes of pictures. He
leaves off where other artists begin. He shirks all
the difficulties ahead, and asks the spectator to com-
plete the picture himself."—*Daily Telegraph.*

" The absence, seemingly, of any power, such as
the great marine painters had, of drawing forms of
water, whether in a broad and wind-swept tidal river
or on the high seas"

F. Wedmore,
" Nineteenth Century."

22.—ARRANGEMENT IN BLACK AND BROWN.

Miss Rosa Corder.

Lent by Graham Robertson, Esq.

"It is bad enough, in all conscience, to be caricatured by the gifted pencil and brushes of the admirable Whistler; and it is surely adding insult to injury to describe the victims and sufferers as ' Arrangements.' With regard to Mr. Whistler's Symphonies, Harmonies, and so on, we will relate a parable. Here it is :—A lively young donkey sang a sweet love song to the dawn, and so disturbed all the neighbourhood, that the neighbours went to the donkey and begged him to desist. He continued his braying for some time, and then ended with what appeared, to his own ears, a flourish of surpassing brilliancy.

" ' Will you be good enough to give over that hideous noise ? ' " said the neighbours.

" ' Good Olympus ! ' said the donkey, ' did you say hideous noise ? Why, that is a " Symphony," which means a concord of sweet sounds, as you may see by referring to any dictionary.'

" ' But,' said the neighbours, ' we do *not* think that " Symphony" is the word to describe your performance. " Cacophony " would be more correct, and that means " a bad set of sounds." ' "

" ' How absurdly you talk ! ' said the donkey. ' I will refer it to my fellow-asses, and let them decide.'

" The donkeys decided that the young donkey's song was a most symphonious and harmonious, sweet song ; so he continues to bray as melodiously as ever. There is, we believe, a moral to this parable, if we only knew what it was. Perhaps the piercing eye of the ' *Nocturnal* Whistler' may find it out."—*Echo.*

" Miss Rosa Corder, and Mr. H. Irving as Philip, are two large blotches of dark canvas. When I have time I am going again to find out which is Rose and which is Irving.

" The rest of the collection is marred by the impatience which has prevented his achieving any finished work of Art."—*Weekly Press.*

23.—"HARMONY IN GREY AND GREEN."

PORTRAIT OF MISS ALEXANDER.

Lent by W. Alexander, Esq.

" A sketch of Miss Alexander, in which much must be imagined.' —*Standard.*

" There is character in it, but it is unpleasant character. Of anything like real flesh tones the painting is quite innocent."—*Builder.*

"But what can we say of Mr. Whistler? His portrait of Miss Alexander is certainly one of the strangest and most eccentric specimens of Portraiture we ever saw. If we were unacquainted with his singular theories of Art, we should imagine he had merely made a sketch and left it, before the colours were dry, in a room where chimney-sweeps were at work. Nobody who sets any value upon the roses and lilies that adorn the cheeks of our blooming girls can accept such murky tints as these as representative of a young English lady."—*Era.*

"It is simply a disagreeable presentment of a disagreeable young lady."—*Liverpool Weekly Mercury.*

"Mr. Whistler again appears on the walls with a characteristic full-length life-size portrait of a girl, Miss Alexander.

"This work is devoid of colour, being arranged in Black and White and intermediate tones of grey. The general effect is dismal in the extreme, and one cannot but wonder how an artist of undoubted talent should wilfully persist in such perversities of judgment."—*Western Daily Mercury.*

"Miss Alexander, almost in Black and White, and about the most unattractive piece of work in the Galleries."—*Edinburgh Daily Review.*

"A 'gruesomeness in Grey.'

"Well, bless thee, J. Whistler! We do not hanker after your brush system. Farewell!"—*Punch.*

"'AN ARRANGEMENT IN SILVER AND BILE.'

"The artist has represented this bilious young lady as looking haughty in a dirty white dress, a grey polonaise, bound by a grey green sash, a grey hat, with the most unhealthy green feather; furthermore, she wears black shoes with green bows, and stands defiantly on a grey floor cloth, opposite a grey wall with a black dado. Two dyspeptic butterflies hover wearily above her head in search *oj a bit of colour* evidently losing heart at the grey expanse around. A picture should charm, not depress, it should tend to elevate our thoughts!"—*Society.*

"This picture represents a child of ten, and is called a harmony in grey and green, but the prevailing tone is a rather unpleasant yellow, and the complexion of the face is wholly unchildlike."—*Echo.*

"A large etching in oil, a 'Rhapsody in Raw Child and Cobwebs,' by Mr. Whistler."—*Artist.*

"Mr. Whistler is as spectral as ever in an unattractive portrait of an awkward little girl, happily not rendered additionally ridiculous by a musical title."

Bedford Observer.

" Flattery is objectionable in art as elsewhere, but some portrait painters seem to find it impossible to tell the truth without being rude."—*Academy.*

" Mr. Whistler has a portrait of a young lady that excites absolute astonishment.

" What charm can there be in such colours as these ? What effect do they produce which would not have been better by warmer and less repulsive tints ?"

Leeds Mercury.

" Mr. Whistler's single contribution is a child's portrait, posed and painted in a rather distant, if obsequious, imitation of the manner of Velasquez, the great difference being that whereas the Spaniard's work is most remarkable for supreme distinction, the present portrait is uncompromisingly vulgar."

Magazine of Art.

24.—NOCTURNE.

BLUE AND SILVER—BOGNOR.

Lent by Alfred Chapman, Esq.

" We protest against those foppish airs and affectations by which Mr. Whistler impresses on us his contempt of public opinion. In landscape he contributes what he persists in calling a Nocturne in ' Blue and

Silver,' and a Nocturne in 'Black and Gold,' which
is a mere insult to the intelligence of his admirers.
It is very difficult to believe that Mr. Whistler is not
openly laughing at us."—*Pall Mall Gazette.*

25.—NOCTURNE.

BATTERSEA REACH.

Lent by Alfred Chapman, Esq.

" Under the same roof with Mr. Whistler's strange
productions is the collection of animal paintings done
by various artists for the proprietors of the *Graphic*,
and very refreshing it is to turn into this agreeably
lighted room and rest on comfortable settees whilst
looking at ' Mother Hubbard's Dog,' or the sweet
little pussy cats in the ' Happy Family.' "

Liverpool Courier.

" A few smears of colour, such as a painter might
make in cleaning his paint brushes, and which, neither
near at hand nor far off, neither from one side nor
from the other, nor from in front, do more than
vaguely suggest a shore and bay, was described as a
Note in Blue and Brown. One who found these
pictures other than insults to his artistic sense could
never be reached by reasoning."—*Knowledge.*

26.—GREEN AND GREY.

CHANNEL.

Lent by Alfred Chapman, Esq.

27.—PINK AND GREY.

CHELSEA.

Lent by Cyril Flower, Esq., M.P.

" of the insolent madness of that school of which Mr. Whistler is the most peccant—we wish we could say the only—representative."—*Knowledge.*

28.—NOCTURNE.

BLUE AND GOLD—VALPARAISO.

Lent by Alexander Ionides, Esq.

" ' A Nocturne' or two by Mr. Whistler—and here we have it in the usual style—a daub of blue and a spot or two of yellow to illustrate ships at sea on a dark night, and a splash and splutter of brightness on a black ground to depict a display of fireworks."

Norwich Argus.

29.—GREEN AND GREY.

The Oyster Smacks—Evening.

Lent by Alexander Ionides, Esq.

" Other people paint localities; Mr. Whistler makes artistic experiments."—*Academy.*

30.—GREY AND BLACK.

Sketch.

Lent by Alexander Ionides, Esq.

31.—BROWN AND SILVER.

Old Battersea Bridge.

Lent by Alexander Ionides, Esq.

" Nor can I imagine any one acquainted with Mr. Whistler's works speaking of any of them as 'completed.'"—*Letter to " Pall Mall."*

32.—NOCTURNE.

Black and Gold.

33.—SYMPHONY IN WHITE, No. II.

THE LITTLE WHITE GIRL.

Lent by Gerald Potter, Esq.

" Another picture, ' The Little White Girl,' was
exhibited about the same time, containing the germ
of that paradoxical Whistlerian humour lately so fully
exemplified in various places about London. It was
called ' A Little White Girl' in the catalogue, and
yet its colour generally was grimy grey."—*London.*

" The white girl was standing at the side of a mirror
where the laws of incidence and refraction would
unfortunately not permit her to see her own beauty."
Merrie England.

34.—NOCTURNE.

BLUE AND SILVER—CREMORNE LIGHTS.

Lent by Gerald Potter, Esq.

" I have expressed, and still adhere to the opinion,
that these pictures only come one step nearer than a
delicately tinted wall paper.
The Art Critic of the " Times."
Evidence at Westminster, Nov. 16, 1878.

" Paintings, like some of the ' Nocturnes,' and some
of the ' Arrangements,' are defended only by a

generous self-deception, when it is urged for them
that they will be famous to-morrow because they are
not famous to-day."

<div align="right">

Mr. Wedmore,

" Nineteenth Century."

</div>

35.—GREY AND SILVER.

CHELSEA WHARF.

Lent by Gerald Potter, Esq.

36.—GREY AND SILVER.

OLD BATTERSEA REACH.

Lent by Madame Coronio.

37.—BLUE AND SILVER.

" He has no atmosphere and no light. Instead of
air he studies various kinds of fog—and his ' values '
are the relative powers of darkness, not of light. He
never paints a sky."—*Merrie England.*

38.—NOCTURNE.

BLUE AND GOLD—ST. MARK'S, VENICE.

Lent by Monsieur Gallimard.

" The mannerism of Canaletto is the most degraded that I know
in the whole range of art.

" It gives no one single architectural ornament, however

near—so much form as might enable us even to guess at its actual one; and this I say not rashly, for I shall prove it by placing portions of detail accurately copied from Canaletto side by side with engravings from the daguerreotype.

" There is *no* stone drawing, *no* vitality of architecture like Prout's."—*Prof. Ruskin, Art Teacher.*

" In Mr. Whistler's productions one might safely say that there is no culture."—*Athenæum.*

" Imagine a man of genius following in the wake of Whistler ! "—*Oracle.*

" The measure of originality has at times been overrated through the innocent error of the budding amateur, who in the earlier stage of his enlightenment confuses the beginning with the end, accepts the intention for the adequate fulfilment, and exalts an adroit sketch into the rank of a permanent picture."

F. Wedmore, " *Four Masters of Etching.*"

39.—CREPUSCULE IN OPAL.

Lent by Fred. Jameson, Esq.

" Mr. Whistler is eminently an ' Impressionist.' The final business of art is not with ' impressions.' We want not ' impressionists' but ' expressionists,' men who can say what they mean because they know what they have heard. [*Sic !*]

"We want not always the blotches and misty suggestions of the impressionist, &c."—*Artist.*

40.—HARMONY IN FLESH COLOUR AND GREEN.

THE BALCONY.

Lent by John Cavafy, Esq., M.D.

"It is perhaps a little difficult for any critic to be quite absolutely just to Mr. Whistler at present, on account of his eccentricities and his apparent determination to make us forget the qualities of the artist in our amusement at the freaks and fancies of the man."—*P. G. Hamerton, in the " Academy."*

"*A Variation in Flesh Colour and Green.* The damsels—they were not altogether meritorious. The draughtsmanship displayed in them was anything but 'searching.' "—*F. Wedmore.*

"At about the same time the artist exhibited other sketches (we ask indulgence for the word) of a like character, notes of impressions of white dresses, furniture, balconies, and incidental faces and figures."

Merrie England.

"The 'evolution principle' has been visibly in operation for a dozen years or so in the successive Whistlers put before the public during that time. First of

all we remember pictures of ladies pale and attenuate poring with tender interest over vermilion scarfs. The taint of realism was on them, but even in them were hints of the pensive humour that was to fetch mankind in the well-known 'arrangements' at a later time. A good deal was left to the spectator's imagination even in them."—*London*.

"We note his predilections for dinginess and dirt."
Weekly Press.

41.—ARRANGEMENT IN BLACK.
La Dame au Brodequin Jaune.

"All these pictures strike us alike.

"They seem like half-materialised ghosts at a spiritualistic *séance*. I cannot help wondering when they will gain substance and appear more clearly out of their environing fog, or when they will melt altogether from my attentive gaze."—*Echo*.

"He has placed one of his portraits on an asphalte floor and against a coal-black background, the whole apparently representing a dressy woman in an *inferno* of the worldly."—*Merrie England*.

"Mr. Whistler has a capricious rendering of a lady dressed in black, in a black recess, on a dark green floor. She is turning affectedly half-round towards

the spectator as she buttons the *gant de suède* upon her left hand, &c. &c. Its obvious affectations render the work displeasing."—*Morning Advertiser*.

42.—ARRANGEMENT IN GREY AND BLACK.

THOMAS CARLYLE.

Lent by the Corporation of Glasgow.

" The purpose of this picture is a form of hero-worship which would certainly not have received the approbation of Carlyle.

". . . . This very doubtful masterpiece—unhappy ratepayers of Glasgow."—*Dundee Advertiser*.

". . . . and to have recorded on a doleful canvas the head and figure of Carlyle."—*F. Wedmore*.

" The rugged simplicity of Mr. Carlyle to have painted these things alone—however strange their mannerism or incomplete their technique."

Nineteenth Century.

" The portentous purchase by the civic authorities of Mr. Whistler's senile Carlyle renders it necessary for that section of the community who are not enamoured of Impressionism to watch with some vigilance the next steps taken by that body towards the formation of the permanent collection.

"A portrait which omits entirely to bring out the individuality of the sitter, stands but little chance of recognition even from immediate posterity."

Letter to "Glasgow Herald," March 4, 1892.

"We cannot forget his encounter some years ago with Mr. Ruskin, nor the contemptuous terms in which that foremost of art critics denounced his work. It has been left to Glasgow to rectify Mr. Ruskin's blunder in this matter, and it vindicates the merits of the American artist over whose artistic vagaries —his nocturnes and harmonies in blue and gold— the *whole press of Britain* made merry."

Dundee Advertiser.

"There is, among portraits of great writers, Mr. Whistler's portrait of Carlyle. It is a picture whose story is complete, whose honours have been gathered abroad—in Paris, in Brussels, in Munich. Its destiny has been accomplished; it belongs to the City of Glasgow, and from the corporation of that city was borrowed for the Victorian Exhibition. The corporation lent it in good faith; the borrowers have treated it with all the indignity it is in their power to bestow on it.

"Could there be a better epitome of the recent history of art in England? One work of Mr. Whistler's

is received with high honour in the Luxembourg on its
way to the Louvre; and at that very moment another
work of his, worthy to rank with the first, is hoist
with equally high disrespect to the ceiling of a gallery
in London."—*N. Y. Tribune, Jan.* 17, 1892.

<p align="center">43.—HARMONY IN PINK AND GREY.</p>
<p align="center">PORTRAIT OF LADY MEUX.</p>

<p align="right">*Lent by Sir Henry Meux.*</p>

"Portrait of Mrs. Meux, in which it was not so
much the face as the figure and the movement that
came to be deftly suggested, if hardly elaborately ex-
pressed."—*F. Wedmore.*

"All Mr. Whistler's work is unfinished. It is
sketchy. He no doubt possesses artistic qualities,
and he has got appreciation of qualities of tone; but
he is not complete, and all his works are in the nature
of sketching."

<p align="center">*The Art Critic of the " Times,"*</p>
<p align="center">*Evidence at Westminster, Nov.* 16, 1878.</p>

<p align="center">44.—ARRANGEMENT IN GREY AND BLACK.</p>
<p align="center">PORTRAIT OF THE PAINTER'S MOTHER.</p>

<p align="right">*Photograph of Picture.*</p>

" This canvas is large and much of it vacant.

" A dim, cold light fills the room, where the flat, grey

wall is only broken by a solitary picture in black and white; a piece of foldless, creaseless, Oriental flowered crape hangs from the cornice. And here, in this solemn chamber, sits the lady in mournful garb. The picture has found few admirers among the thousands who seek to while away the hours at Burlington House, and for this result the painter has only to thank himself."—*Times*.

"'Arrangement in Grey and Black: Portrait of the Painter's Mother,' is another of Mr. Whistler's experiments.

"It is not a picture, and we fail to discover any *object* that the artist can have in view in restricting himself almost entirely to black and grey."—*Examiner*.

"The 'arrangement' is stiff and ugly enough to repel many."—*Hour*.

"Before such pictures as the full-length portraits by Mr. Whistler, critic and spectator are alike puzzled. Criticism and admiration seem alike impossible, and the mind vacillates between a feeling that the artist is playing a practical joke upon the spectator, or that the painter is suffering from some peculiar optical delusion. After all, there are certain accepted canons about what constitutes good drawing, good colour, and good painting, and when an artist deliberately sets

himself to ignore or violate all of these, it is desirable that his work should not be classed with that of ordinary artists."—*Times.*

> " He that telleth a tale to Carlyle's majority speaketh to one in a slumber: when he hath told his tale he will say, What is the matter?"

RÉSUMÉ.

" It is impossible to take Mr. Whistler seriously."
 Advertiser.

" A combination of circumstances has, within the last year or two, brought the name and work of Mr. Whistler into special publicity. . . .

" At the Grosvenor Gallery the less desirable of his designs aroused the inconsiderate ire of a man of genius and splendid authority.

" If it be Mr. Whistler's theory that that which all the world of greatest artists (?) has mistaken for mere means has been in very seriousness the end, then the aim of Art is immeasurably lowered !

" If there be anything to the point, it is to implore us to take a stone for bread, and the grammar of a language in place of its literature.

" Mr. Whistler has assumed that it is only the painter who is occupied with art. . . . Unless he is a very exceptional man. . . . If he is not of the school of Fulham, he is of the school of Holland Park, or of the Grove End Road.

" Has he, like Mr. Ruskin, devoted thirty years of a poet's life to the Galleries of Europe ?

" Has he, like Diderot, inquired curiously into the meaning and message of this thing and that ? And *appreciating Greuze*, been able to *appreciate Chardin ?* (! !) "

> *Mr. Wedmore,*
> *" Nineteenth Century "*

" Mr. Ruskin's whole body of doctrine, from the very young days, in which he took the duty of teacher, on to his old age, was contradicted by Mr. Whistler's pictures."—*Merrie England.*

" In painting, his success is infrequent, and it is limited.

" In painting, Mr. Whistler is an impressionist. His best painting betrays something of that almost modern sensitiveness to pleasurable juxtapositions of delicate colour which we admire in Orchardson, in Linton (*sic !*), and in Albert Moore ; it betrays, sometimes, as in a portrait of Miss Alexander, a deftness of brush-work in the wave of a feather, in the curve of a hat . . . and of high art qualities it betrays not much besides.

" It is true that the originality of his painted work is somewhat apt to be dependent on the innocent error that confuses the beginning with the end, accepts the intention for the execution, and exalts an adroit sketch into the rank of a permanent picture."

F. Wedmore, " Four Masters of Etching."

" I think Mr. Whistler had great powers at first, which he has not since justified."

Mr. Jones, R.A.

Evidence in Court, Nov. 16, 1878.

" The right time and the right place for the conspicuousness of an Impressionist were undoubtedly England, and the moment when Mr. Whistler rose up and astonished her.

" In Paris he was one of many, though he would be at peace in France, that peace would not be unattended with a certain comparative obscurity.

"Inconspicuous solitude would not have had the same charms for him."—*Merrie England.*

" Au musée du Luxembourg, vient d'être placé, de M. WHISTLER, le splendide *Portrait de M^{me} Whistler mère*, une œuvre destinée à l'éternité des admirations, une œuvre sur laquelle la consécration des siècles semble avoir mis la patine d'un Rembrandt, d'un Titien ou d'un Velasquez."—*Chronique des Beaux-Arts.*

MORAL.

" Modern *British* (!) art will now be represented in the National Gallery of the Luxembourg by one of the finest paintings due to the brush of an *English* (!) artist, namely, Mr. Whistler's portrait of his mother."—*Illustrated London News.*

A Zealous Inquirer

The World,
Mar. 23, 1892.

" A brown-paper covered catalogue compiled by Mr. Whistler

" Several opinions (and his ' evidence at Westminster') are quoted of ' Mr. Jones, R.A.,' in the year 1878. Who is Mr. Jones, R.A. ? Mr. Jones, R.A. (of whom the Duke of Wellington—but no matter), died in 1869. Mr. Burne-Jones was not elected an A.R.A. until 1885. I am afraid I expose myself, but I still venture to ask, who is ' Mr. Jones, R.A.' ? "

Final Acknowledgments

ATLAS,—Your correspondent proposes that "Mr. Jones, R.A." is not R.A.—but *A*.R.A.

The World,
Mar. 30, 1892.

You know these things, Atlas—perhaps he is right, and curiously microscopic—for surely here we have "a difference without a distinction!"

However, R.A. or A.R.A., and, in my opinion he deserves to be both, I personally owe Mr. Jones a friendly gratitude which I am pleased to acknowledge; for rare indeed is the courage with which, on the first public occasion, he sacrificed himself, in the face of all-astounded etiquette, and future possible ridicule, in order to help write the history of another.

These things we like to remember, Atlas, you and I—the bright things, the droll things, the charming things of this pleasant life—and here, too, in this lovely land they are understood—and keenly appreciated.

As to those others—alas! I am afraid we have

done with them. It was our amusement to convict—
they thought we cared to convince!

Allons! They have served our wicked purpose—
Atlas, we "collect" no more.

"Autres gens, autres mœurs."

PARIS, *March* 26, 1892.

FINIS

INDEX

DATE DUE